YORKSHIRE

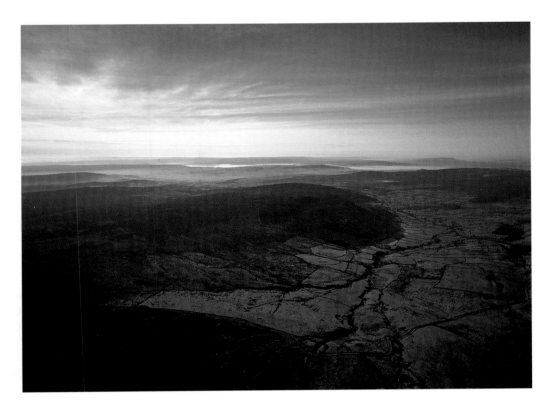

FROM THE AIR

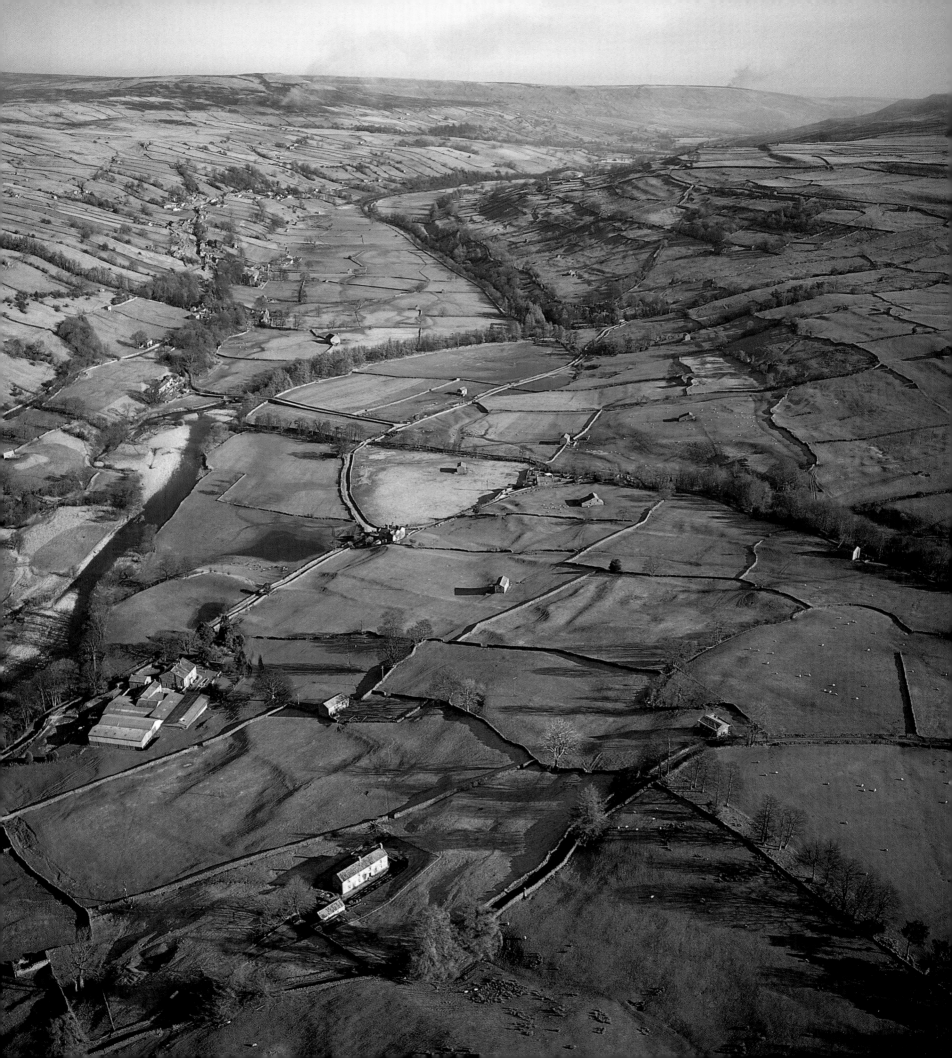

YORKSHIRE

FROM THE AIR

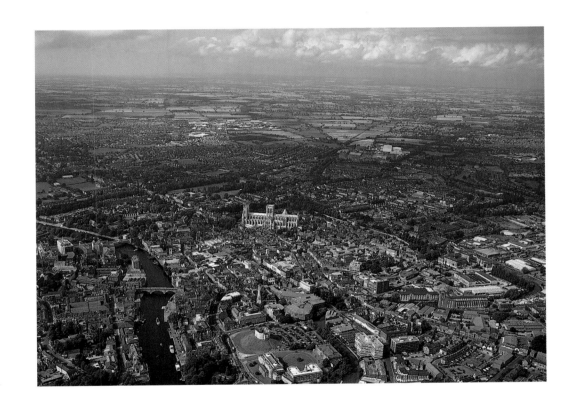

JASON HAWKES

TEXT BY ADELE McCONNEL

EBURY
PRESS

First published in Great Britain in 2001

1 3 5 7 9 10 8 6 4 2

Copyright © Jason Hawkes 2001
Text © Adele McConnel 2001

Ebury Press

Random House, 20 Vauxhall Bridge Road, London SW1V 2SA

Random House Australia (Pty) Limited
20 Alfred Street, Milsons Point, Sydney, New South Wales 2061, Australia

Random House New Zealand Limited
18 Poland Road, Glenfield, Auckland 10, New Zealand

Random House (Pty) Limited
Endulini, 5a Jubilee Road, Parktown 2193, South Africa

The Random House Group Limited Reg. No. 954009

www.randomhouse,co.uk

Papers used by Ebury Press are natural, recyclable products made
from wood grown in sustainable forests.

A CIP catalogue record for this book is available from the British Library

ISBN 0 09 187905 1

Designed by David Fordham

Typeset in Trajan and Fournier by MATS, Southend-on-Sea, Essex
Printed and bound in Portugal by Printer Portuguesa.Lda

CONTENTS

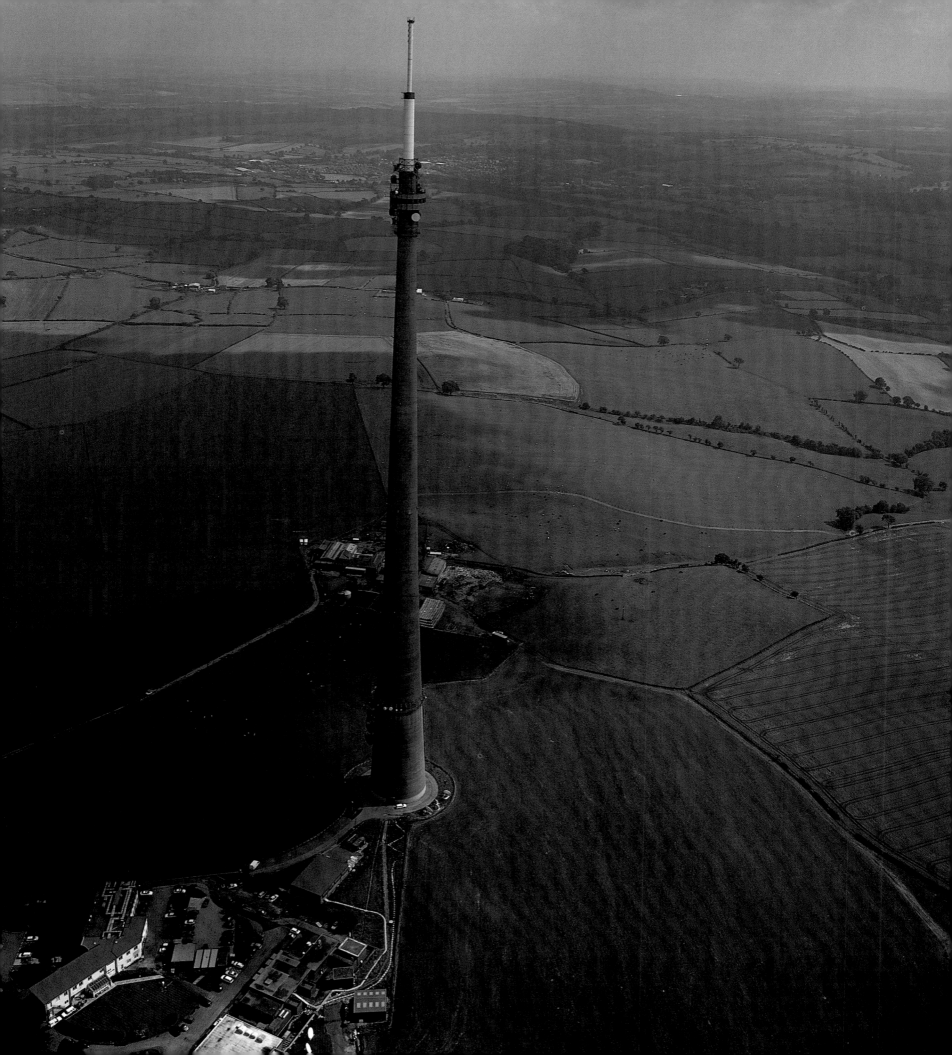

INTRODUCTION
YORKSHIRE FROM THE AIR

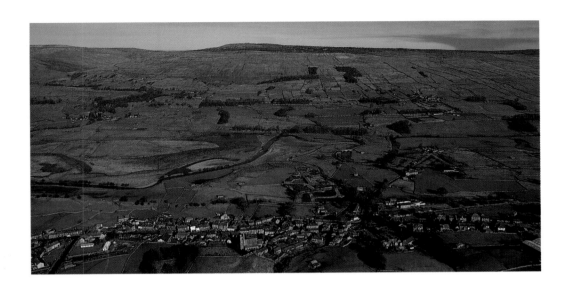

WITH MORE THAN A LITTLE HELP from a certain veterinary surgeon, Yorkshire has come to be one of Britain's best known and best loved landscapes. It is a countryside recognized by many, even if they have never set foot in Yorkshire, thanks to the inordinate amount of popular television series and films that have been located here. Think of *All Creatures Great and Small*, *Heartbeat*, *Emmerdale* and *Last of the Summer Wine*; and for the big screen, *The Full Monty* and *Brassed Off* immediately spring to mind. Just why has Yorkshire proved so popular as a backdrop? The answer has to lie in the sheer variety of scenery to be found here; the rolling green hills, flat arable fields, brooding moors, small rural villages and large industrial towns that all add up to make Yorkshire what it is.

Variety of scenery also lends Yorkshire uncommonly well to a book of aerial photography. Today, the vast technological strides in aeronautics mean that many of us have at least glimpsed the ground from the air ourselves, be it by aeroplane, helicopter, microlight or hot-air balloon, but perhaps not with such clarity as shown in these photographs. When man first took to the air, it changed his perception of the world forever and even today, part of the power of aerial photography is that it can change our perception of the ground. Distance becomes meaningless, huge trees become fir cones, and people are hardly significant, if visible at all. To put it into the words of the Italian Futurists of 1929, 'From a plane the flying painter sees the essential features of a landscape flattened, artificial, shifting, as though recently fallen from the sky.'

While this introduction is in no way intended to be an all-knowing lecture on the intricacies of the history of Yorkshire, the county is so full of mementoes from days gone by that you can not explore present-day Yorkshire without stumbling across the past. The following brief oversight touches on some of the events that have combined to make the north of England what it is today. If it seems slightly York-centric, it is supposed to be. It was this settlement that gave the entire region its name ('shire' means 'the county of') and until the Industrial Revolution, York was second only to London in terms of population and importance.

EMLEY MOOR MAST AND HAWES, WENSLEYDALE

Left In 1969, ice and wind caused the original 365m (1200ft) high steel television mast that had stood here since 1956 to collapse, destroying the local Methodist church. Understandably, the villagers were less than thrilled with the prospect of having another mast built in the same place; ironically, the mast is now a listed structure.

From the Anglo-Saxon word 'haus', meaning mountain pass, Hawes (*above*) is the 'capital' of Wensleydale, the broadest and least-secretive of the Dales.

So, to quantify the region covered by these photographs, Yorkshire makes up almost an eleventh of England. At its widest points, it stretches to around 87 miles north to south and 100 miles east to west. However, in a few centuries' time Yorkshire's width might be quite different. The rugged coastline north of the Humber estuary is slowly vanishing as the North Sea violently bites into the clay cliffs, eroding them at a frightening rate. Villages known to have existed in medieval times have long since disappeared and the slim, curved hook of Spurn Head changes shape almost annually.

Yorkshire's landscape owes much to the last Ice Age. The retreating ice formed favourite visitor spots such as Malham Cove (see page 40) and left many small freshwater lakes. Most of these have since silted up, but Hornsea Mere remains as an example of the waters that would have once peppered the area. Humans began shaping Yorkshire around 4000 years later, starting with the people of the Stone Age in 8000 BC. Archaeologists have found flint tools and weapons dating back to this time, and the next phase of technological development, the Bronze Age, left similar clues to their way of life.

As is true of much of Britain, history is much better documented after the Romans moved in. The Vale of York may have been inhabited since pre-historic times, but it took the Romans to capitalize on the many advantages of York's position. The tidal nature of the River Ouse enabled ships to sail up the River Humber, ensuring easy access for the import and export of goods, and York was elevated above the surrounding plain, keeping it dry despite its proximity to the river and easily defendable. The Romans established a fortress-like HQ at 'Eboracum' and lived up to their reputation of a road-building nation by connecting this main location to other forts at Malton and Doncaster, for example, as well as to the lead mines in the Pennines.

More than just a garrison settlement, Eboracum soon became a major Roman town and a typical example of just how advanced the Romans were. Gaining quick success as a port, the town soon included public baths, temples to a variety of Roman gods, a water supply, drainage and shops. Some houses were even supplied with underground heating and decorated with beautiful mosaic floors and marble panelling. Before long, it became one of the most important towns of the Empire.

In 410, the Romans were permanently withdrawn from England to defend their collapsing empire at home against the wrath of the Goths. The North was left at the mercy of the invading Angles from southern Denmark, who brought with them cultural, linguistic and political changes. Their legacy lives on today in many place names around Yorkshire, for example Thorganby, Wetherby and Danby. Most significantly, however, it was an Angle King, Edwin, that brought Christianity to this part of Britain and soon missionaries started to preach to his subjects, beginning Yorkshire's long and ardent history as an important ecclesiastical centre.

The Domesday Book documents just how much of Yorkshire was laid to waste after the infamous Norman Conquest of 1066. William the Conqueror did not manage to capture the North immediately and the strong-willed inhabitants rebelled, massacring his troops and appointed earls. William's strategy was to show conclusively he would accept no disobedience. By building castles, one of which can still be seen at York, he reinforced his image of authority, but more brutally, he ordered his men to retaliate by burning houses and murdering the locals. His soldiers also burnt the land, meaning nothing could be grown, so people starved. This became known as the 'Harrying of the North' and was so severe that no village was left inhabited between York and Durham. This took place in the winter of 1069 and it is hard today to appreciate the full devastation of this and the years after where disease and starvation followed. Nowhere else had he shown such cruelty.

Many of the great monasteries that the North had become famous for in Anglo-Saxon times had been destroyed by relentless Viking attacks, or abandoned and allowed to fall into disrepair. Those that still existed were pulled down and rebuilt by the Normans. But from around 1074, religious buildings celebrated a revival and building work was begun in earnest all around Yorkshire. Encouraged by Thurstan, the Archbishop of York, monasteries and abbeys such as Fountains and Rievaulx dominated huge sections of the landscape, and the Cistercian, Augustine and Benedictine

monks went about their daily rituals. They earned a not inconsiderable living from farming sheep and selling the wool, but were also donated land and money by aristocrats who were keen to keep up appearances and be seen to donate to such a worthy cause. The monasteries became quite powerful landowners and started to run the lead mines that had been in use since Roman times.

And so religious life continued … until the Pope refused to annul Henry VIII's first marriage. In his fury, the King decided to break with the Roman Catholic Church and established the Protestant Church as the Church of England. He ordered the Dissolution of all the 650 monasteries across England and Wales in 1538 and the buildings once again fell into disrepair. His decision particularly took its toll on York, which was crammed with religious houses. Throughout this dissolution, York remained strongly wedded to the Catholic cause and this is one of the factors that continues to draw so many visitors here. The city has not only managed to preserve its medieval rampart and walls, but parts of York Minster date back to Norman times.

In the last few centuries, it has been the Industrial Revolution that has had the most impact across Yorkshire, bringing technological, socio-economic and cultural changes. In all but the last 300 years, rural activities such as lead mining and agriculture were the most important source of employment in the region. York, which for so long had been the capital of the North, was largely passed by, whereas other cities flourished. Factories sprung up, canals and roads were built and the advent of the railroad and the steamship widened the market for manufactured goods. What started as the local production of wool soon blossomed into the south and west of Yorkshire, becoming known as one of the greatest woollen textile manufacturing centres of the world. Leeds, Halifax, Wakefield and Huddersfield were among the most successful towns as rivers flowing from the Pennines provided both waterpower and a transport route to the sea. At Bradford, you can still visit Saltaire, the textile factory and village built by the entrepeneur Sir Titus Salt. Built to emulate an Italian palazzo, it is larger than St Paul's Cathedral and was the biggest factory in the world when it opened. During the same period, Sheffield developed a first-class reputation as a metalworking centre.

Unfortunately, ruthless economic logic led to the collapse of this glory. Lead mines were exhausted, textile mills fell into disuse, engineering works were abandoned, depression was vast and unemployment affected everyone. It looked like the golden age was well and truly over. Nevertheless, displaying a practicality that Yorkshire men and women are famed for, the cities are now picking themselves up and dusting themselves off, ready to start again. Sheffield steel production has risen to its highest level ever, Leeds has reinvented itself as a cultural centre and other places are maximizing their attractiveness to tourists. Money has been spent ensuring that the North can now look forward to a positive and profitable future.

Outside of the built-up cities and towns, there is an altogether softer and gentler rural Yorkshire, characterized by villages that seem to have sprung up organically from the surrounding acres of moorland and dales. With more than 1000 square miles of protected National Parks, the Yorkshire scenery has always had a vast capacity to inspire famous writers, poets and painters, as well as thousands of mere mortals who come here to take advantage of the innumerable variations of walking routes.

Just as aerial photography, by turning our ceiling into our ground, can give a totally different perspective, revealing patterns and symmetry that would otherwise have been missed, the many faces of Yorkshire itself is simply a question of perspective. Perhaps you would agree with Emily Brontë who used the desolate bleakness of the moors to symbolize her characters' inner turmoil, or perhaps your view matches the thoughts of James Herriot who writes in his book of Yorkshire, 'when the sun beats down on the lonely miles these uplands are a paradise, the air heavy with the sweetness of warm grass, the breeze carrying a thousand scents from the valley below.'

Whichever you subscribe to, there are plenty of photographs over the course of this book that will challenge, conform to and complete your individual perspective of Yorkshire.

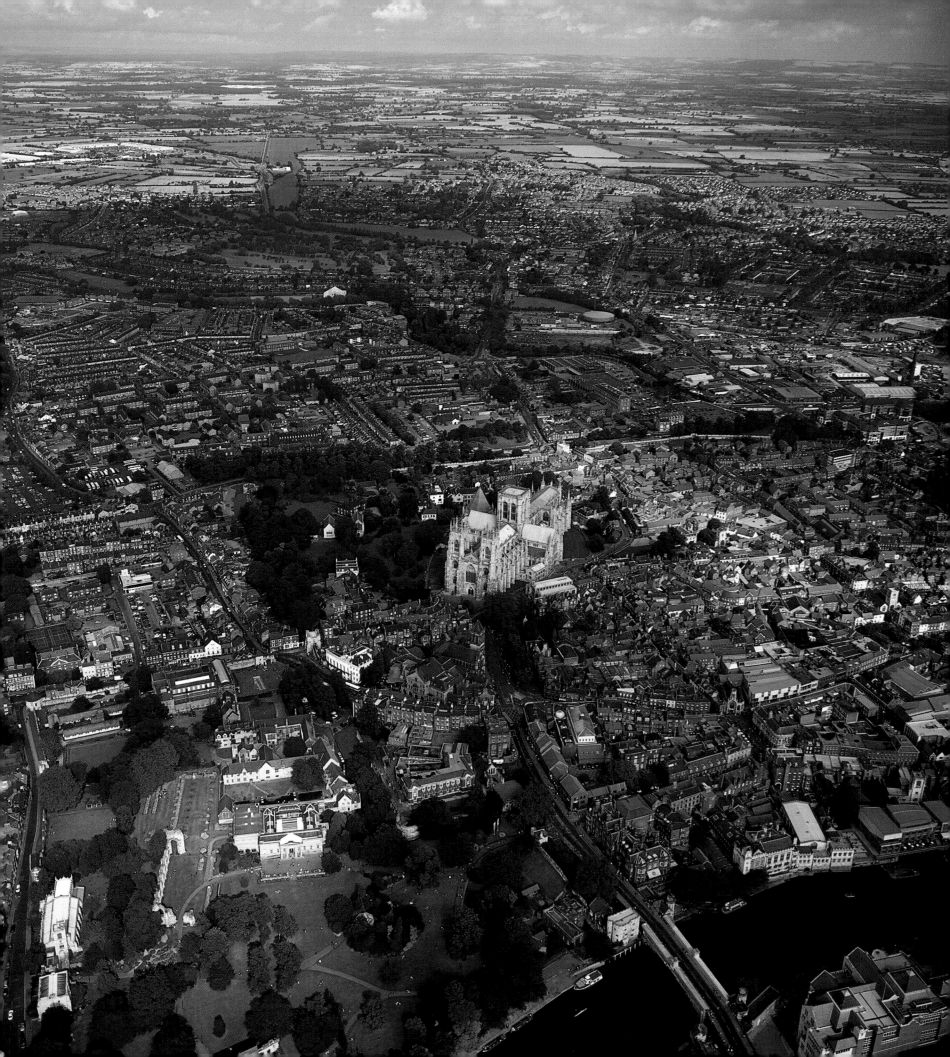

CITIES AND
INDUSTRIAL TOWNS

SURVEYING THE WILD AND TRANQUIL LANDSCAPE of the North York Moors, you would be forgiven for finding it hard to believe that Yorkshire has had a very strong industrial past. In fact, it was one that the moors were once part of as both alum (used to fix dye) and jet (for jewellery) were mined here. Whitby jet, in particular, reached its pinnacle of popularity after Queen Victoria's consort, Prince Albert, died and mourning wear became fashionable. At its peak in 1870, the jet industry in Whitby employed around 1500 people in more than 200 workshops.

The Dales too have played an important part in the industry of Yorkshire, in the form of lead mining. Mining was most likely introduced by the Romans, who would have brought knowledge gained in Spanish mines, and the industry just grew and grew. The Industrial Revolution saw the transformation of mines from little more than rabbit warrens to carefully constructed tunnels, which were systematically organized to exploit every pocket of lead. At its zenith, between 1845 and 1870,

Yorkshire produced around ten per cent of Britain's output and it is said that lead from Yorkshire mines was used in Windsor Castle, St Peter's in Rome and even on church roofs in Jerusalem.

However, the most important Yorkshire industries of the last century have to be textiles and steel. Steel was such a driving force in the economy of Sheffield that it is still referred to as the City of Steel. The textile industry was started on the moors and dales by monks but soon moved to cities in the south and west of Yorkshire. In the nineteenth century, Leeds and Bradford were among the world's mightiest producers of textiles. Leeds was located in a promising position with excellent trading links to the sea. Close enough to the rich agricultural Vale of York, it was also easy to bring in food for the workers, and mill after mill was opened. But other towns were not part of these booming industries. The Industrial Revolution largely passed York by, for example, and Harrogate found prosperity in a different way.

YORK AND HARROGATE

Left The Romans called York Eboracum, the Danes called it Jorvik and George VI famously stated that its history represented the history of Britain. In fact, until the Industrial Revolution, York was second in importance and population only to London.

Above Once nothing more than a village, Harrogate's prosperity increased ten-fold when a physician claimed the spa water had healing properties, which could cure anything from nervous tensions and gout to rheumatism.

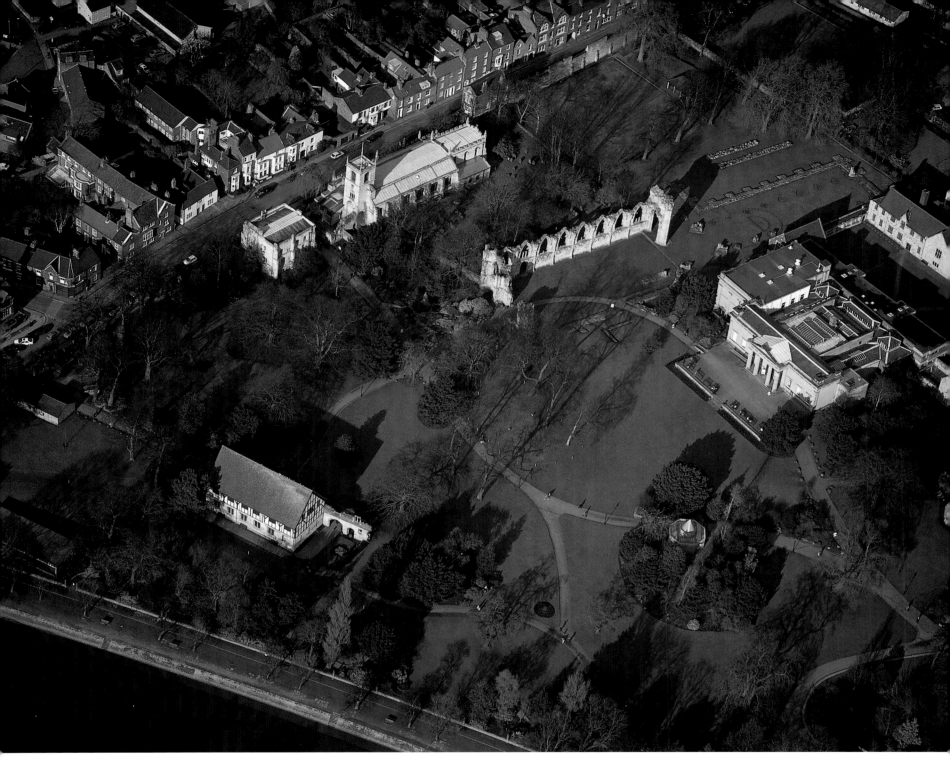

Yorkshire Museum and St Mary's Abbey, York

Above Set in ten acres of lush botanical gardens in the city centre, the Yorkshire Museum covers 1000 years of heritage. At the heart of the museum lies the majestic ruin of the medieval St Mary's Abbey, founded by King William Rufus in 1088, and the most wealthy and powerful abbey in the North for 450 years. The monks who lived here transferred from the old monastic centre of Lastingham and abided by Benedictine rules. Its location just outside the city walls led to territorial and jurisdictional disputes and many monks left to found the Cistercian Fountains Abbey in 1132. Nonetheless, St Mary's continued until 1539 when the desire for reformation became too strong and the abbey succumbed to the Crown.

Parliament Street, York

Right Built by the Victorians in 1834, the wide and often busy Parliament Street has a lively reputation as its sheer size has made it the ideal location for fairs and street entertainers. Parliament Street leads from St Sampson's Square down to the more modern Piccadilly and the much older Pavement. Meaning paved way, Pavement is home to several buildings that date back to the fifteenth century.

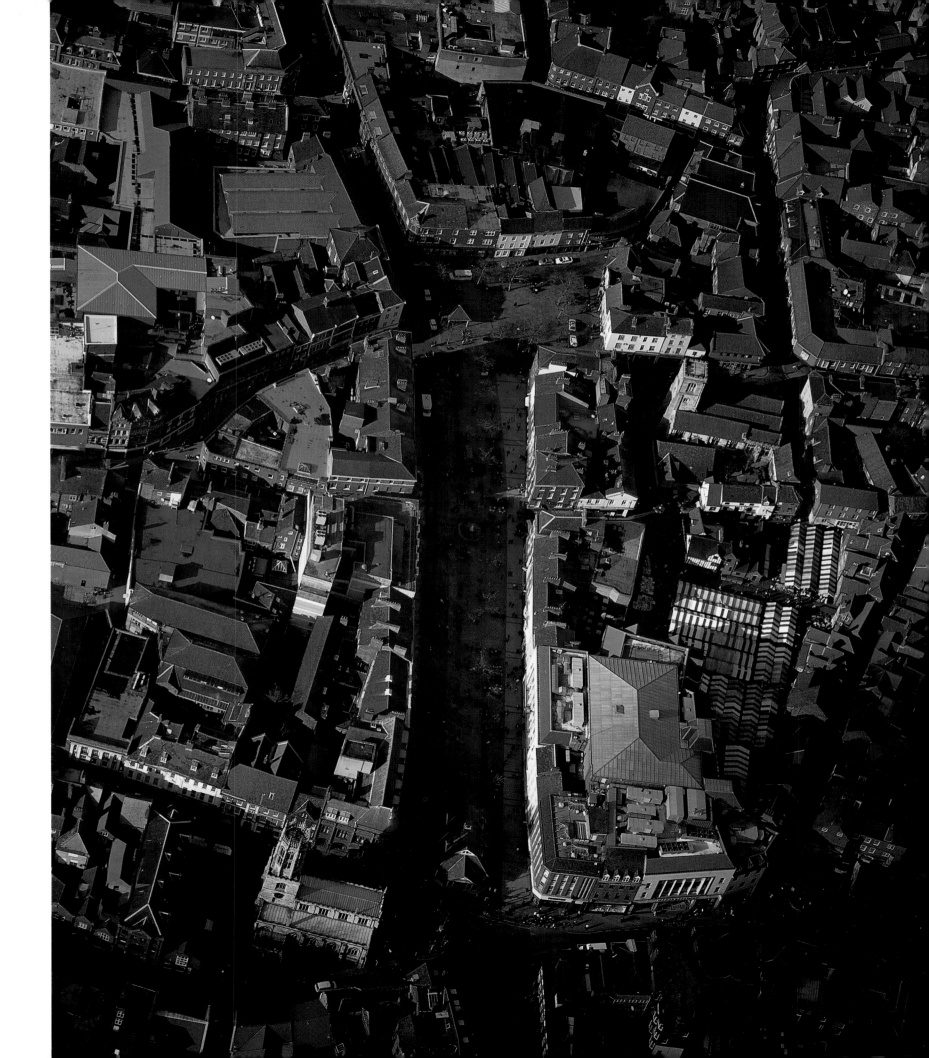

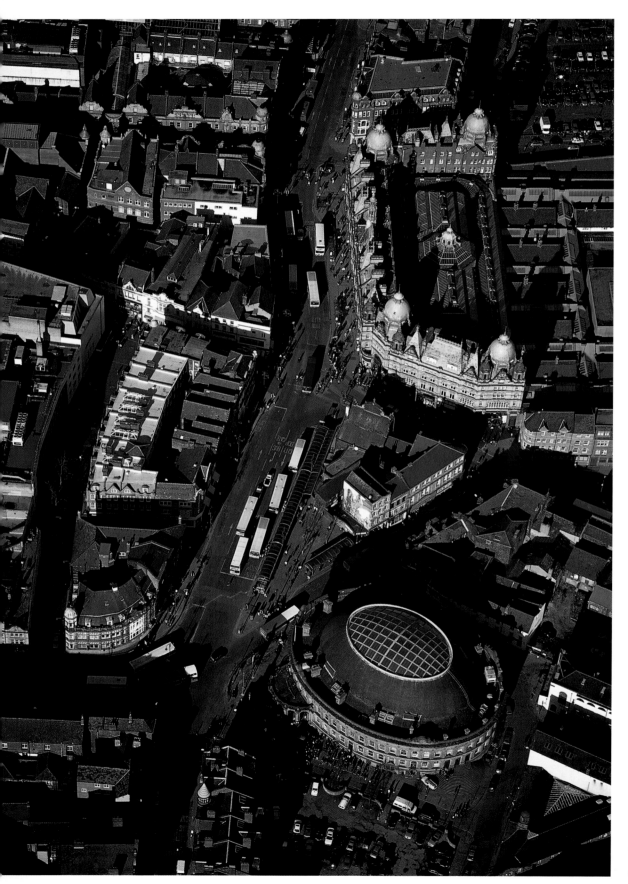

CORN EXCHANGE, LEEDS

Left With an elliptical dome standing at 22m (75ft) above the building, the Leeds Corn Exchange must be one of the best known old landmarks of the city and this photograph shows just how it fits into the landscape. Originally inspired by the Corn Exchange in Paris, it was designed by Cuthbert Broderick, a young Yorkshire architect who also designed the internationally acclaimed and competition-winning Leeds Town Hall. Built in 1862, the whole building was painstakingly planned – for example, the large windows in the domed roof of the Corn Exchange allowed sunlight in so merchants could clearly see the quality of the grain. The building underwent an extensive refurbishment in the late 1980s, and the opening of the piazza area, coupled with its popularity as a shopping centre, have led it to being dubbed the 'Covent Garden of the North'.

OVERVIEW OF LEEDS

Right It is thought that Leeds was once the centre of a Roman settlement, although there is no definite evidence for this. The first concrete mention of its existence was in Anglo-Saxon times when it was referred to as Loidis. Literally, Loidis meant 'people of the flowing river', an early reference to the River Aire on which Leeds is situated. However, Leeds was destined to become one of the world's most famous centres for wool-making. By the eleventh century, Kirkstall Abbey, just outside the city, owned around 5000 sheep, and the cottage craft industries of weaving and spinning developed throughout the Middle Ages.

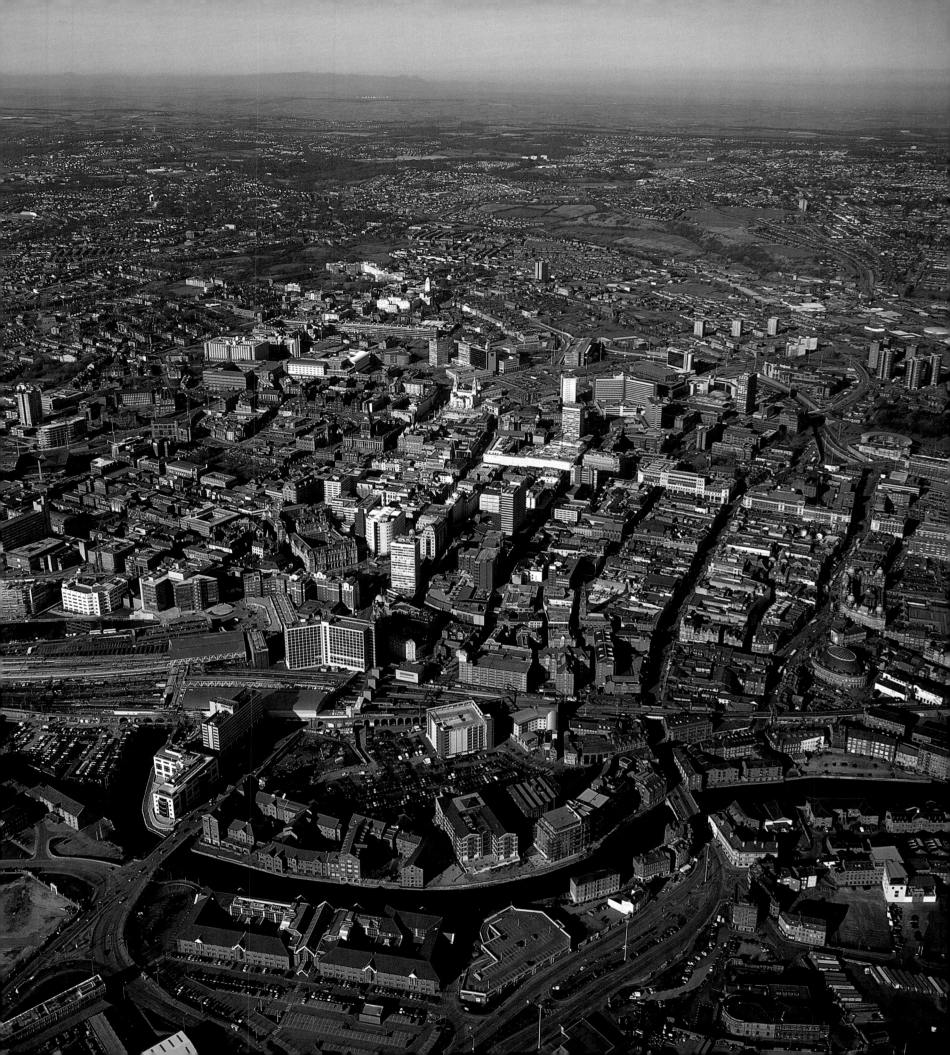

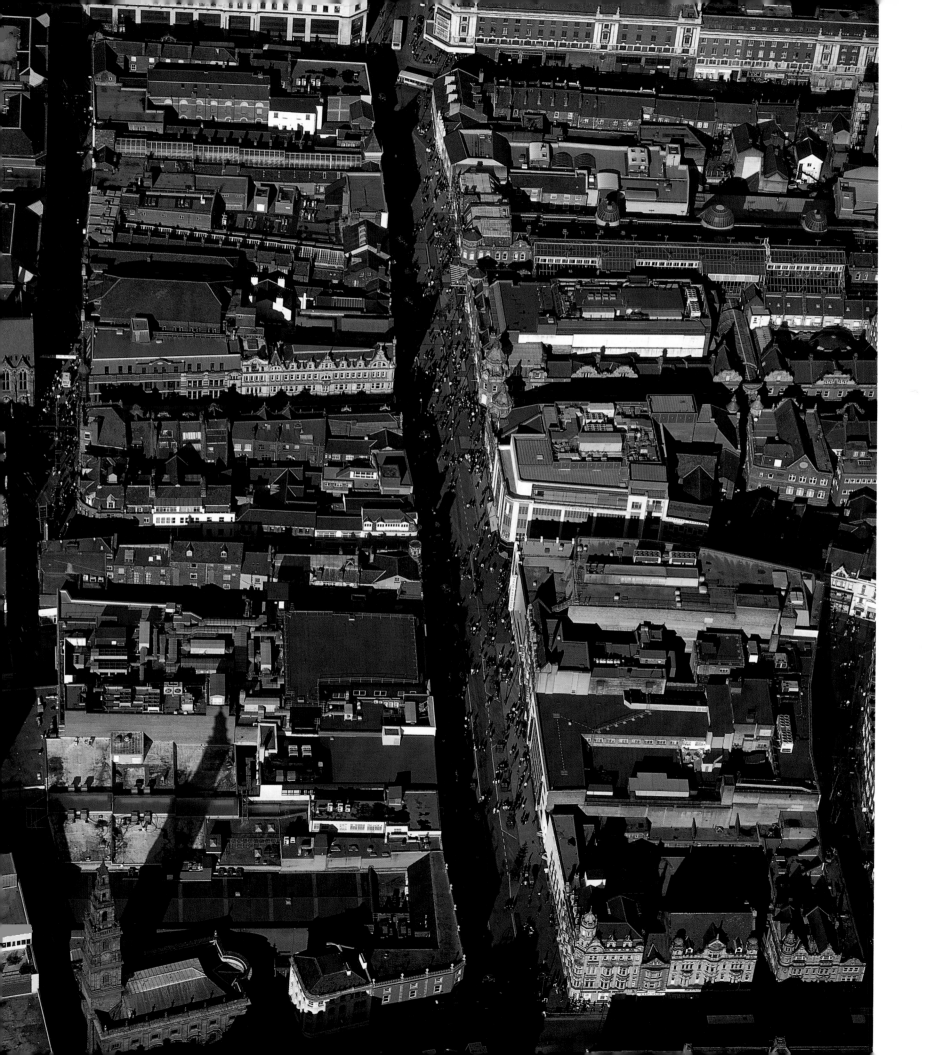

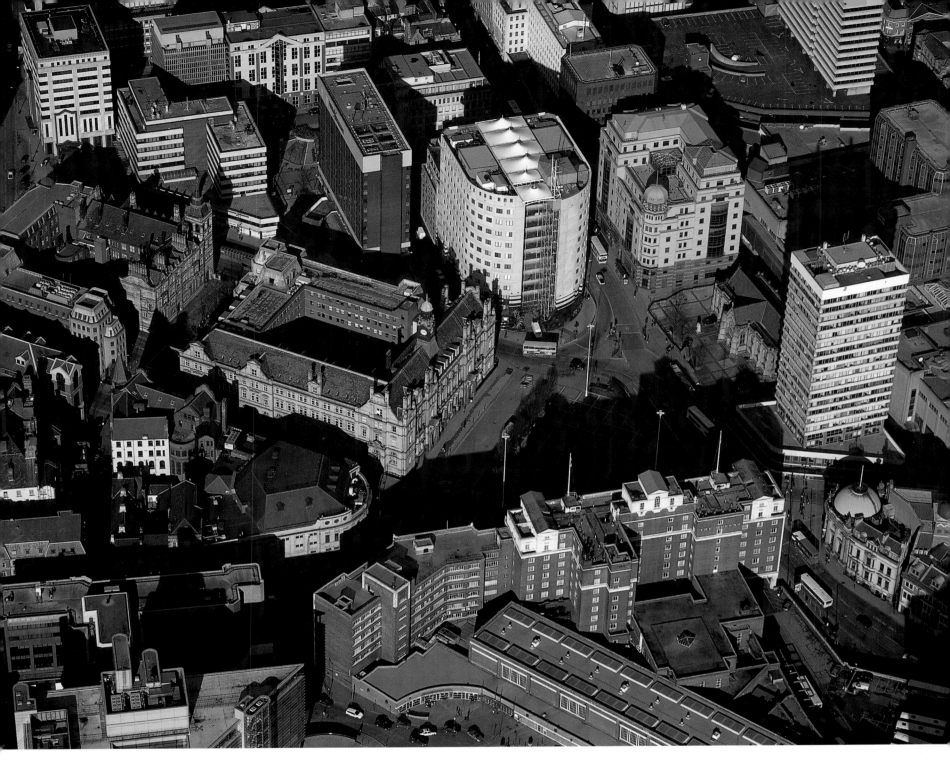

BRIGGATE, LEEDS

Left By the mid-sixteenth century, Leeds was showing the first signs of major growth and the streets of Kirkgate and Briggate already existed – gate being a Scandinavian suffix for street. Following in the footsteps of its past, the Victorian shopping arcades are today packed with clothes shops and Briggate is deemed of sufficient importance to house Britain's second Harvey Nichols.

LEEDS CITY CENTRE

Above The area's success in cloth and wool manufacturing led to the need for a well-located town where a market could be devoted to the trade. Halifax and Wakefield were strong contenders but Leeds was bigger and more important by this time, and its situation on the River Aire facilitated links to the sea. Leeds' heyday was still to come, however. The Industrial Revolution introduced machinery that allowed mass production, and prosperity boomed.

17

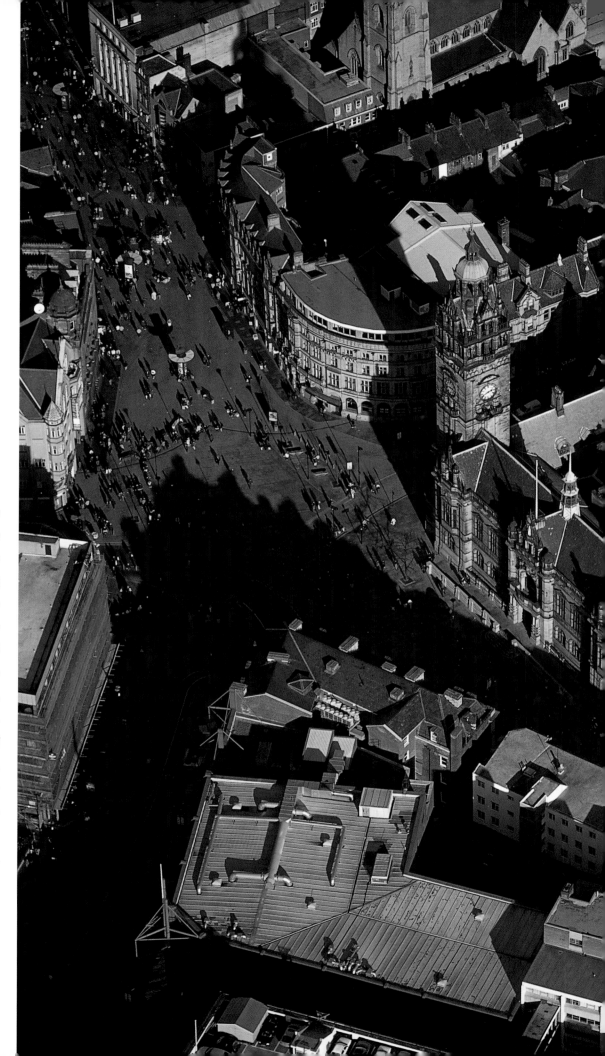

SHEFFIELD CITY CENTRE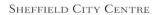

The internationally renowned City of Steel began life as an Anglo-Saxon settlement named in the Domesday Book as Escafield. Benjamin Huntsman is generally recognized as the pioneer of steelmaking thanks to the processes he developed in the mid-1700s, although the use of iron ore dates back to medieval times. The ore was smelted with local sandstone and charcoal and then effectively put to use by the city's smiths and cutlers. Unfortunately, Sheffield suffered heavily during both world wars. During the First World War, the canals, one of Sheffield's greatest assets in the Industrial Revolution, fell to rack and ruin, and the Second World War saw bombs destroy part of the city and kill around 700 people. Even more damaging was the 1980s' downturn in the steel industry, resulting in mass redundancies. The social consequences were portrayed in bitter-sweet fashion in the 1997 hit film *The Full Monty*. Nonetheless, Sheffield today is bouncing back and is producing better steel than ever.

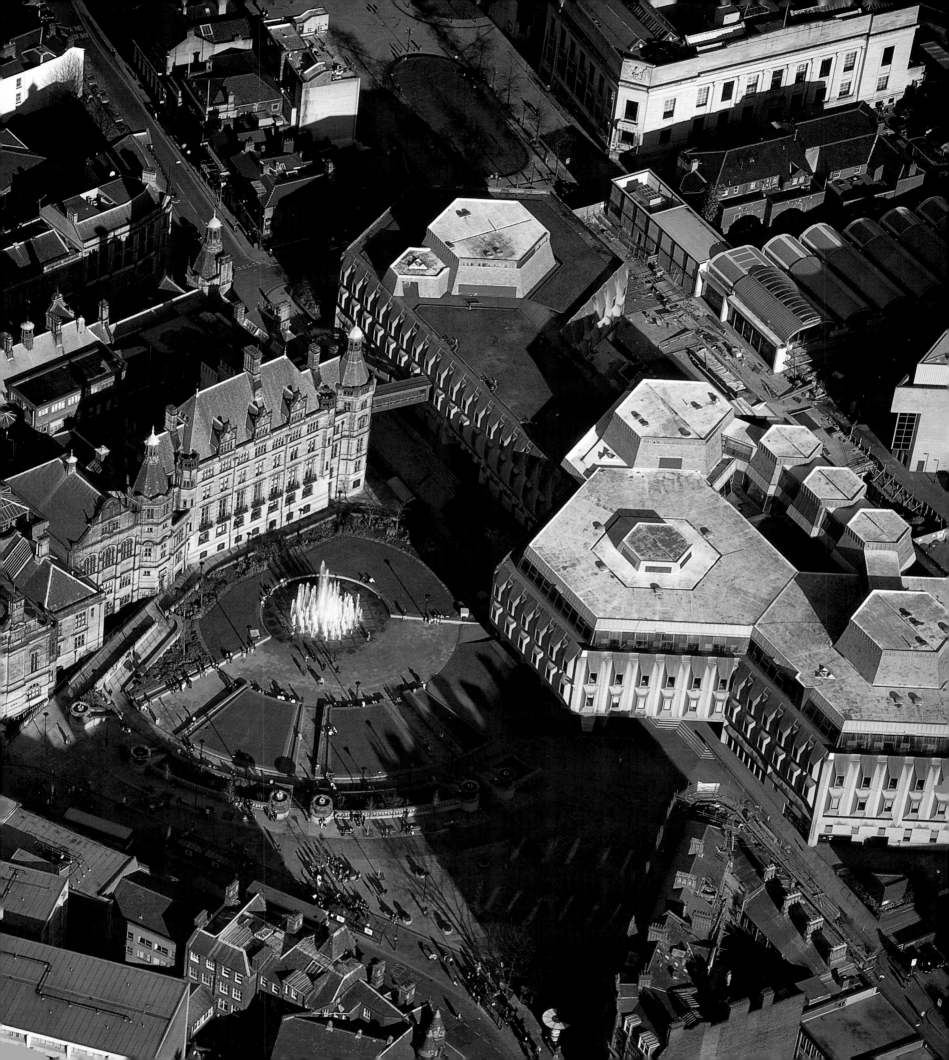

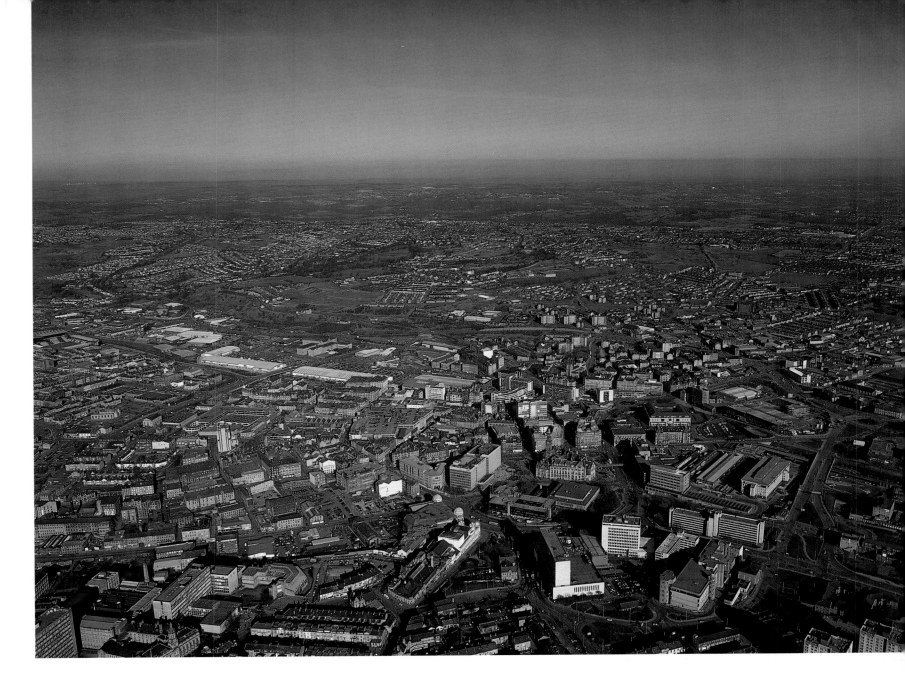

BRADFORD

Left Like Leeds, Bradford dates back to Anglo-Saxon times – its name simply means broad ford – and like Leeds, Bradford was an important woollen and textile centre during the Middle Ages. However, the town didn't really begin to grow until the nineteenth century when its industries attracted labour from all over Europe and the British Empire. The downside of this growth was the dirt the mill chimneys pumped across the city, earning it the reputation of a grotty, decrepit urban sprawl. Despite much insensitive post-war redevelopment in the city centre, Bradford has managed to turn around this reputation and now boasts a plethora of tourist attractions including the National Museum of Photography, Film and Television.

BRADFORD

Above To say that Bradford boomed in the nineteenth century is something of an understatement and the city's population figures says it all. In 1801, there were 13,000 people living in Bradford; by 1901, the figure had grown to 280,000. It won't, therefore, come as any great surprise to discover that many of Bradford's major buildings date back to the Victorian age, when they were often influenced by classical European styles. The most famous of these is arguably Lockwood and Mawson's St George's Hall, a concert hall in Bridge Street dating from 1851, but even industrial buildings were affected by foreign styles, as seen overleaf.

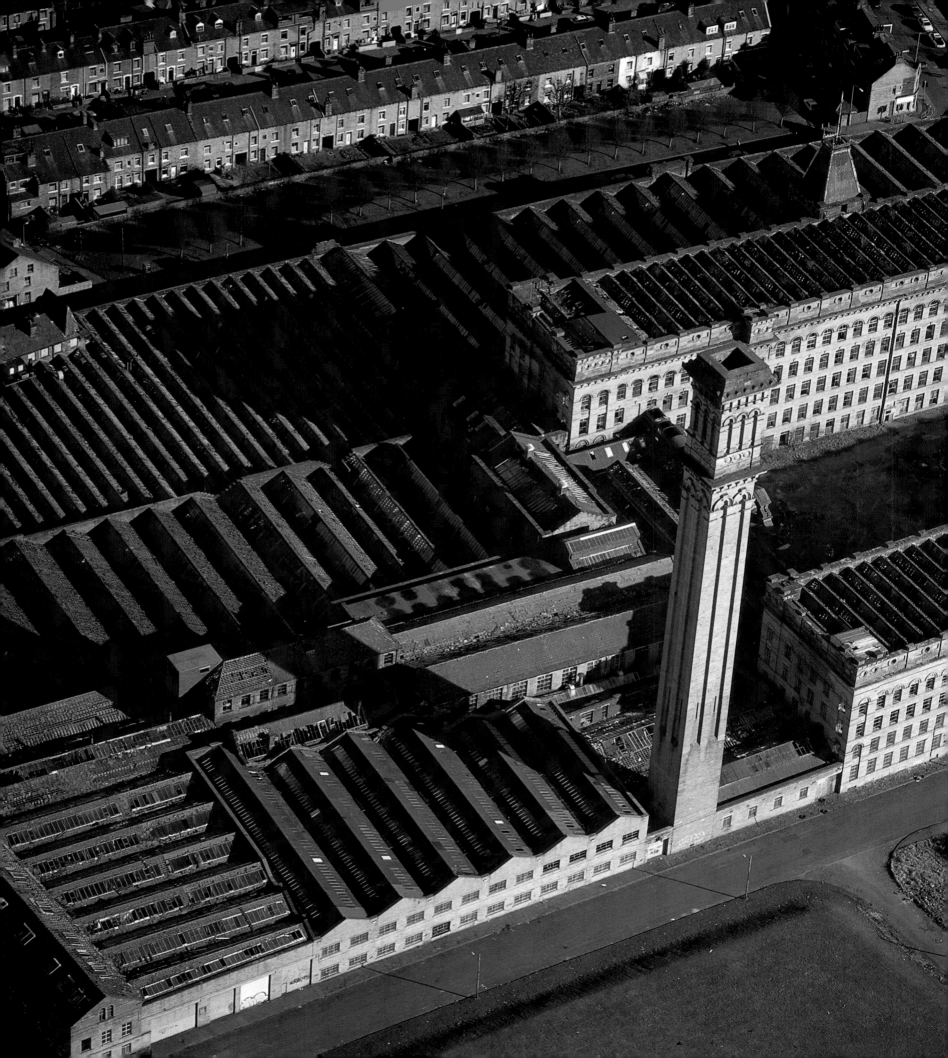

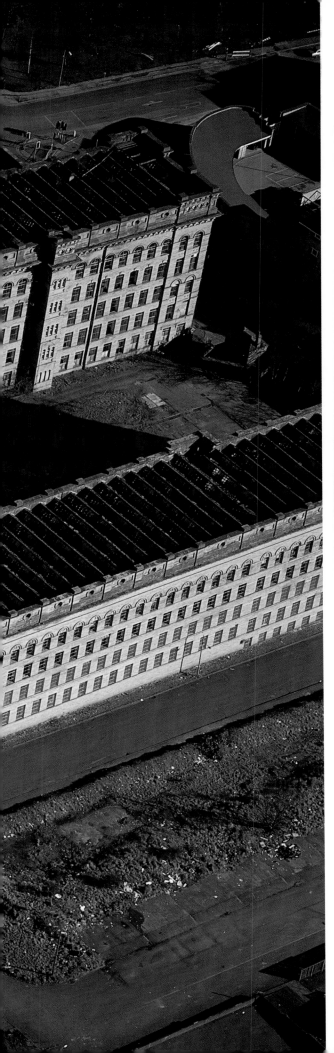

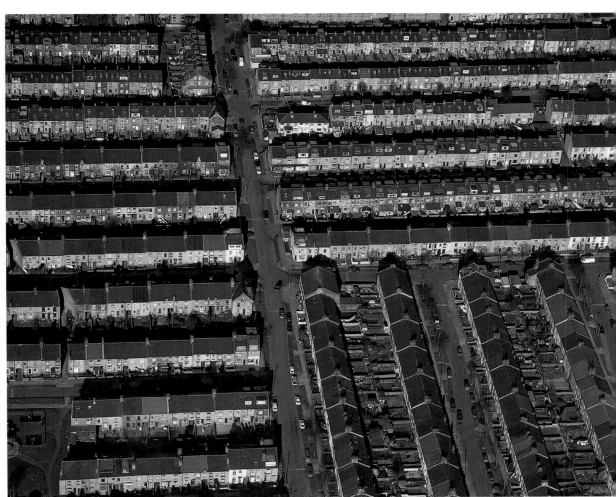

LISTER'S MILL, MANNINGHAM, BRADFORD

Left Lister's Mill has dominated the skyline since it was built in 1873. Many entrepreneurs have made their fortune in Bradford and Samuel Lister was one such man, who amassed his wealth by devising a way to manufacture silk from worthless silk waste. His flagship, Manningham Mill, burnt down and was replaced with the mill that exists to this day. The architecture of the mill is Italianate, with the equally impressive 76m (250ft) chimney modelled on a Venetian campanile bell-tower. Built entirely of stone (the chimney alone is made of 8000 tons), the whole building covers 16 acres of floor space and has been called 'one of the wonders of the Victorian age'.

HOUSING IN LAISTERDYKE, BRADFORD

Above From the air, these tightly packed, severely regimented rows look like Monopoly houses. Houses that back directly on to each other, with no back entrances, are known as back-to-back houses, and many were pulled down in the 1960s to make way for high-rise blocks – an unsuccessful solution to the accommodation problems here. Unfortunately, Laisterdyke ranks highly in terms of social deprivation and out of a population of over 12,000, around 75 per cent claim housing benefits.

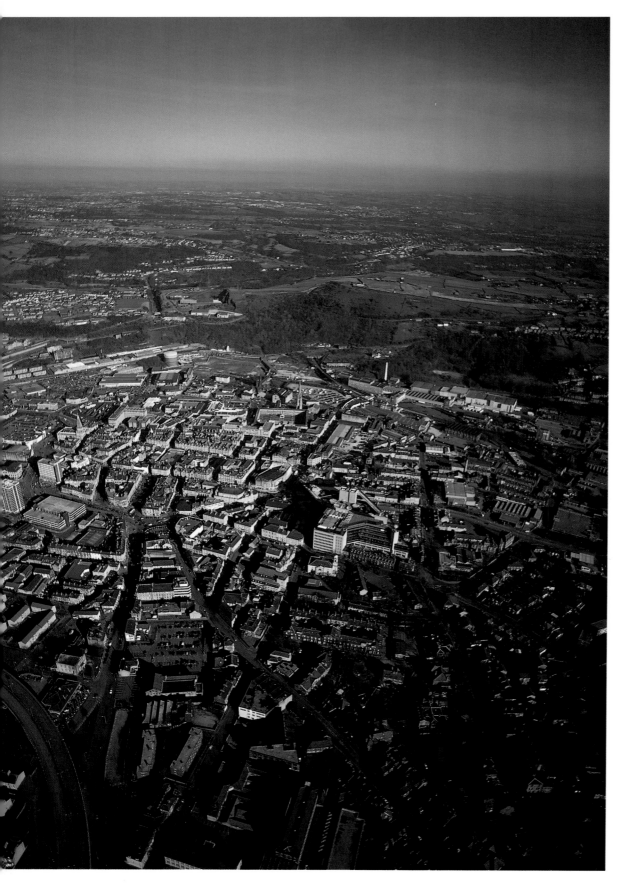

HALIFAX

Left Halifax was once known as the 'town of a hundred trades', but it was its success in the textile industry that secured its place in history. Dating back to the fifteenth century, the cloth trade created significant prosperity in the area and led to the beautiful Gothic parish church of St John being built, primarily during the reign of Henry I. In the lower part of town is the Italianate courtyard of Piece Hall, first opened in 1779, and erected by manufacturers as a place sell their 'pieces' of cloth.

HUDDERSFIELD

Right There has been a settlement in Huddersfield ever since the time of William the Conqueror and it was mentioned in the Domesday Book. However, the layout of the town would have been very different then and was most likely divided into five hamlets. Like Halifax, Huddersfield is well known for its cloth, but it also had booming chemical and engineering industries. The townscape is industrial and retains a sense of Victorian civic pride; in fact Friedrich Engels described Huddersfield as 'the handsomest by far of all the factory towns in Yorkshire and Lancashire by reason of its charming situation and modern architecture.'

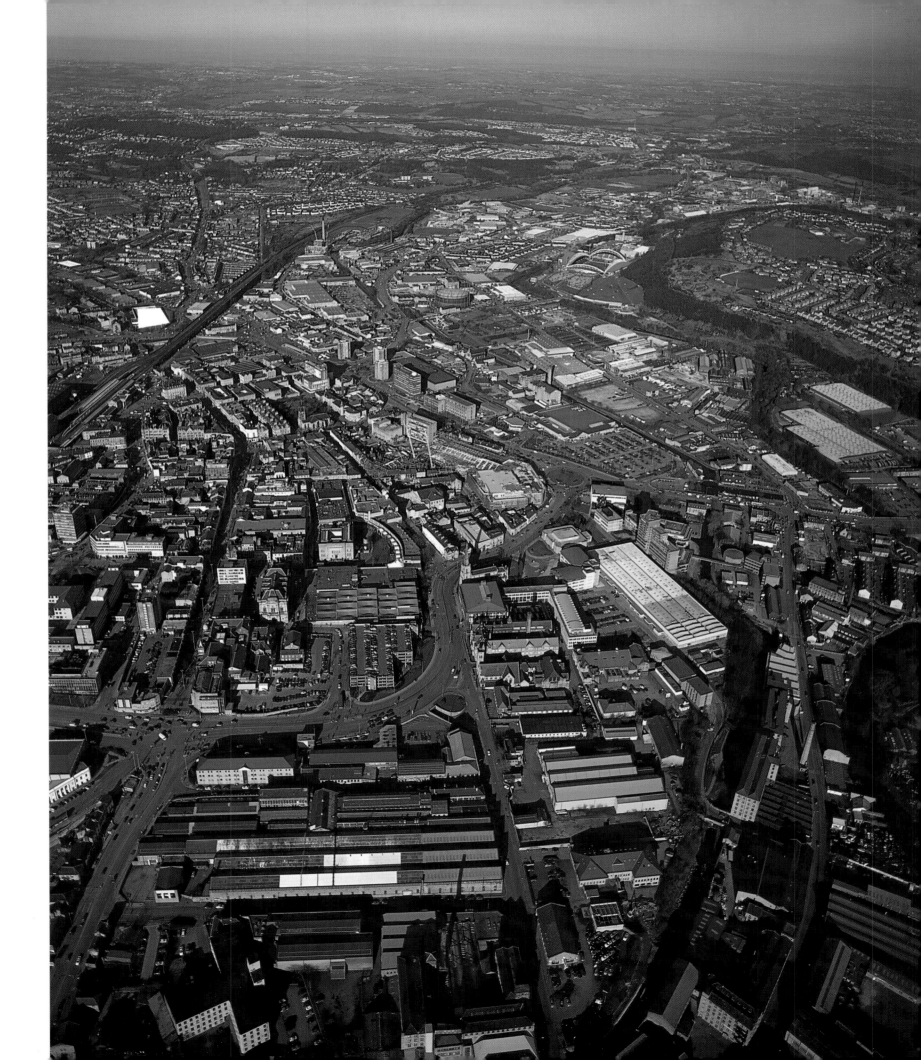

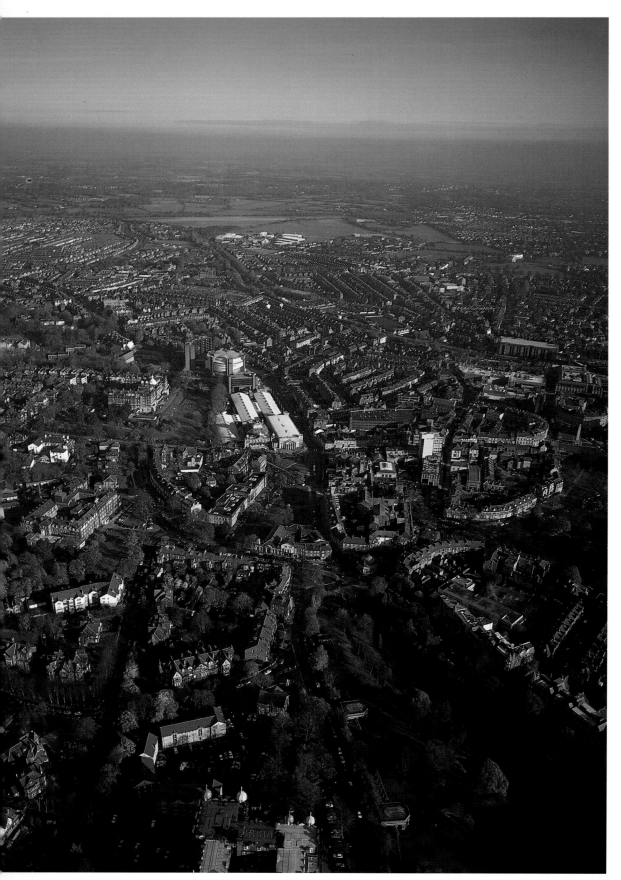

HARROGATE

Left Harrogate's fame as a spa town is usually attributed to William Slingsby, who discovered the first of more than 80 spring waters rich with sulphur and iron in 1571 in a well called Tewit Well. Before Slingsby's time, Harrogate would have been dwarfed by the neighbouring town of Knaresborough, but this discovery conspired to make Harrogate into one of the country's leading spa towns. The elixir can still be tasted and even bathed in at the Turkish baths, which are fed by a sulphur well. In flavour, Harrogate overflows with Edwardian and Victorian atmosphere and there is a certain charm about a place referred to as Yorkshire's teashop capital.

HULL FROM THE RIVER HUMBER

Right Originally an area of wasteland known as Wyke (a Scandinavian word meaning 'creek'), Hull has its roots in the eleventh century. However, its history is rather better documented from 1299 when the city received royal attention from Edward I. Realizing the strategic importance of this growing port, the King gave it the title of Kings Town upon Hull and granted it a Royal Charter. To this day, the city's official name is Kingston-upon-Hull and while the fishing fleets may have collapsed, Hull remains famous for its docks. Business is still booming in the port, handling around 9 million tonnes of cargo and a million passengers each year.

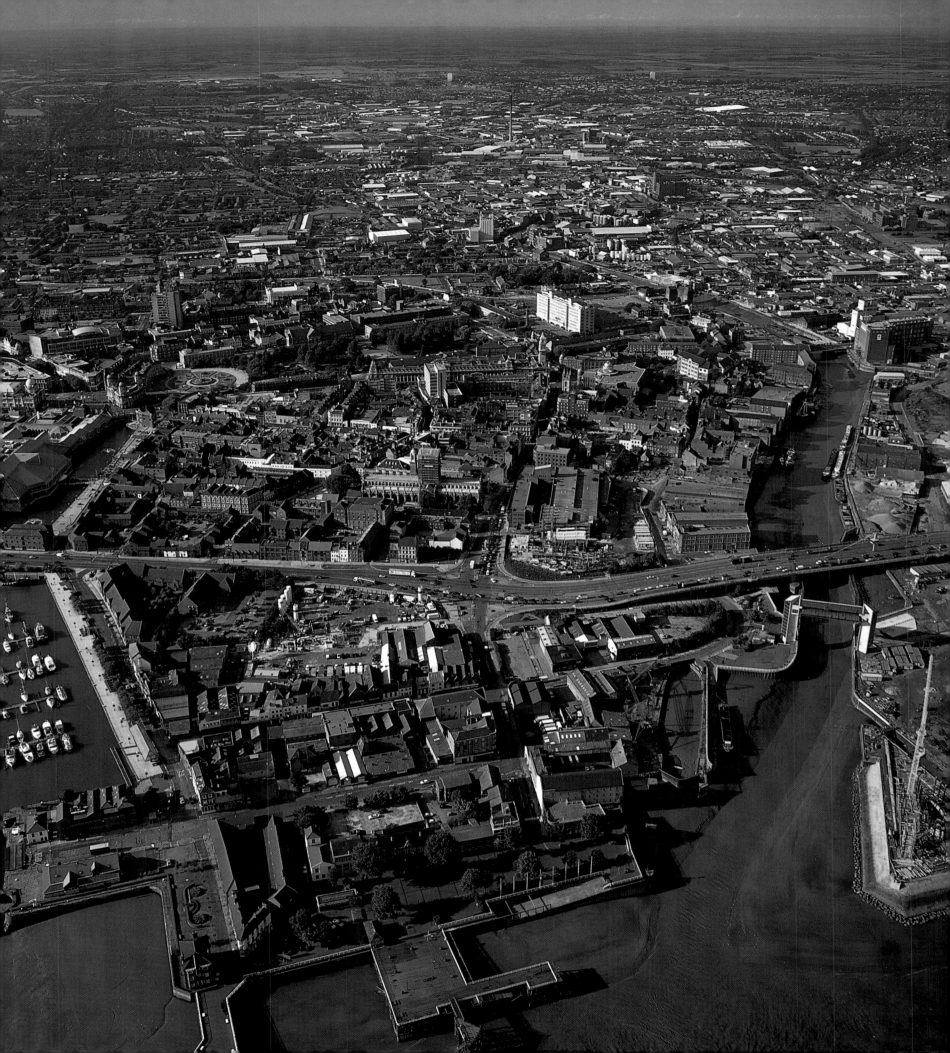

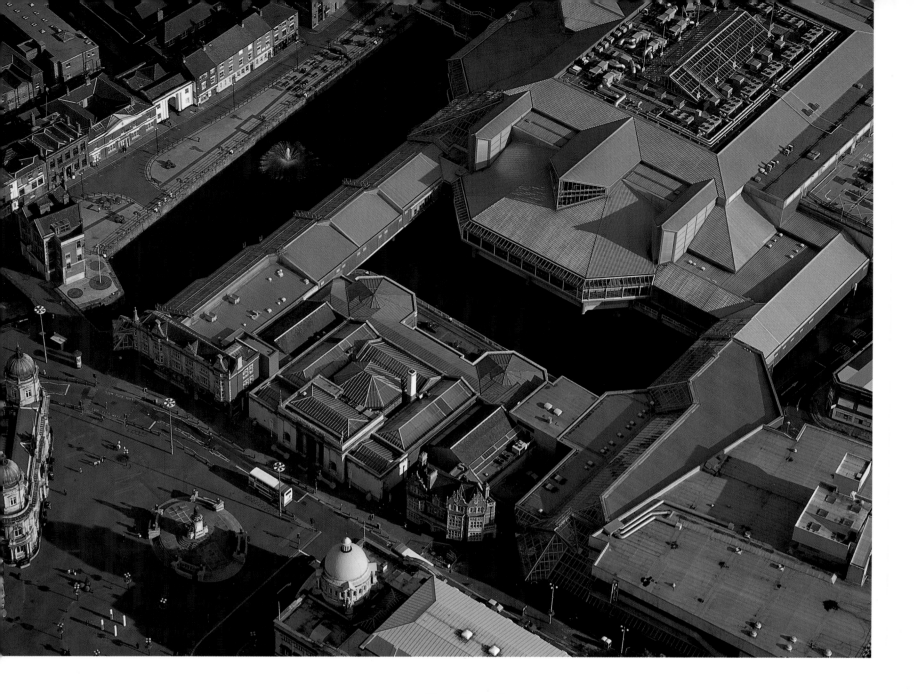

HULL CITY CENTRE

Above and opposite top Over the last 700 years, Hull has grown from just a few streets – notably High Street and Lowgate/Market Place – to a large city with a population of more than 269,000. The majority of the buildings in Hull city centre are relatively modern, a result of the two world wars. Although Hull is barely ever acknowledged as a place that suffered badly during 'Britain in the Blitz', reports show that it was actually one of the most heavily bombed cities in Britain with 7000 people killed and double that disabled in the First World War. The Second World War brought more tragedy with a staggering 92 per cent of houses damaged by the bombs. On a more positive note, however, Hull's industries have always been well diversified, unlike many other Yorkshire towns. As well as sea-related trades such as fishing, other main industries have traditionally been oil-milling (vegetable oil), paint making, engineering and transport and the more recent pharmaceutical development, so that the town has never suffered from such depth of depression as other single industry places.

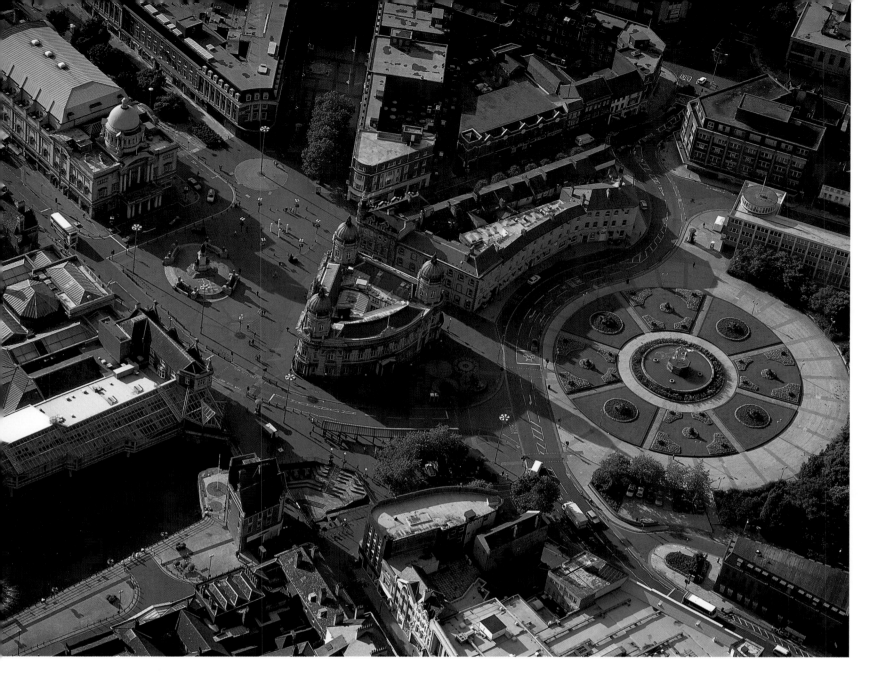

HOUSING, HULL

Right Hull was never an agricultural community and the inhabitants historically made their living from the sea. In 1293, there were two long streets running parallel to the river Hull, both on the west bank, with four shorter streets giving the only public access to the river. Obviously a population boom leads to a property boom, and modern estates such as the one pictured here look very different to the 29 properties reported to have existed at the end of the thirteenth century.

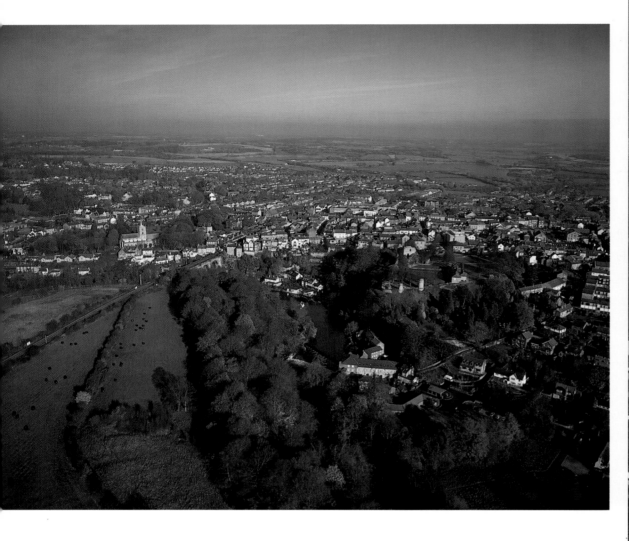

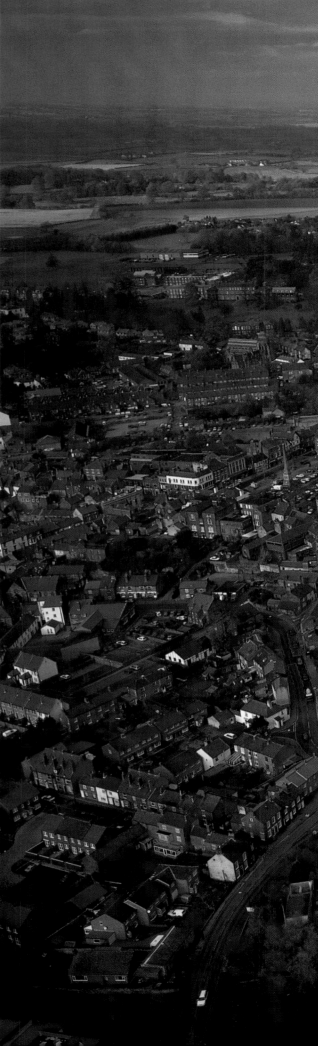

KNARESBOROUGH

Above First mentioned in the Domesday Book, Knaresborough owed its initial prosperity to the textile industry, which was mentioned in records dating back to 1211. The town has given birth to two semi-legendary figures. Robert Floure became a hermit in a riverside cave at Knaresborough and was attributed with miracles of healing and powers over wild animals. When he died in 1218 a cult emerged in his name and the waters of St Robert's Well were said to have healing powers. Mother Shipton, on the other hand, was a famed prophetess who foresaw the great fire of London, trains and telegraphs, but was slightly out with her prediction the world ending in 1881.

RIPON

Right Ripon Cathedral was started by St Wilfrid who laid foundations here in 672, and the original crypt is still extant below the central tower. Having been systematically pulled down and re-built by the Normans, the majority of what is on view dates from the twelfth century. For some 1000 years, a bugler has blown a horn at 9pm in the giant market place near the cathedral, to reassure the inhabitants that they were safely in the hands of the nocturnal watchmen.

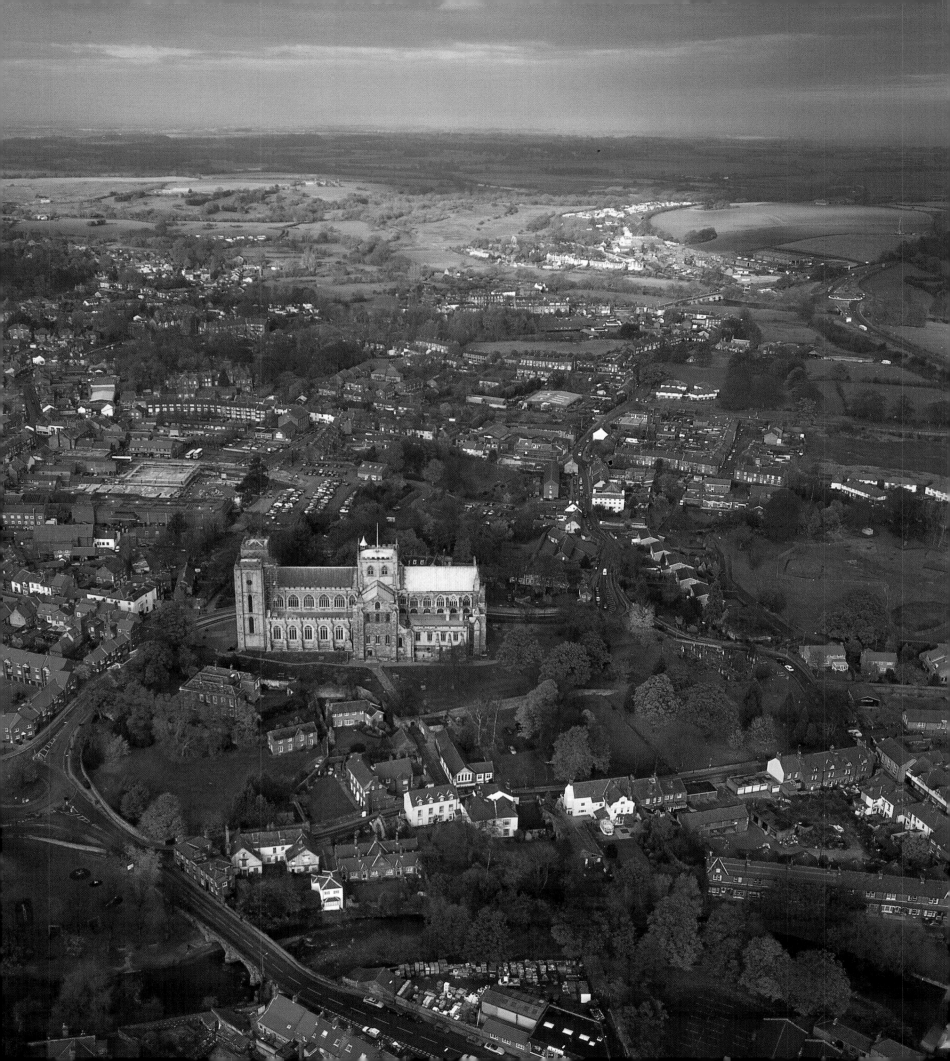

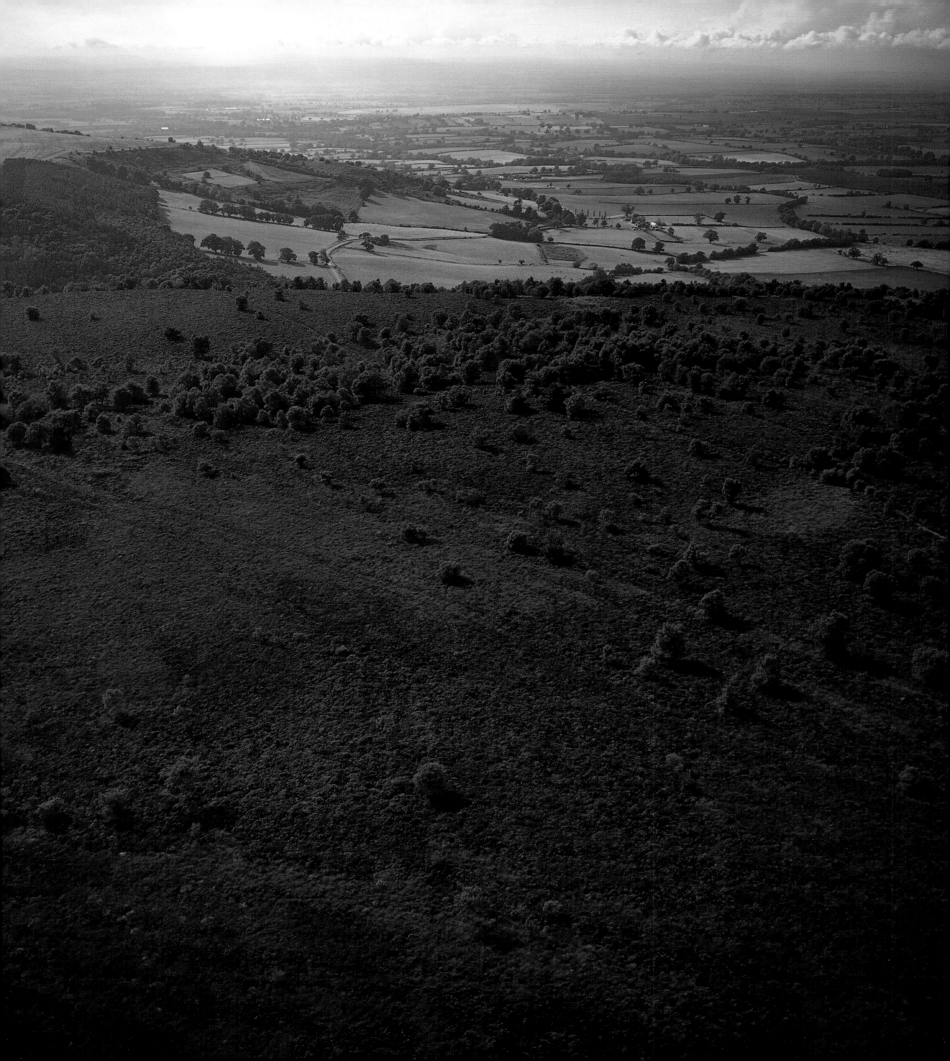

THE COUNTRYSIDE AND RURAL LIFE

EVEN WHILE LEEDS, Sheffield and the like were sweltering under a deluge of factories and the moors were pillaged for lead and coal, huge swathes of open countryside have remained relatively untouched in Yorkshire. The two most extensive examples of this have both been designated National Parks (two of eleven National Parks in England and Wales) in order to safeguard the diverse range of wildlife and to conserve the scenery, local history and cultural heritage of the area.

The North York Moors was the first of the two to be designated a National Park in 1952. It covers 553 square miles and is bordered by the Hambleton, Cleveland and Tabular Hills, with the North Sea coastline to the east. About 40 per cent of the park is covered in heather, and while its geographical position means that it is subject to very little rainfall, it also means it can be a cold, bleak place in the depths of winter. The landscape here has been formed over literally hundreds of millions of years, starting in the Jurassic Period, when the sandstone deposited later became the

Cleveland and Hambleton Hills. Over time, these were gashed by the tributaries of the River Esk and Derwent and sliced again by rivers such as Danby Beck.

The Yorkshire Dales National Park was opened in 1953 and is the larger of the two, covering 684 square miles. Straddling the Pennines, the park incorporates the Three Peaks of Ingleborough (723m/2349ft), Whernside (736m/2392ft) and Pen-y-Ghent (694m/2255ft). However, if you prefer to go down rather than up, this park is also home to Gaping Gill, the biggest pothole in Britain at 109m (357ft). The word 'dale' is derived from the Viking word 'dalr' meaning valley, and the park is not a carefully-planned picture-perfect vision of loveliness. Instead, the limestone landscape is scarred with the effects of age and of glacial damage, resulting in eccentricities such as Malham Tarn and Cove and Gordale Scar. Nonetheless, the Yorkshire Dales have been inspiring visitors, locals and writers alike for many years.

THE HAMBLETON HILLS, NORTH YORK MOORS

Left Bordering one of the two National Parks in Yorkshire, the Hambleton Hills form a long ridge on the western edge of the North York Moors. The Forestry Commission started a local programme of afforestation in 1920 and has made use of marginal agricultural land such as these hills to replace older woodlands. All over the Yorkshire Dales dry-stone walls are a traditional feature (*above*). There are thousands of miles of these walls, which were erected without the aid of mortar or cement. Instead, they relied on the skill of the builder laying stone after stone in a carefully locked pattern.

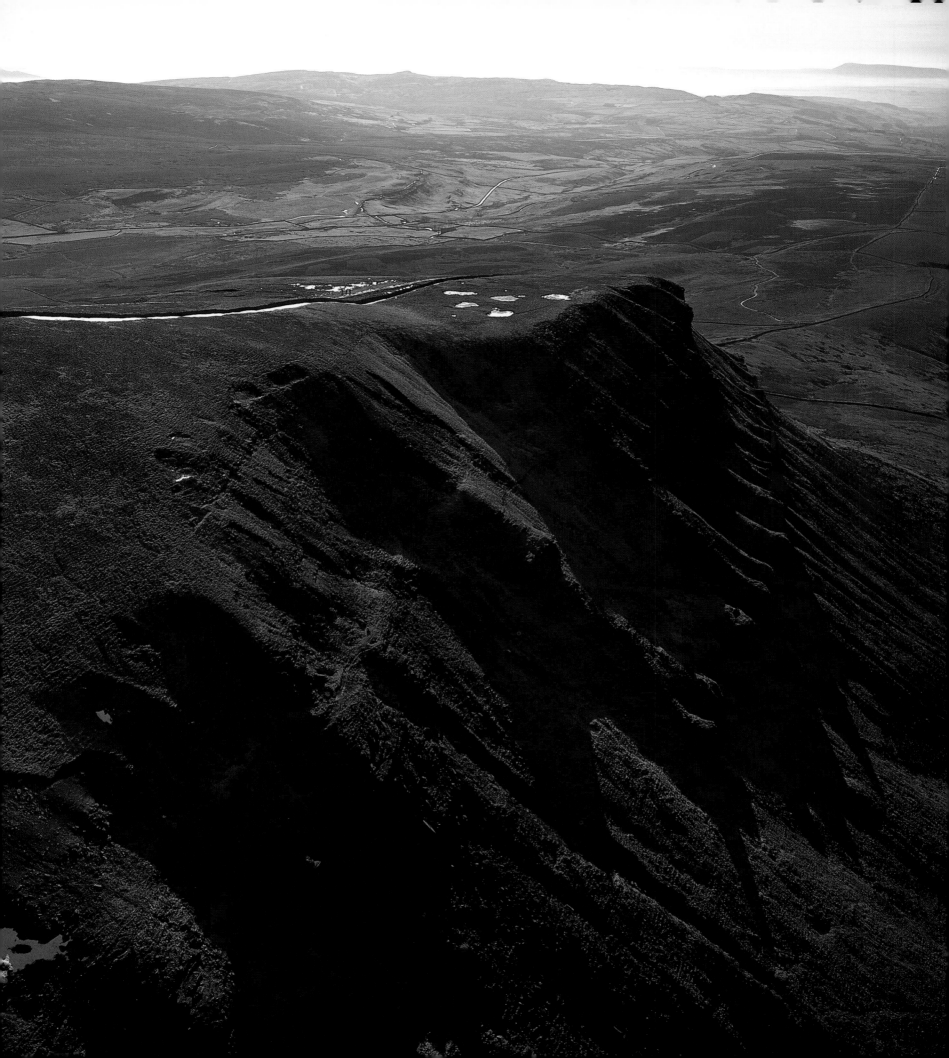

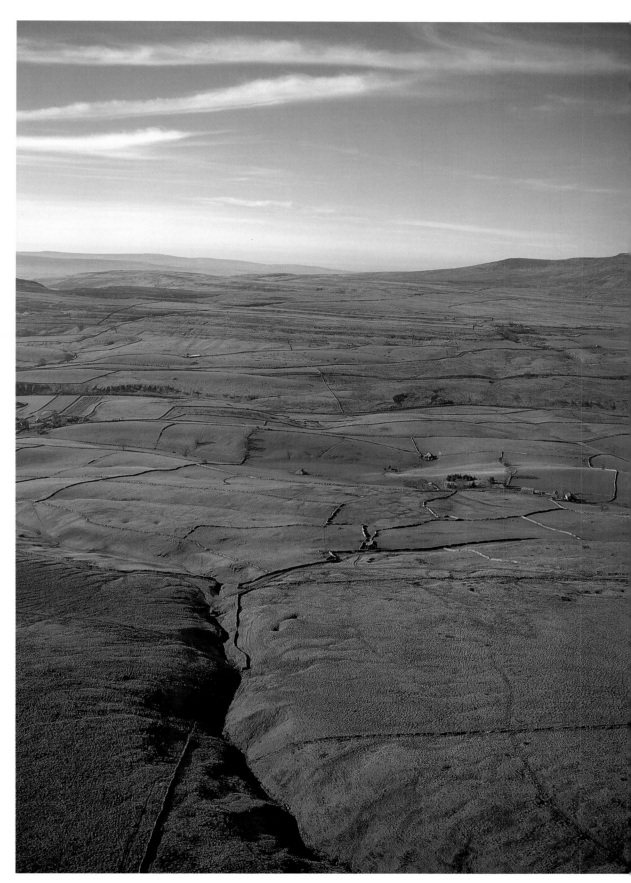

PEN-Y-GHENT, YORKSHIRE DALES

Left At 694m (2255ft), Pen-y-Ghent is actually the lowest of Yorkshire's famous Three Peaks, but it is also the 'peakiest'. Towering over Ribblesdale on the western side of the Yorkshire Dales, this mountainous bulk has been a mecca for keen mountain walkers and pot-holers for many years. The best known of the many caves and potholes are the gaping chasm of Hull Pot and the smaller slit of Hunt Pot. Interestingly, the name of the mountain means 'The Head of Ghent'. Although there is no solid evidence to back up this theory, it is possible that the mountain marked out a boundary between two kingdoms at some point in the past.

LANDSCAPE NEAR HIGH BIRKWITH, NORTH YORK MOORS

Right Unlike National Parks abroad, in Britain 'National' does not mean 'owned by the nation'. Instead, it indicates that these areas have significant importance to the heritage of Yorkshire and should be treated with respect and care. Much of the land is privately owned and people continue to work and live within the boundaries of the park. The park is looked after by an independent authority within local government which has two main duties: to 'conserve and enhance the natural beauty, wildlife and cultural heritage of the area' and to 'promote opportunities for the understanding and enjoyment of the special qualities of the National Park by the public.'

LANDSCAPE AROUND HAWKSWICK, YORKSHIRE DALES

The aims of the authority who administer the Yorkshire Dales are the same as the aims of the North York Moors; namely to conserve, enhance and protect the beauty and cultural heritage of the place. The Dales are a mixture of remote fells, bare limestone rocks (all rocks have been eroded by waters/glaciers), gritstone moors and lush green pastures. They are criss-crossed by literally thousands of miles of traditionally built dry-stone walls and dotted with rural villages and remote farmsteads. The main dales, such as Wharfedale, were scooped out by glaciers and exist as corridors, but the Craven district in the southern dales is rather different and was formed millions of years ago by a series of earthquakes.

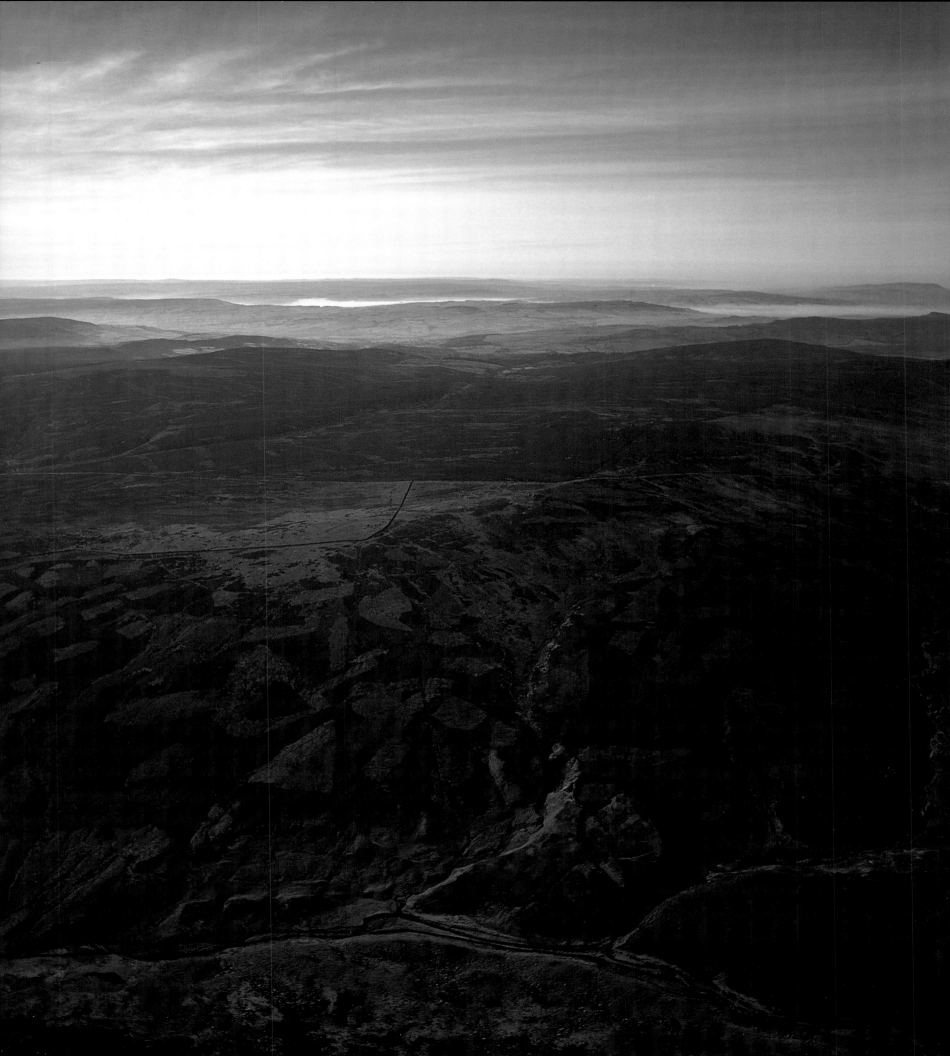

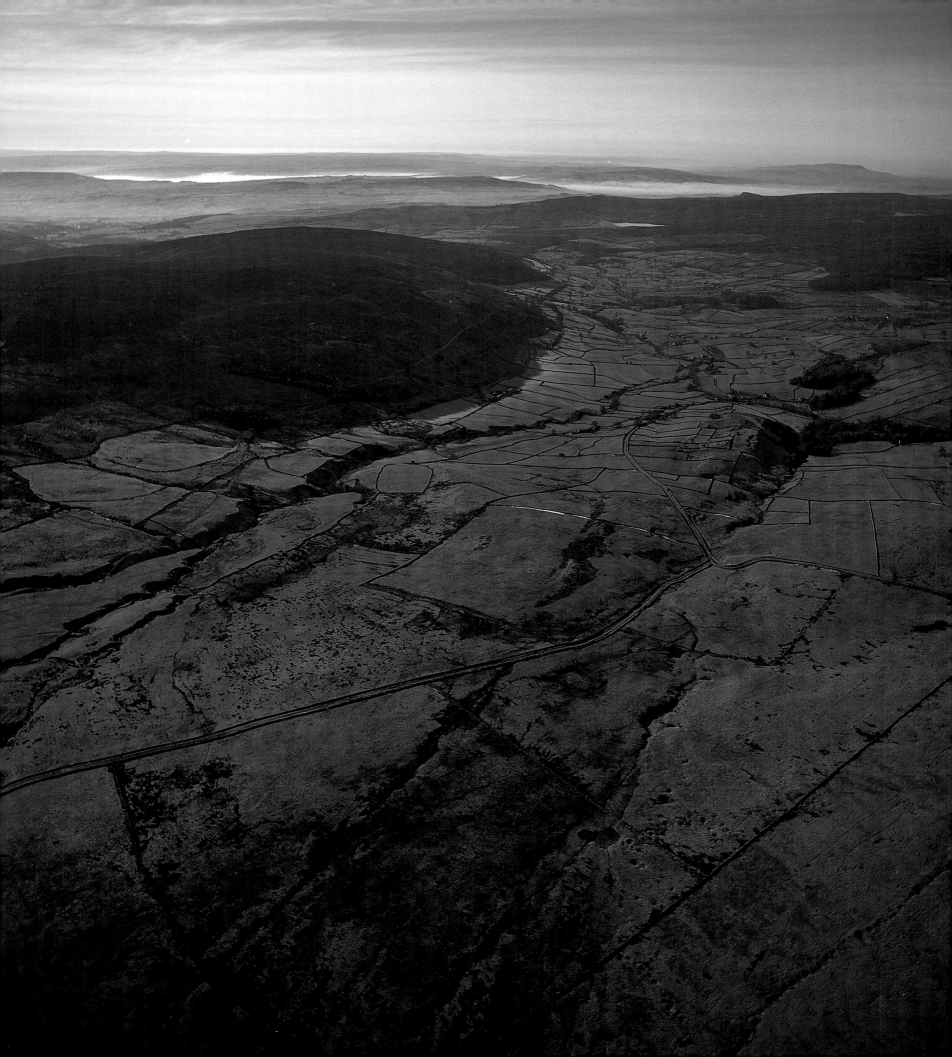

LANDSCAPE JUST EAST OF BURNSALL, YORKSHIRE DALES

Left In his book *Walking the Yorkshire Dales*, Colin Speakman describes the pleasure of walking as 'a sensuous experience, an opportunity to return to simpler, truer ways of perceiving our environment, knowing it as medieval, Renaissance or even eighteenth-century man knew it, a larger, subtler, more complex world than the clichés of modern packaged travel allow. To walk across a landscape is to rediscover its vastness.' Thousands of people choose to walk across the unspoilt Dales from Burnsall every year, surely to experience something close to the pleasure described by Speakman. Just west of this photograph lies Burnsall village. Set in the midst of heather covered hills and close to the River Wharfe, this village enjoys a truly idyllic setting.

ROAD AND CLIFFS AT SWALEDALE, YORKSHIRE DALES

Right There are more than 20 main dales in the National Park and all differ from each other both in character and atmosphere. While labelling any dale 'the best' would necessarily be subjective, Swaledale, wedged between high moors and commons, is ideal for walking as it comprises a wide variety of scenery and industrial heritage. The most northernly of the Dales, the steep-sided narrow valley of Swaledale is not as populated as some of the other areas owing to its distance from large habitations. Its remoteness means the hills, moors and becks remain much as seen by the invading Romans and the raiding Scots, although the landscape has been altered in other ways by later generations. Abandoned mines, crumbling stone walls and the odd farmhouse or barn are all indicative of the way man has worked the earth.

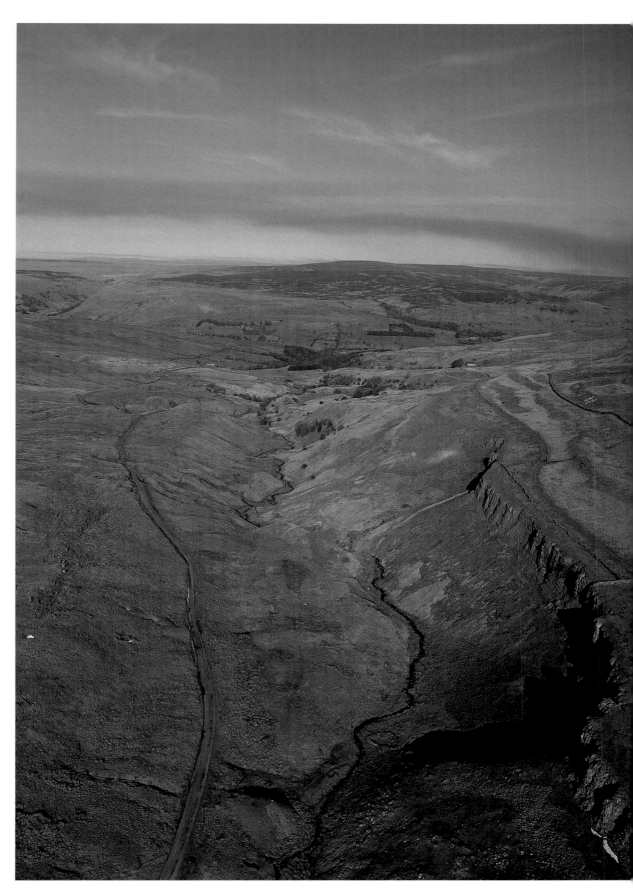

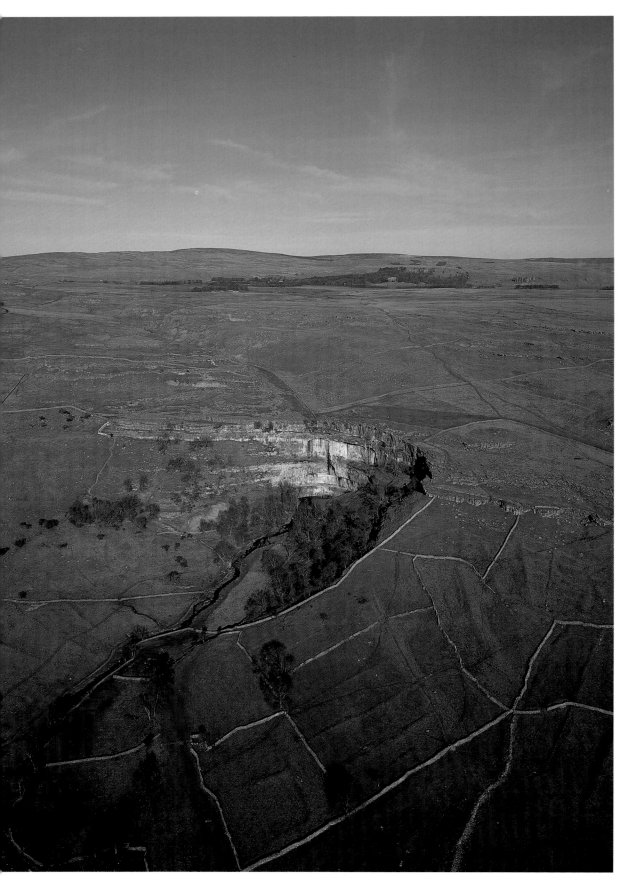

MALHAM COVE, YORKSHIRE DALES

Left The area around Malham Tarn is often noted for its imperfect beauty. Instead of appearing in 'soft-focus', the landscape here is scarred with crags, cliffs and limestone outcrops, and the farming landscape is interspersed with ancient dry-stone walls and pockets of woodland. Malham Cove is one of the more unusual and immediately striking features of this landscape and with more than 150 ways to climb from top to bottom, is something of a rock-climber's paradise. For the less adventurous, there are limestone pavements with their clints (small flat blocks) and grikes (deep crevices) in between. The cove itself happened naturally and exposes a bed of limestone, which has been eroded by weather, vegetation and the pollutants of man.

Right For many people, Malham Cove is the single most memorable rock formation in all of the Yorkshire Dales. Situated just outside the small village of Malham, the cove is a huge limestone formation, similar in shape to an amphitheatre. Rising to around 91m (300ft) and at 304m (1000ft) wide, it has been slowly formed by ice and water over the last million or so years. The yawning chasm is sliced in half, revealing a near vertical rocky face and there is a small stream that flows below called Malham Beck. In prehistoric times, the cliff would have been completed with a waterfall, but today the river has found an alternative route deep underground and so the valley above the cove remains dry.

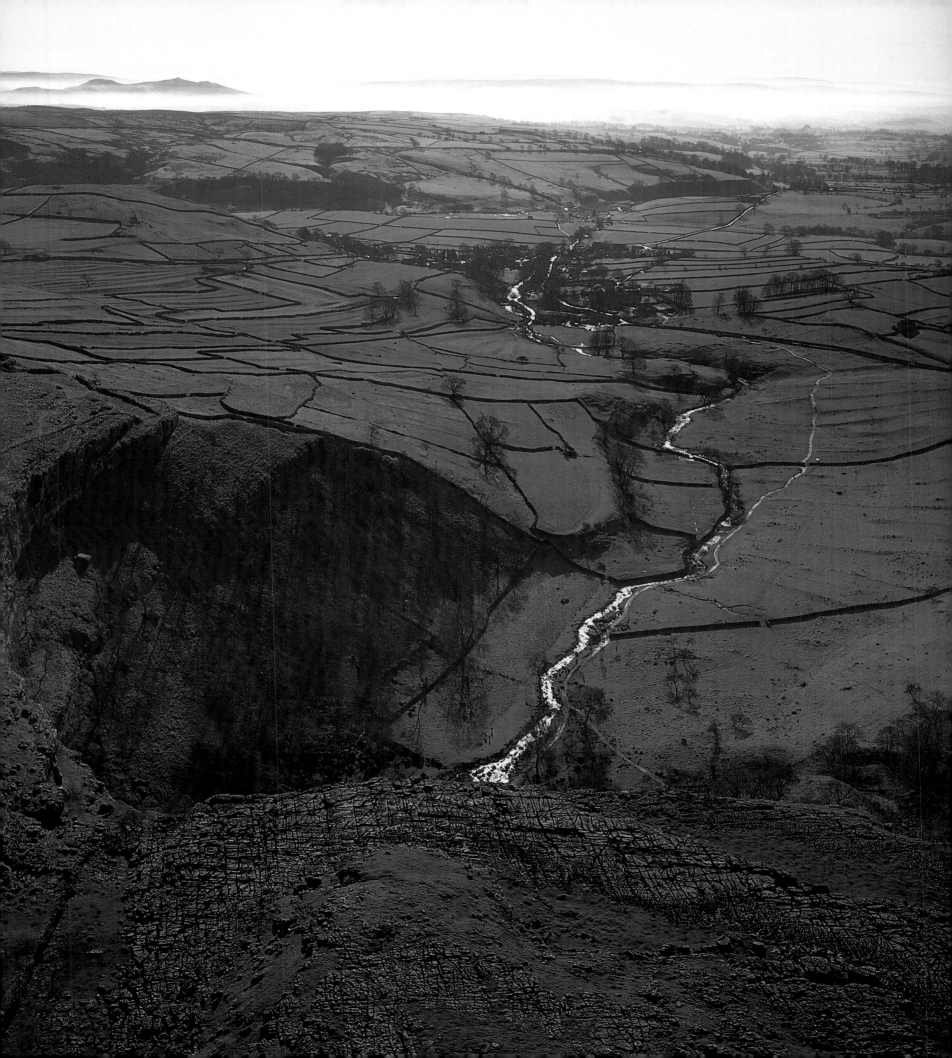

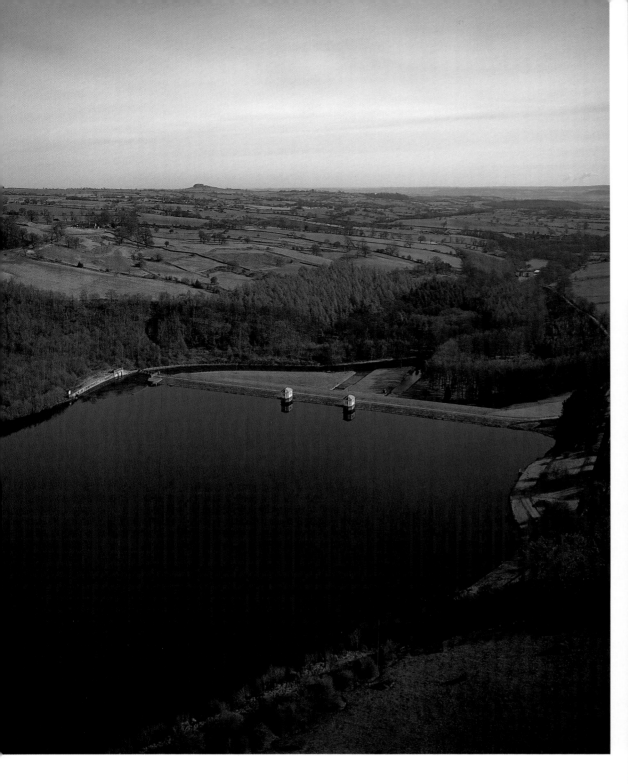

Washburn Valley

Above Three miles outside Otley is the Washburn Valley. Comprising Fewston and Swinsty reservoirs and Thrushcross Dam, this valley has been described as the Yorkshire equivalent to the Lake District.

Malham Tarn

Right The large lake of Malham Tarn was scoured out 15,000 years ago by a glacier in the Ice Age. Lying on a bedrock of slates high above Malham Cove, it is the highest lime-rich lake in the country and is fed by springs bringing in dissolved limestone from the surrounding hills. It also supports a rich variety of waterfowl.

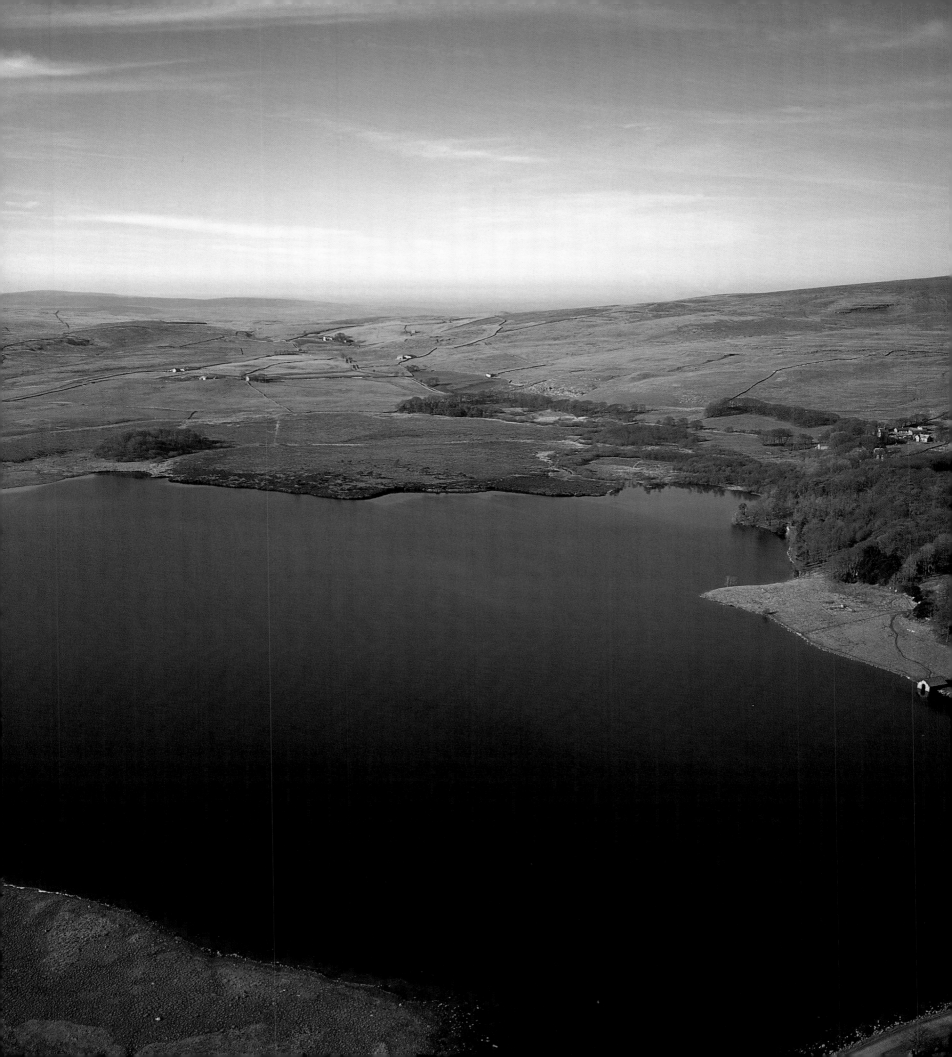

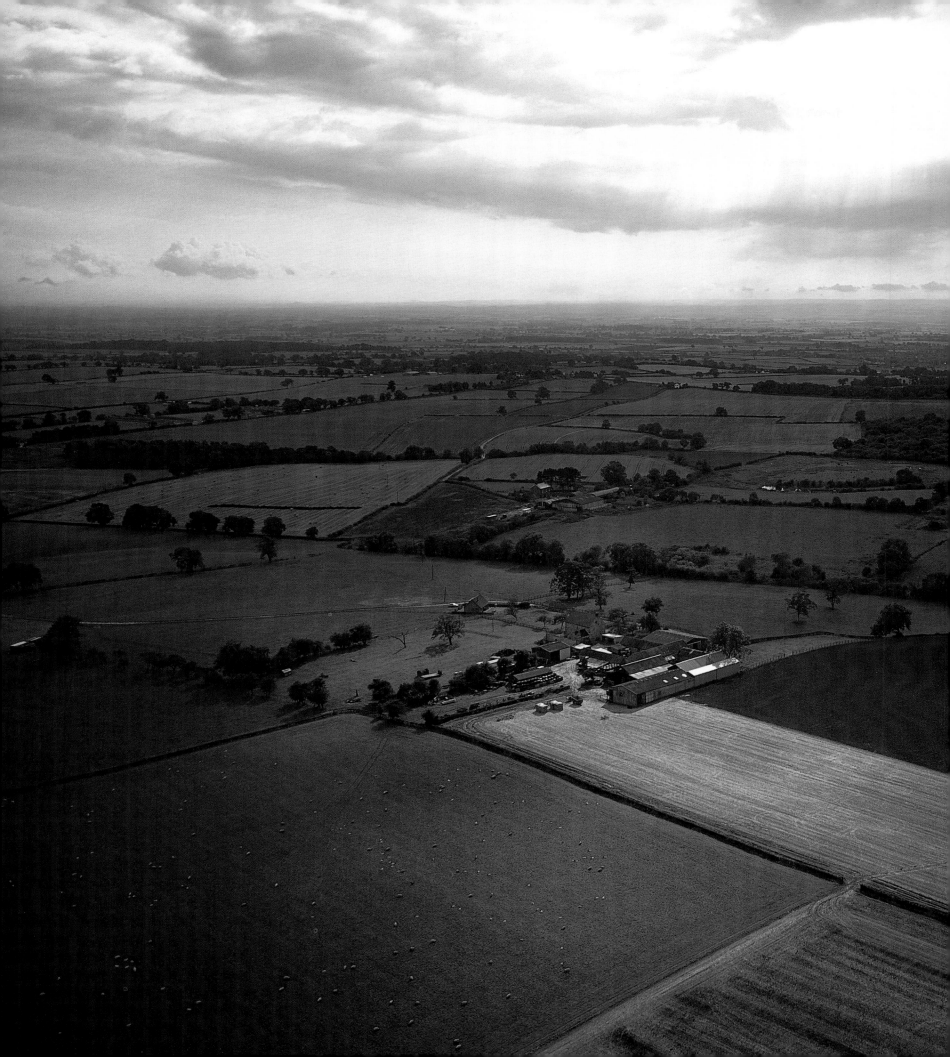

FARM NEAR WINTON, NORTHEAST OF
NORTHALLERTON

For all but the last 300 years, agriculture has been the
mainstay of Yorkshire's economy. Plenty of past
generations worked the soil to make a living, however
meagre. Today, almost any walk across the Dales will
lead you to a farm – whether it is in working order or
ruined, of course, it another story.

LANDSCAPE, SOUTH OF RIPON

Above Between the towns of Knaresborough and Ripon lies this landscape, dotted with tiny villages such as Copgrove, Bishop Monkton and Staveley. This photograph was taken from a height of 640m (2100ft) and clearly shows the patchwork of fields and small tributary rivers that lead into the River Ure. Just to the northeast of this landscape is a famous prehistoric site called 'The Devil's Arrows'. These three standing stones range from 5.4 to 6.7m (18 to 22ft) in height and so would be one of the few prehistoric sites in Britain that would not be done justice to by aerial photography.

FARM BETWEEN MALHAM TARN AND STAINFORTH

Right Agriculture is far from a thing of the past in Yorkshire. The Yorkshire Agricultural Society (YAS) has played a part in its survival. As well as organizing the Great Yorkshire Show, they also have a hand in ensuring the future of farms such as the one pictured here outside of Stainforth. In their words, their job is 'To advance, promote and improve agriculture including forestry, horticulture, pisciculture, the breeding of livestock, rural crafts and allied industries.'

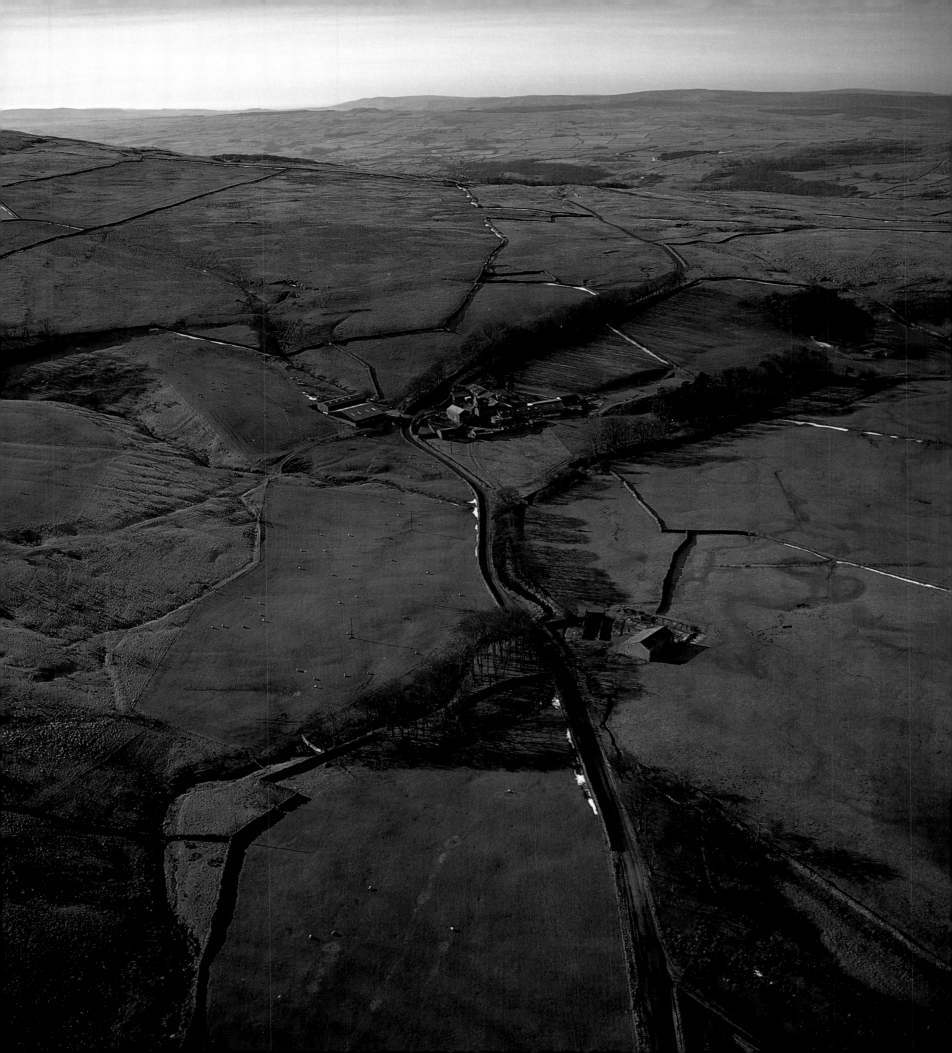

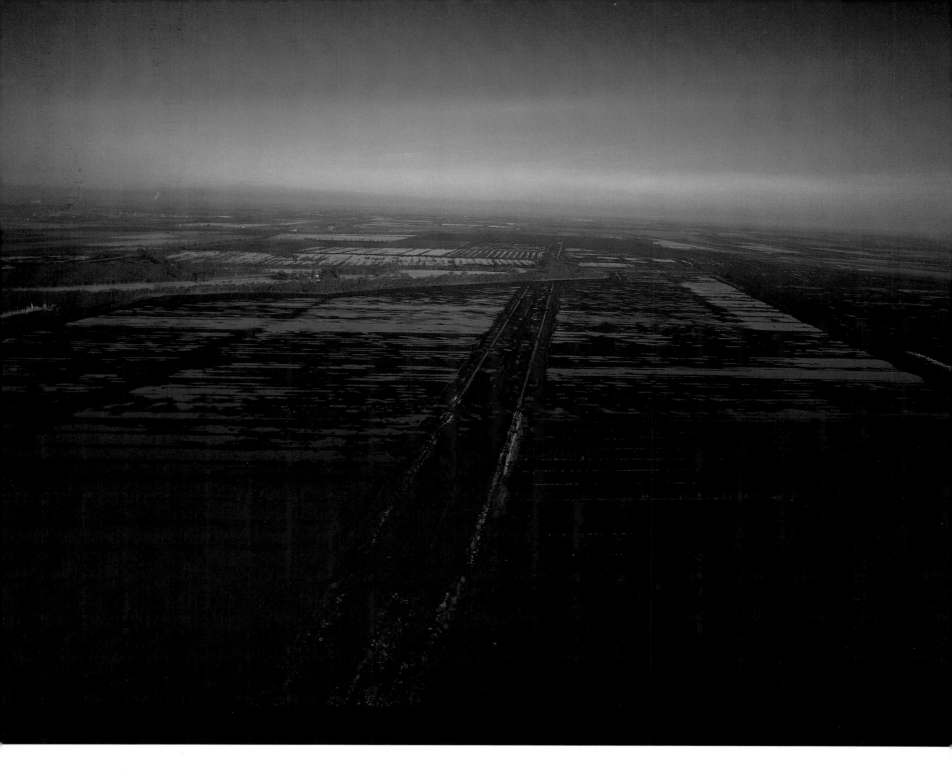

Peat Fields near Doncaster

The landscape east of Doncaster was for many years little more than peat bog and marsh as the ground was regularly flooded by the rivers Don, Torne, Idle, Went and Aire. Charles I eventually commissioned Cornelius Vermyden, a Dutch engineer, to design a scheme that would drain the land and in 1626 Vermyden managed to reduce the Don from three channels to one. However, the work caused floods elsewhere and it was not until the twentieth century that satisfactory drainage was built. At the same time, peat extraction was causing the loss of a number of rare plants and insects and damaging the land. Leeds Friends of the Earth campaigned against this devastation and their determination has paid off as Thorne and Hatfield Moors are to be saved from further pillage.

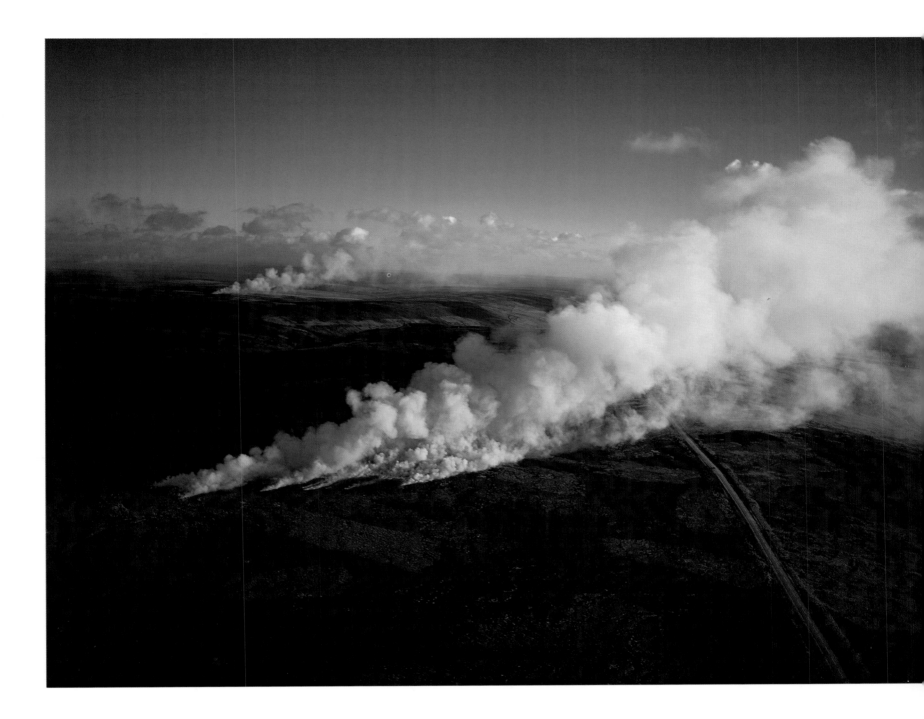

HEATHER BURNING ON ROSEDALE MOOR

One of the typical features on a heathland landscape, heather is burnt in an effort to arrest its succession. The burning, in this photograph just north of Thorgill on the Rosedale Moor, normally takes place in spring when the heather is not fully mature. However, there are problems associated with the burning as it removes the top layer of dead organic matter from the soil. Left alone, this matter would rot and become humus to promote plant growth. The North Yorkshire Moors National Park have recognised that heather moorland is also threatened in some areas by over-grazing and inappropriate burning and are dedicated to its conservation.

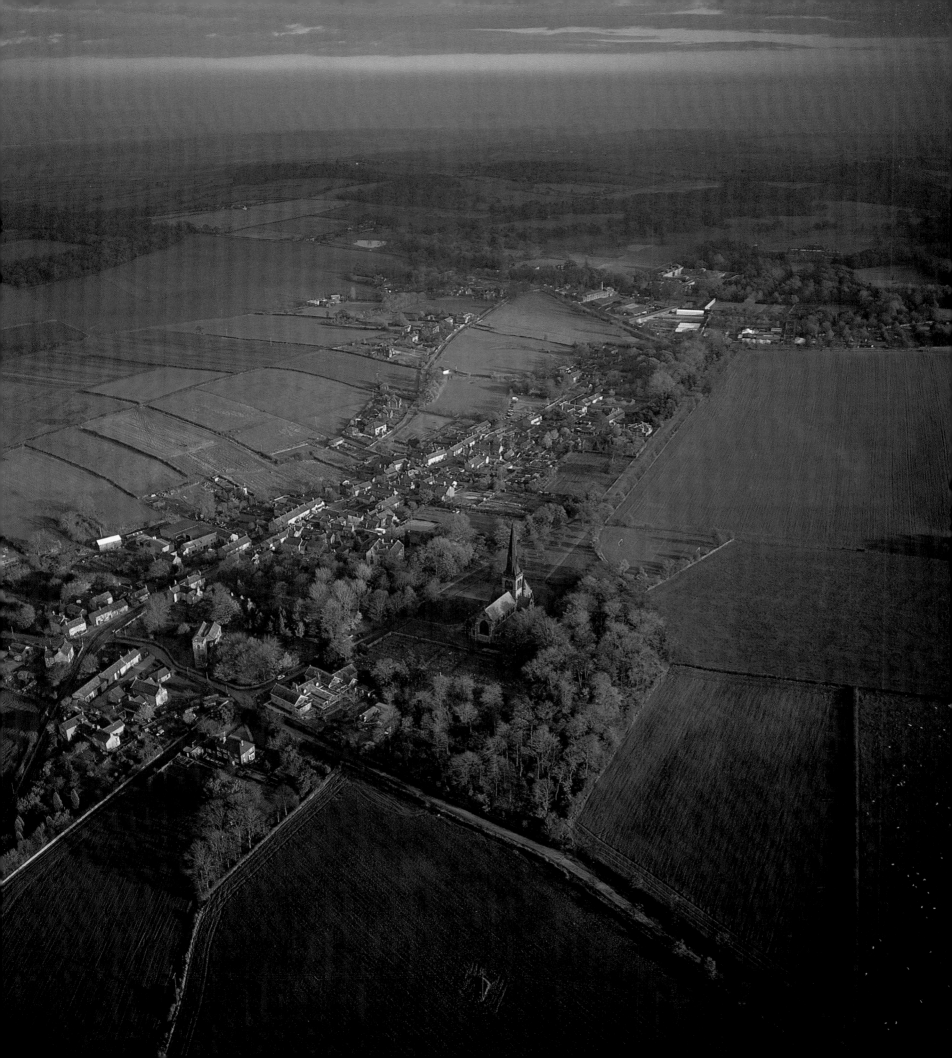

VILLAGES

THANKS TO POPULAR television series such as *Heartbeat*, *Last of the Summer Wine* and *All Creatures Great and Small*, villages are likely to be one of the first things people think of when they think of Yorkshire. Stereotypical it may be, and certainly not the only face of Yorkshire, but nonetheless there is something magical about coming across a seemingly random cluster of houses, barns and other buildings in the midst of endless acres of rolling green hills and valleys.

Since Saxon times, the majority of the population would have lived in such villages, supporting themselves by growing their own food and labouring on the land. However, the Industrial Revolution of the eighteenth century increased mechanization but drastically cut the number of people needed to work the land, so other alternatives had to be found. But this wasn't difficult, Tadcaster, for example, has long been known for its water

quality and is now the premier brewing village of Yorkshire. And you only need to hear the name Wensleydale to think of its delicious cheese.

Villages are, of course, just as man-made as their industrial counterparts, but their remote settings make them look almost organic from the air. Perhaps it is because building material was originally taken from the surrounding hillsides and woodland, at least until the railway was built and roads started to improve. Limestone, sandstone and even millstone grit were the usual materials, and the effects of age, severe weather conditions and the surprisingly agile creep of moss and lichen have ensured that these buildings now melt into their surroundings. While each village has its own distinctive 'personality', and while there are many more villages in Yorkshire than the brief selection over the following pages, the advantage of a downwards view is a clearer idea of just how each one fits into the bigger picture.

WENTWORTH

Left Wentworth sits in what was once the major steel making and coal mining area of Yorkshire. However, it was never particularly affected by these industries and remains to this day a traditional English village.

RICHMOND

Above From the Norman word for noble hill 'riche-mont', Richmond's jewel in the crown is its castle. It is still very much lord of all it surveys and the town has clearly sprung up around it. The town was only built around the front of the castle because the back of the castle stands directly on the edge of the bank of the river.

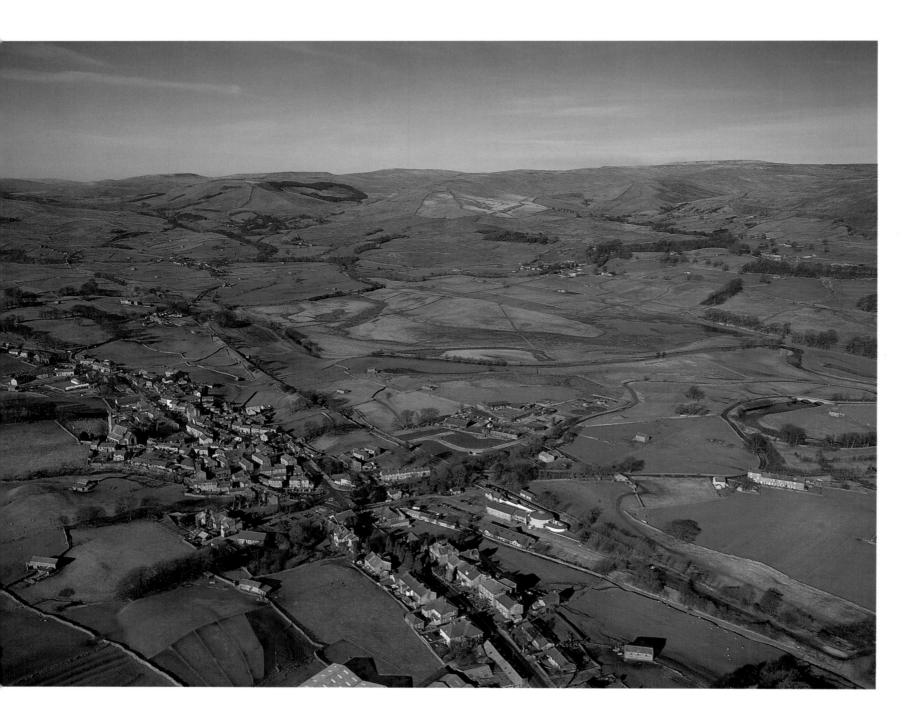

HAWES, WENSLEYDALE

Above As the chief town of Wensleydale, Hawes is home to the production of the famous Wensleydale cheese. The town has been an important trading centre and market place for around 700 years, but it hasn't rested on its laurels and, indeed, it has won the English Tourist Board Silver Award winner for the 'best day trip out'. It could have been a very different story, as much of Yorkshire, including Hawes, was turned into wasteland under William the Conqueror. Hawes was eventually designated Royal Forest and soon came under the management of Cistercian monks who primarily made a living by sheep farming, and eventually began to process the milk into the Wensleydale cheese that is such a favourite today.

REETH VILLAGE

Right At the juncture of two of North Yorkshire's arguably finest dales, Arkengarthdale and Swaledale, Reeth was the ideal setting for *All Creatures Great and Small*. Formally a small settlement, by the Norman Conquest, Reeth had grown sufficiently to be mentioned in the Domesday Book. Primarily a farming market town, it was also a centre for hand knitting and the lead industry.

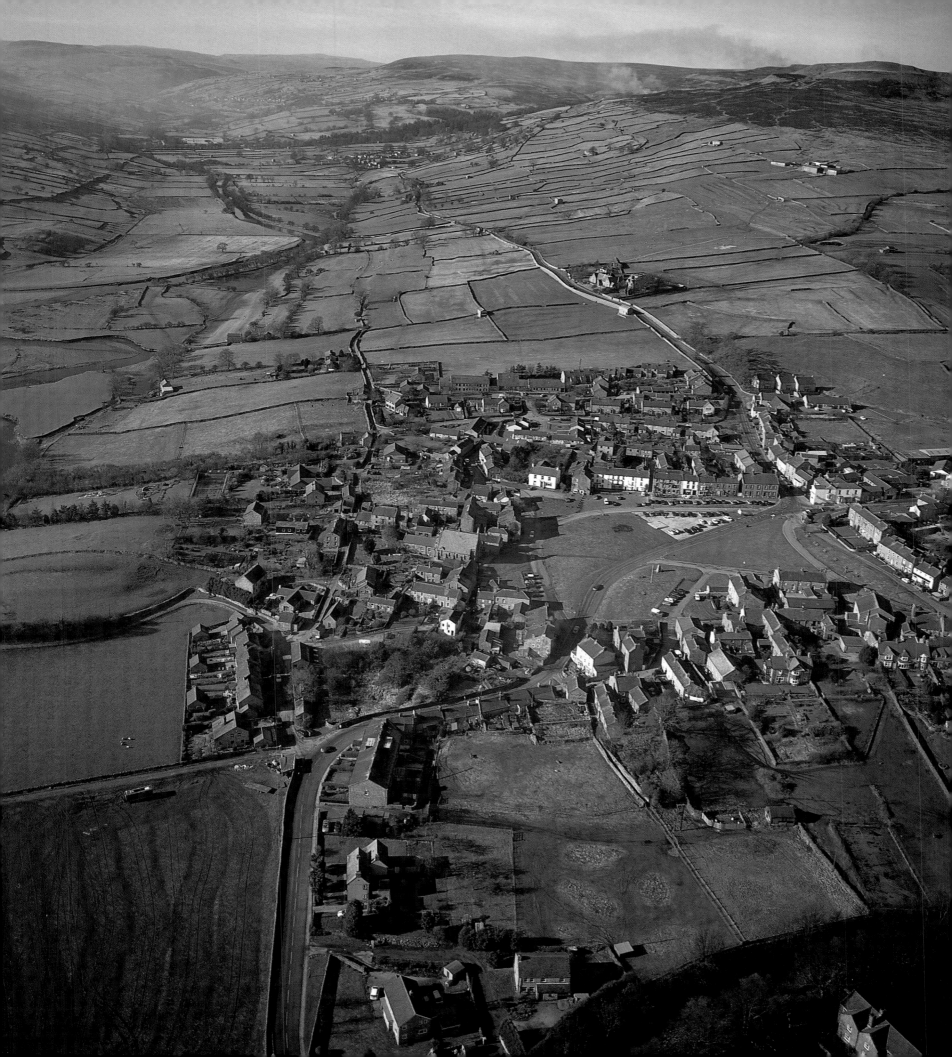

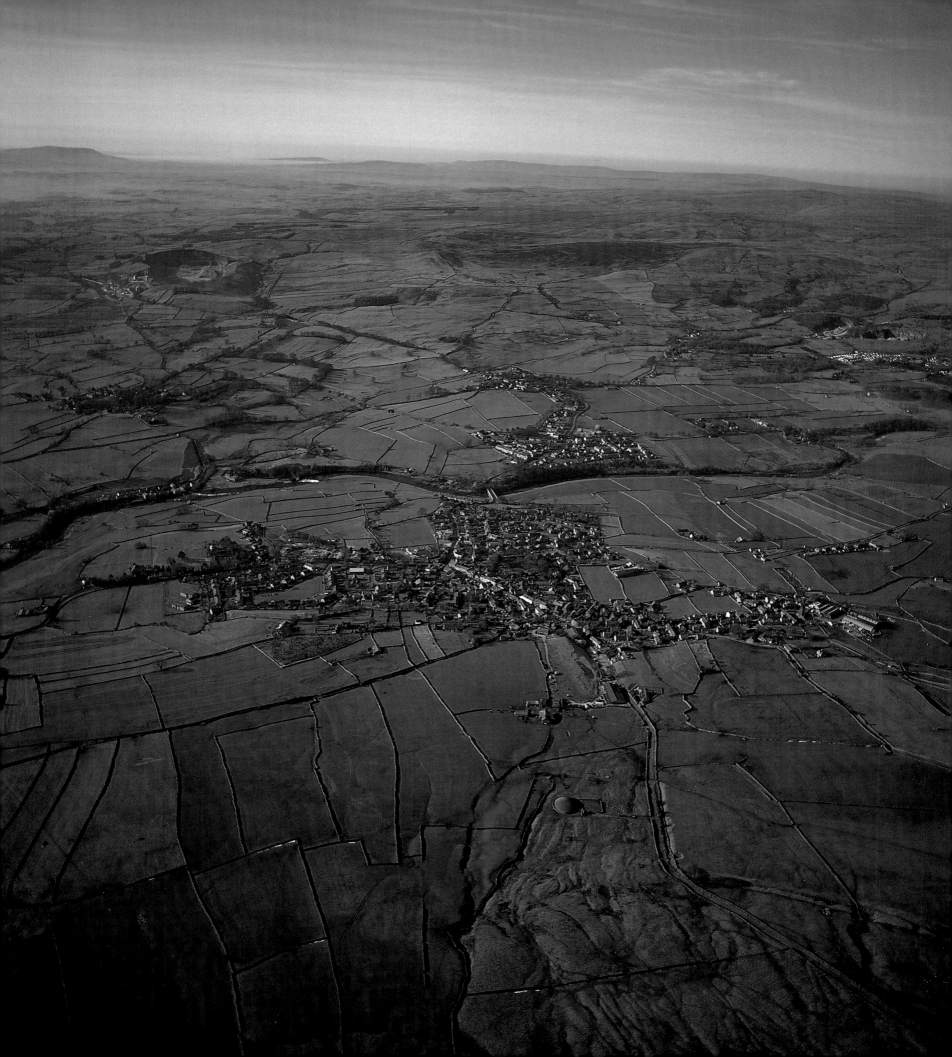

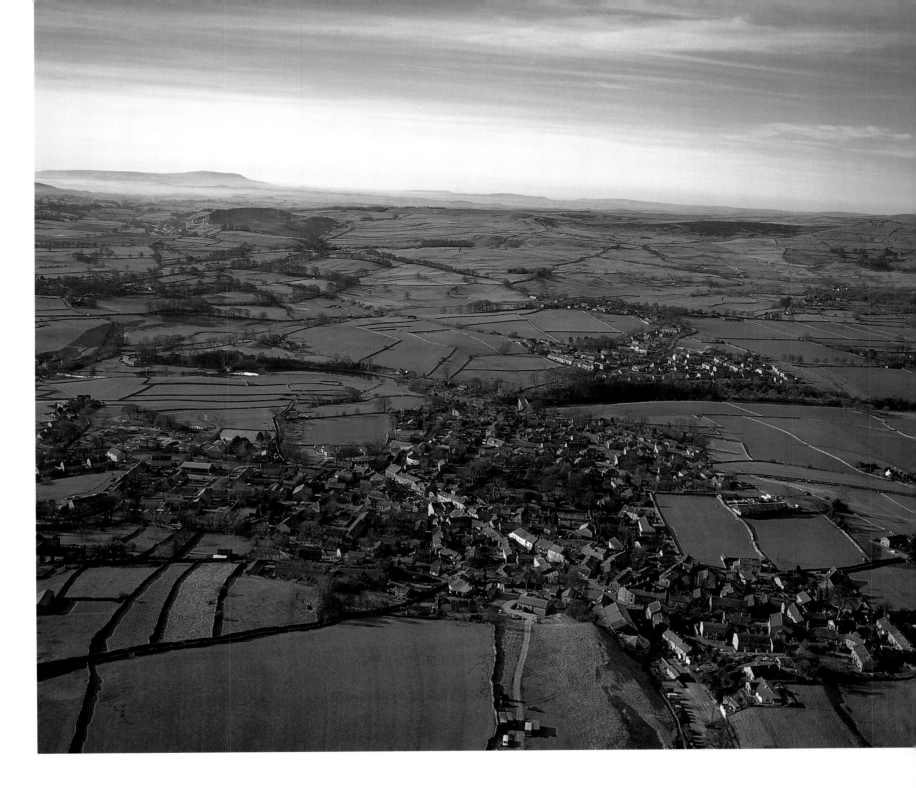

Grassington

Locals are fond of describing Grassington as a village but, as its name suggests, it is officially a small town. The focus of Upper Wharfedale and the limestone Dales, the town may have expanded since it was first granted a charter for a weekly market and annual fair in 1282 (which, incidentally, continued until around 1860) but that hasn't diminished its rural feel. It may be overrun as a tourist centre in the summer, but it retains a genuine quality, which is easy to lose. For example, it has managed to keep genuine 'olde world' names such as the Woggins, Jacob's Fold and Chamber End Fold without sounding twee and if you stay for a week, you will be recognized in all the local shops by the second day.

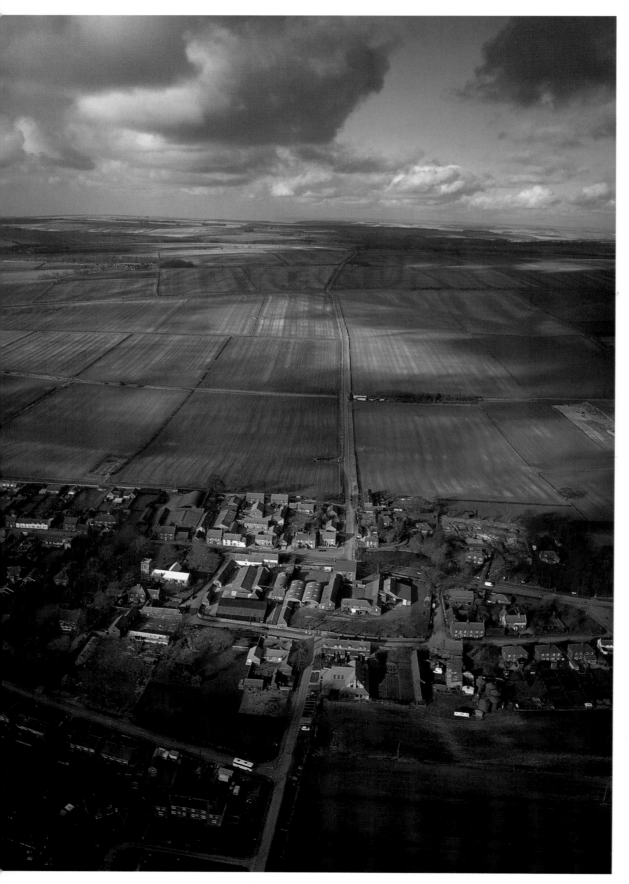

WETWANG

Left With a population of around 300 and a fabulous name that harks back to the fact that this was once Danish England, Wetwang has two distinguishing features. First, the beautiful black swans that have been the focal point of the village for many years and can almost always be seen swimming in the village pond. Second, that for the last few years Richard Whitely (of *Countdown* fame) has enjoyed the civic status of being Mayor of Wetwang, thanks to a bit of on-screen joking with his female counterpart, Carol Vorderman.

GARTON ON THE WOLDS

Right There are two chapels in Garton on the Wolds, built within 20 years of each other in the late 1800s. One on the main street now stands empty and the Methodist church is used as a workshop by the village joiner. However, the *pièce de resistance* in this peaceful village is the beautiful St Michael's and All Angel's Church. Established in 1132, this Norman church is positioned above the village so that it commands wonderful views (though clearly not as dramatic as the view by helicopter) across the Wolds on one side and the village on the other.

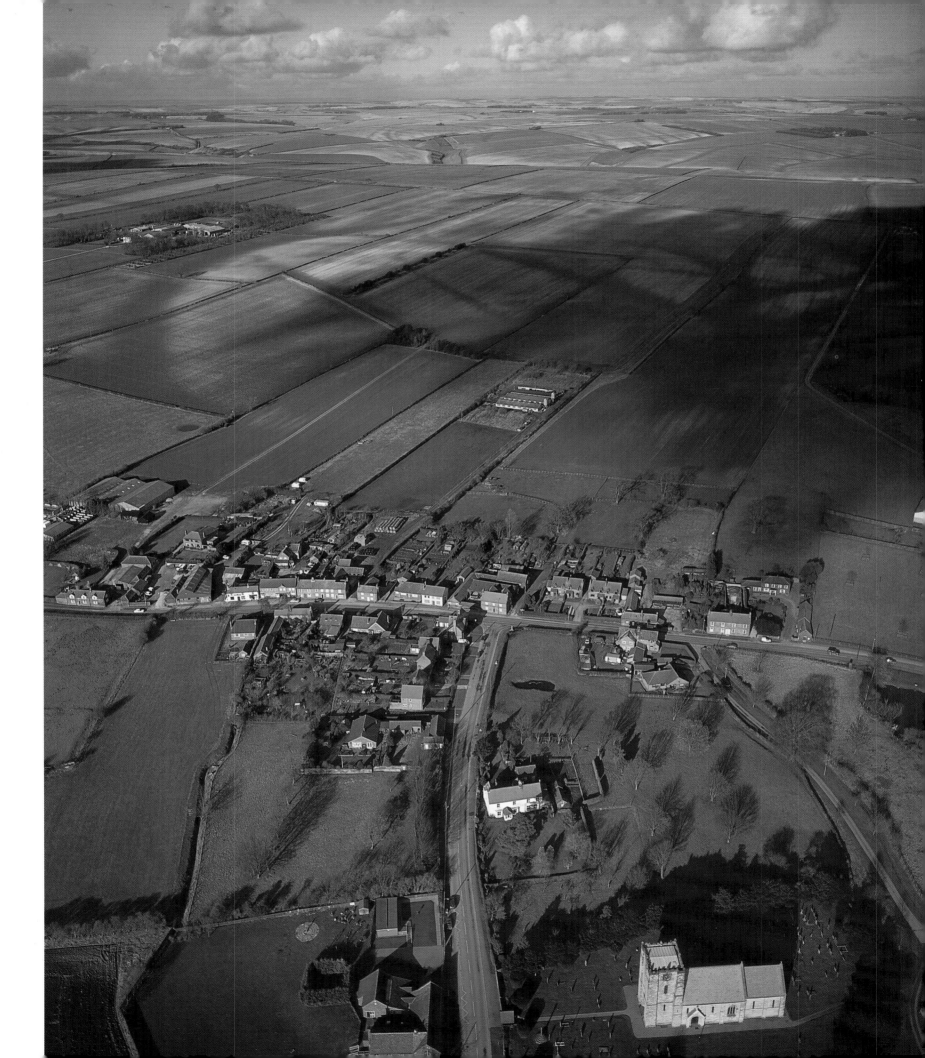

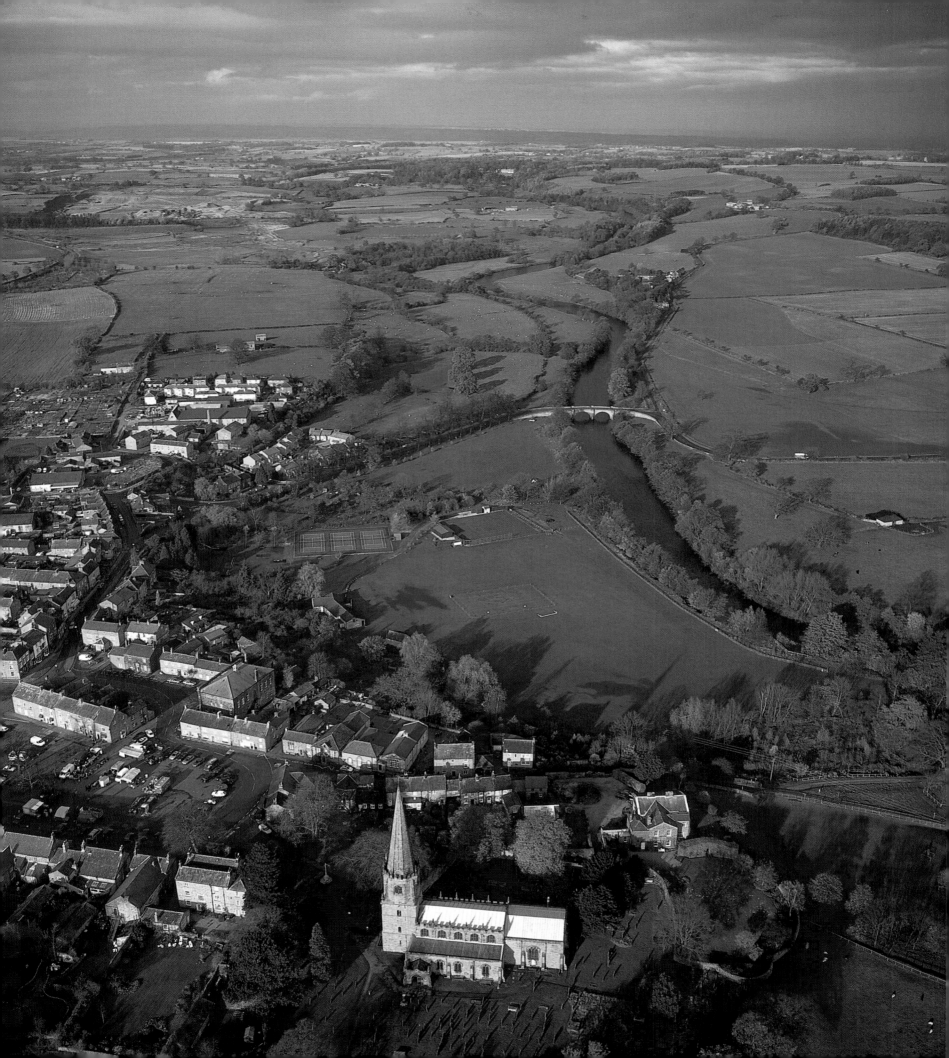

MASHAM

Left Set in rolling green hills, with its dignified houses, unusual almshouses and beautiful church, Masham is the very picture of tranquil Old England and overlooks the River Ure. The church, seen in the foreground of this photograph, was first mentioned in the Domesday Book (1086) although the spire dates from the fifteenth century. There was certainly an earlier church than the one that stands today on this site and remains of a huge Saxon cross can be found in the churchyard. Masham was once an important market town, as indicated by the main market square. It was granted a charter in 1393 by Richard II and a weekly market still takes place today.

STAINFORTH

Right This Yorkshire Dales' village once stood on a major trading route between York and Lancaster, which crossed the seventeenth-century packhorse bridge just outside the village. Close by this elegantly arched bridge is Stainforth Force – force being a word of Nordic origin denoting waterfall – which rushes over flat rocks. In the days before the bridge, traffic crossed by a 'stony ford' – the origin of the name Stainforth.

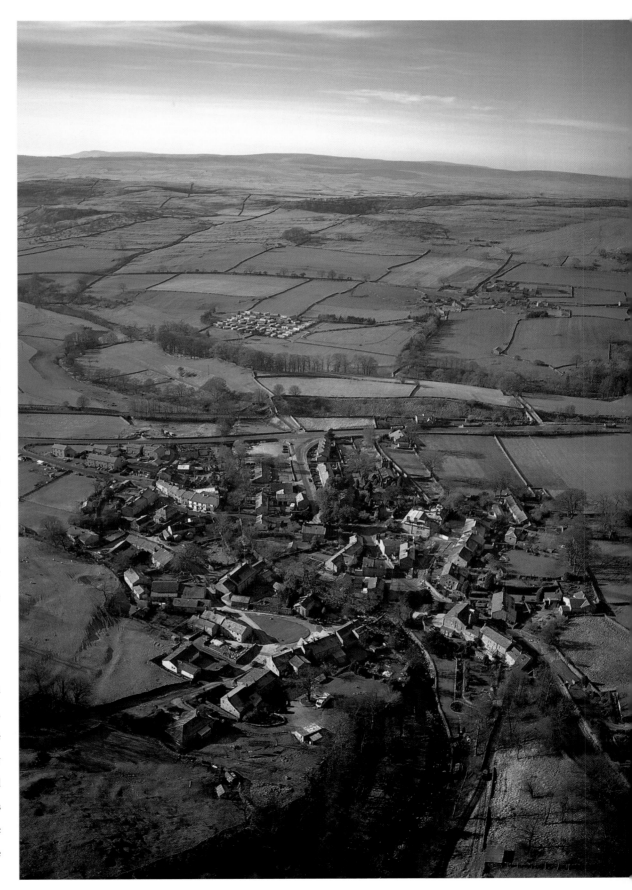

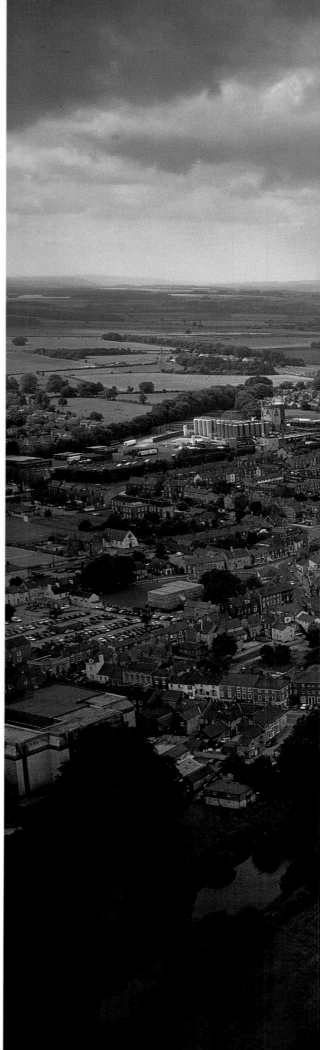

TADCASTER

Situated on the banks of the River Wharfe, Tadcaster
was originally named Calcaria, meaning place of
limestone. With a reputation for high-quality drinking
water, Tadcaster's main industry, and one that has been
traditional since 1341, is brewing. As one of Britain's
most prominent brewing spots, the village is today
home to John Smith's and Samuel Smith's breweries.

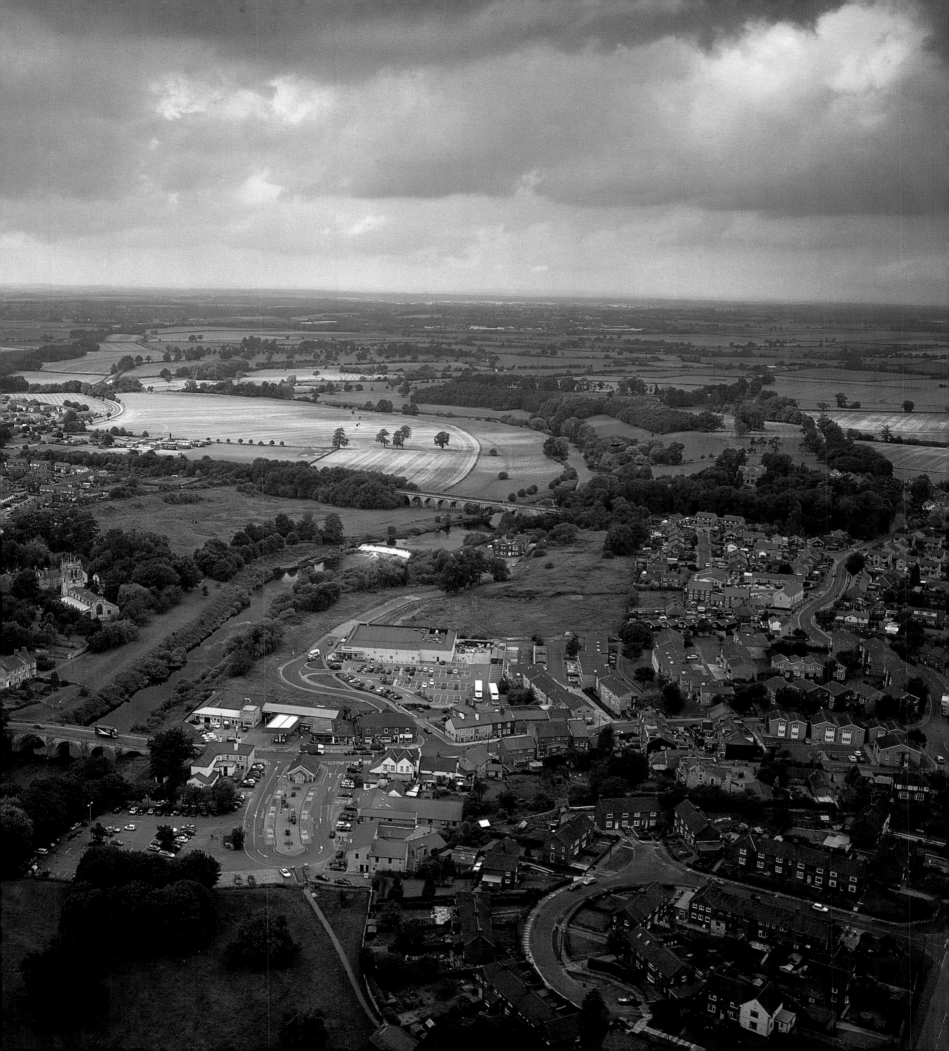

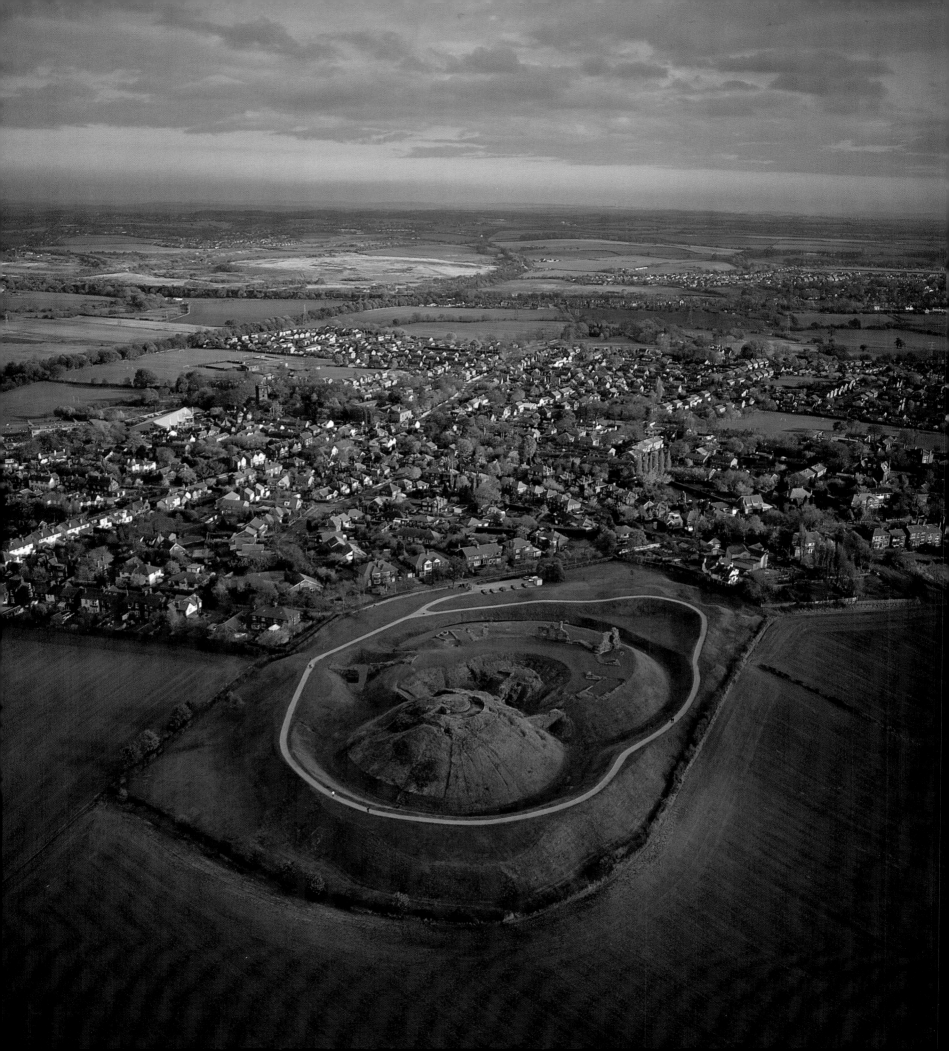

HISTORIC BUILDINGS AND COUNTRY HOUSES

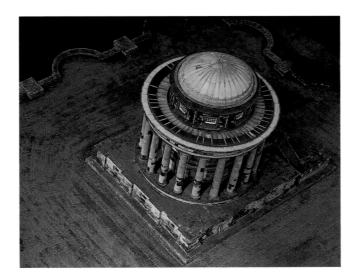

For anyone with even a passing interest in historic Yorkshire, the obvious place to start would surely be York. Second only to London until the Industrial Revolution, York has been well documented since it was founded around 2000 years ago and the compact city is packed to bursting with mementoes from the past. Chosen as a settlement by the Romans, 'Eboracum', as it was then called, was soon the capital of the empire's northern European territories and an important administrative centre. Since these beginnings it has been occupied by the Saxons, the Danes and the Vikings.

As well as the celebrated York Minster, the city contains other relics of days gone by, including part of a castle and St Mary's Abbey. However, although York may have many monuments, it is far from the only place with historical associations. Castles aside, Yorkshire was an area famous for its holy men and women from Saxon times, and monasteries soon gathered around them. Some were destroyed in Viking attacks and some fell to ruin, but the Norman Conquest in 1066 breathed new life into religion and new monks began to arrive in the North. These continental monastic orders all had different ideas about how to best serve God. The widespread Benedictine monks were never a great force in Yorkshire and although the Augustinian canons were influential, it was the strict Cistercians who really came into their own in the county, making Rievaulx the centre of their order in England. Luckily, there was plenty of available land and generous lords eager to purge their spirits by donating it to a monastic foundation. Monasteries dominated Yorkshire life for 470 years, until Henry VIII's Dissolution of the Monasteries swept most of them away, but even today around 40 monastic houses remain.

Every viewing point has its advantages and disadvantages, and this notion is perhaps most obvious in a chapter devoted to historic buildings and country houses. A conventional visit to one of these places would allow you to admire the architectural details. From the air, these specifics are missed but the reward is a view of totality: a vision of the architectural achievement that was denied to even the architects or stone masons.

SANDAL CASTLE, WAKEFIELD AND FOLLY AT CASTLE HOWARD

Left In a necessarily intimidating position overlooking the Calder Valley sit the excavated remnants of what was once the impressive stone motte and bailey fortress of Sandal Castle, which is best known for the 1460 Battle of Wakefield in which Richard, Duke of York was killed. The impressive grounds of Castle Howard (see page 75) (*above*) are just as magnificent with lawns, fountains and rose gardens. On the top of a hill sits the impressive Temple of the Four Winds, a Palladian folly designed by Vanbrugh.

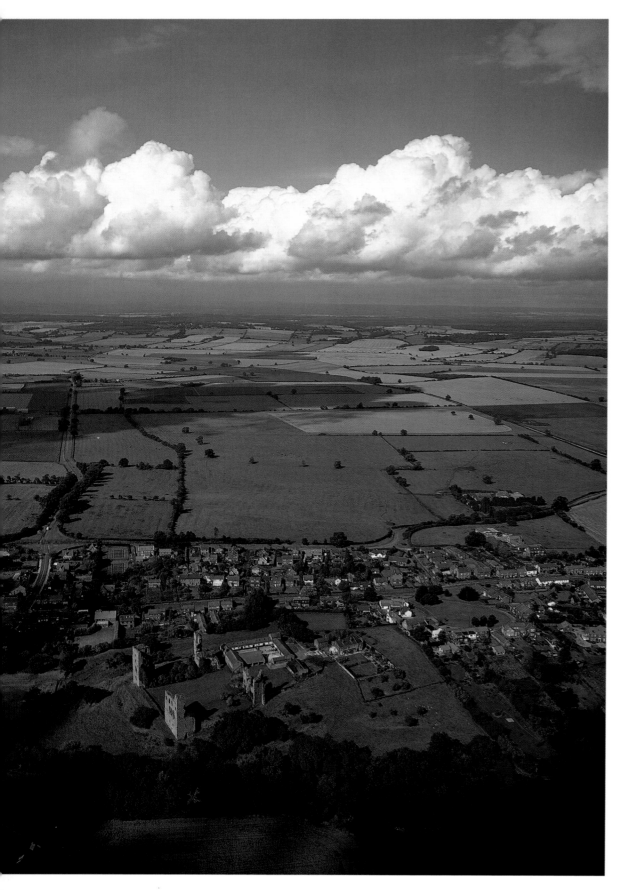

SHERIFF HUTTON CASTLE

Left It has been more than 800 years since the first castle was built here by the man who gave this village and castle their distinctive name, Bertram de Bulner, the Sheriff of Yorkshire. When his daughter married into the Neville family, the property passed to her husband John and it was he who rebuilt the castle in the fourteenth century, adding a deep moat, 2-m (6-ft) thick walls and the Neville coat of arms. Many years later, Richard III held court here and the tomb of his only son Edward, Prince of Wales lies in the nearby church, marked by a small, battered alabaster figure.

EASBY ABBEY

Right Situated less than a mile away from Richmond on the north bank of the Swale, Easby Abbey was founded in 1155 for the Premonstratensian order and was dedicated to St Agatha. Whereas the Cistercian orders, based at abbeys such as Fountains and Rievaulx, preferred to keep themselves to themselves, the Premonstratensians favoured taking part in community life and preaching to the outside world. Because of the white habits they wore, they became known locally as the White Canons. The sheer size of what remains of the buildings hints at the generosity of the founder Roald, a constable at Richmond Castle, and later benefactors, but Easby also had a large sheep farming business, which allowed it to be relatively self-sufficient.

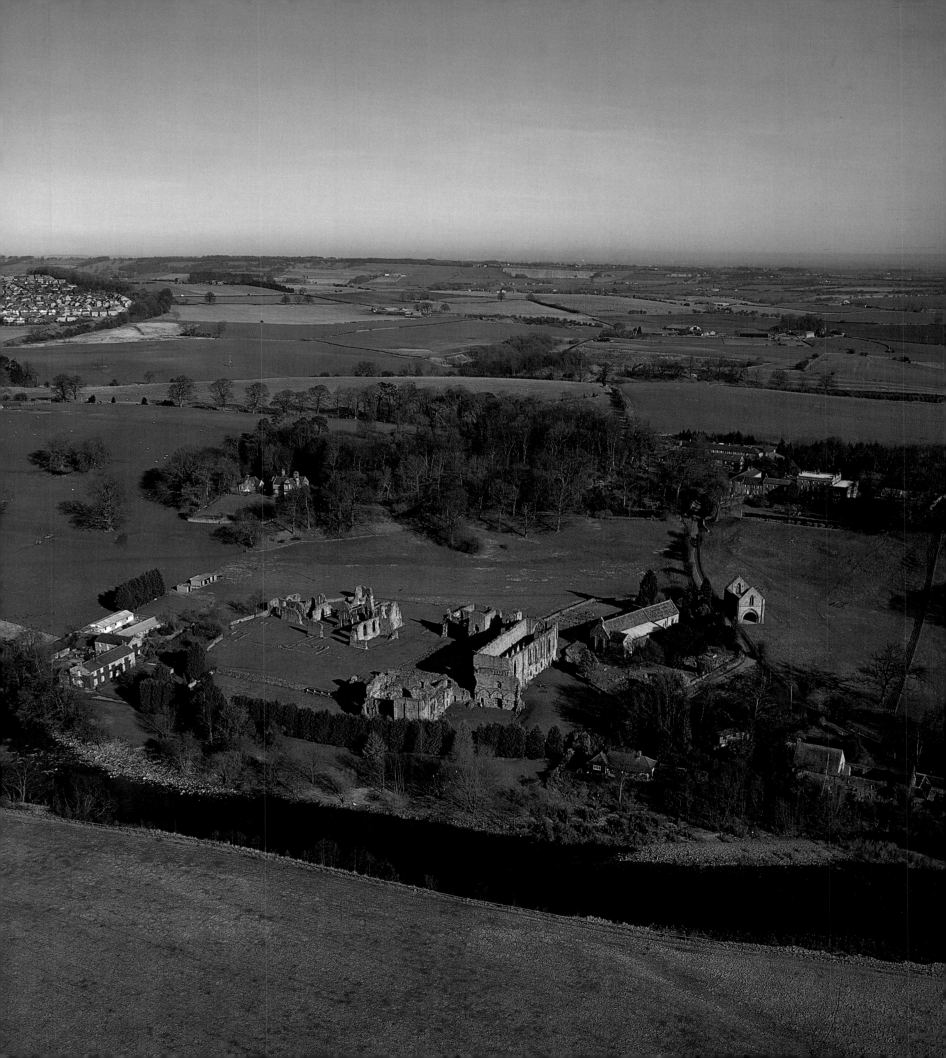

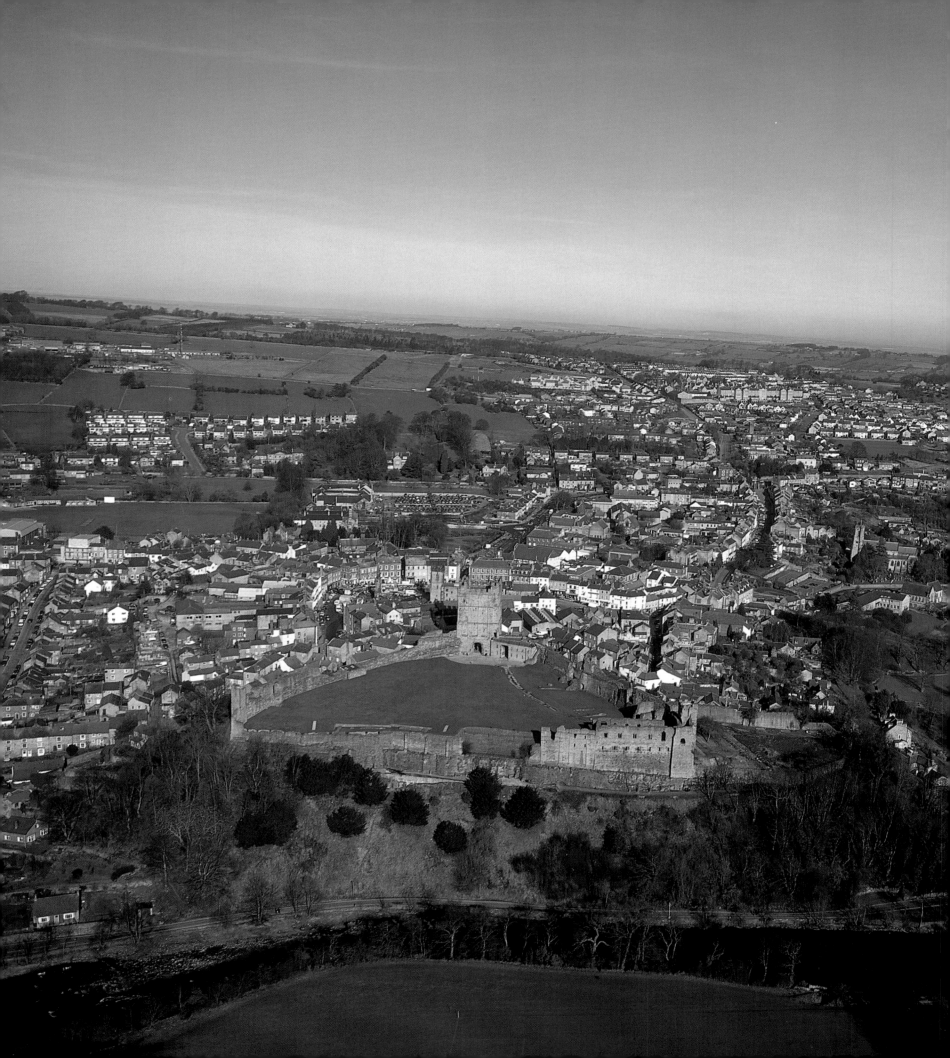

RICHMOND AND RICHMOND CASTLE

Set around a large market place with both Georgian and Victorian buildings, the name of this historic Swaledale town is derived from Riche-Monte, a common Old French place name meaning strong hill. The name dates back to Norman times when an earl called Alan 'the Red' Rufus began building the castle in 1071, making it one of the earliest stone castles in the area. The fortress's primary purpose was to defend the Earl and his followers from English attacks against their Norman conquerors. However, except for skirmishes with Scottish raiding parties, Richmond Castle saw very little fighting. The castle passed to the Dukes of Brittany who eventually lost the castle at the height of the Hundred Years War, and it was subsequently passed from the Dukes of Bedford to the Tudors to Richard III. While never specifically abandoned, the castle gradually fell into disuse and then ruin.

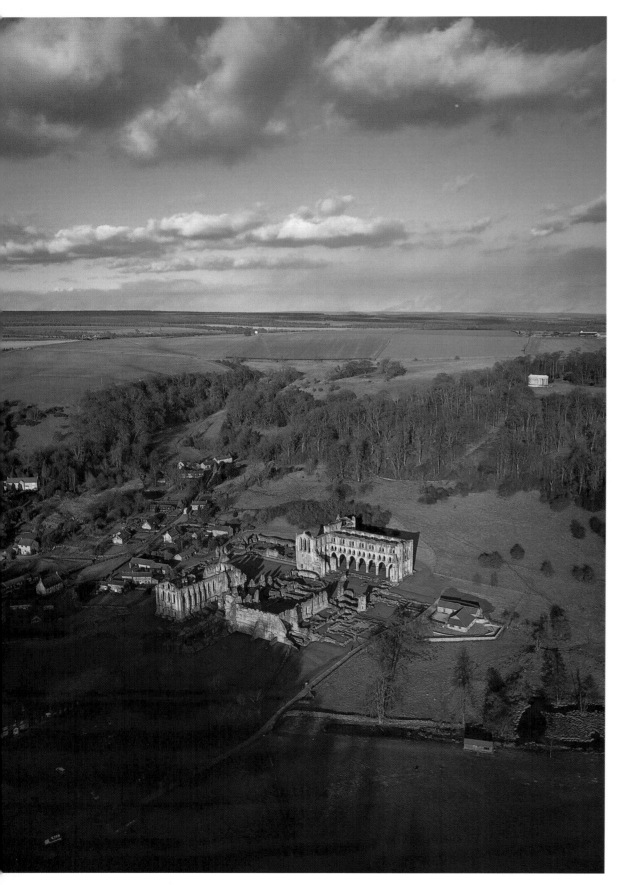

RIEVAULX ABBEY

Left Embedded in the thickly wooded valley of Rye Dale, Rievaulx Abbey was founded by French Cistercian monks from Clairvaulx in 1132. (Rievaulx simply means Rye Valley in French.) It was the first abbey of its kind in Yorkshire and within 15 years of being built was inhabited by 140 monks and 500 lay brothers. Between 1147 and 1177, another Cistercian abbey stood just two miles away, but the monks were confused by the tolling of the bells at Rievaulx and eventually moved to a new site at Byland near Coxwold. Like many other Yorkshire monasteries, Rievaulx remained in use until the Dissolution of the Monasteries during the reign of Henry VIII.

HELMSLEY CASTLE

Right In a prominent position guarding the Rye Valley, this early thirteenth-century castle is protected by an impregnable double ditch cut from solid rock. Although it is thought that the founder of nearby Rievaulx Abbey had a castle on this site at the beginning of the twelfth century, it was Robert de Ros and his wife, Isabel, who began to develop the castle and held it against King John's siege, which occurred in 1216. It has been continually attacked and modified since, but today only gaunt ruins of the castle remain. After Helmsley Castle was surrendered to General Fairfax in the Civil Wars, much of its stonework found its way into local houses. Ironically, Fairfax's daughter later married the castle's owner, the Duke of Buckingham.

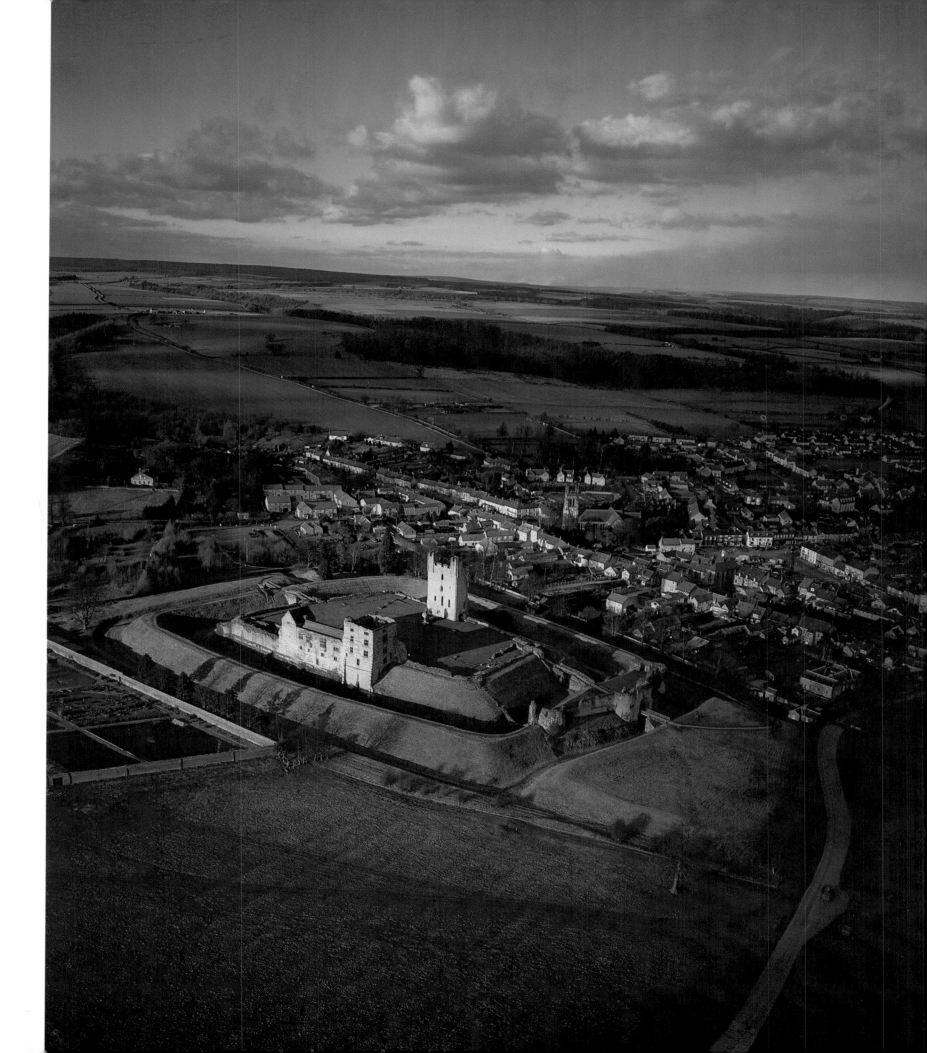

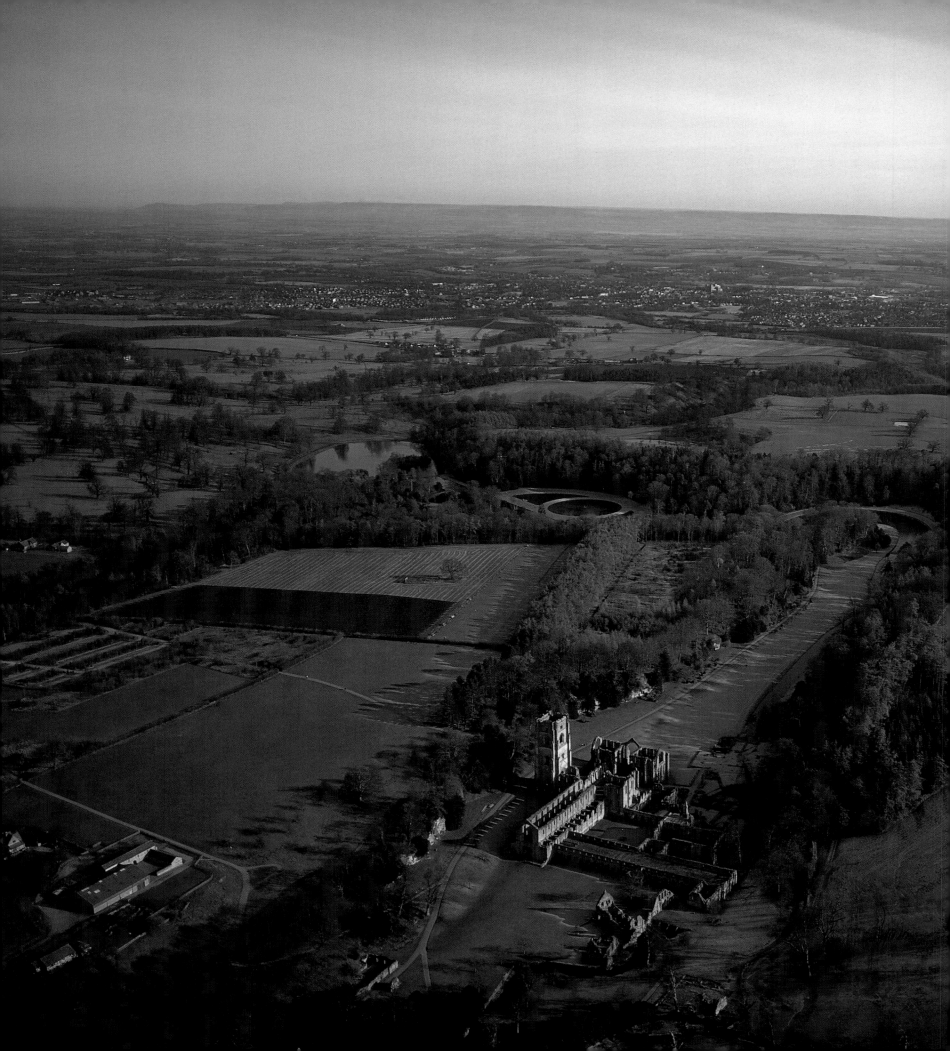

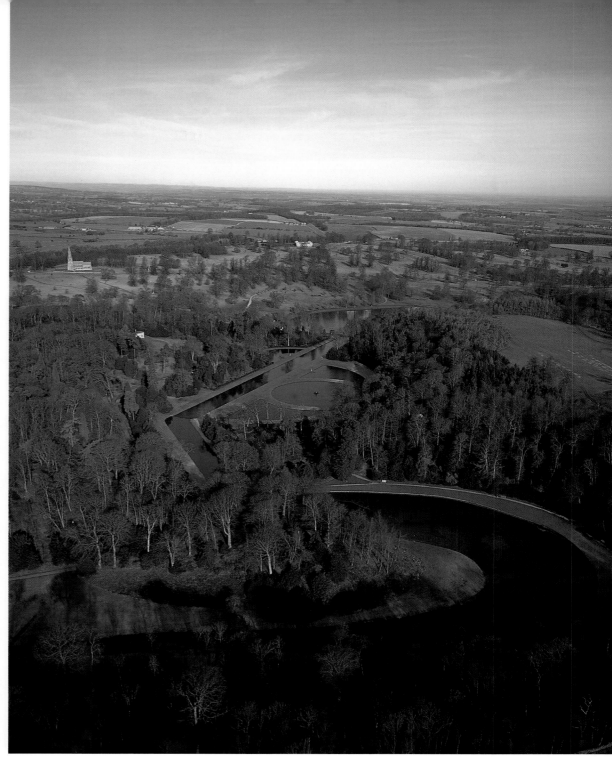

GARDENS AT FOUNTAINS ABBEY

First conceived as a deer park, the gardens at Fountains Abbey were originally created between 1716 and 1781 by John Aislabie and his son William. They were built to enclose the medieval Studley Royal Manor House, which Aislabie had inherited, but this house was destroyed twice by fire and eventually demolished. Set deep in a wooded valley among the dramatic ruins of Fountains Abbey, inspiration for the garden was never going to be a problem, and the design contrasted the wild natural landscape with a carefully crafted planning of serene water gardens, immaculate lawns, temples and sculptures. Even though it has since been extensively restored by the National Trust, it is still one of the very few great eighteenth-century Georgian gardens to survive substantially in its original form.

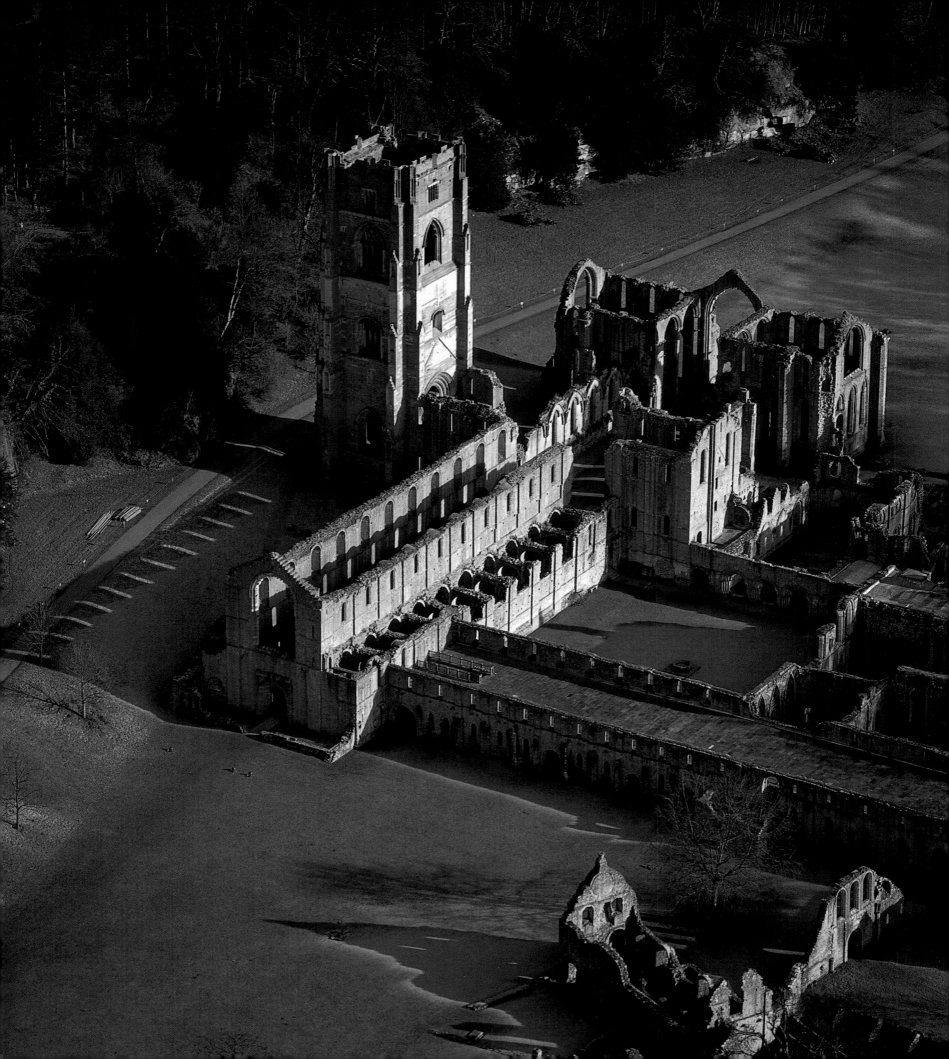

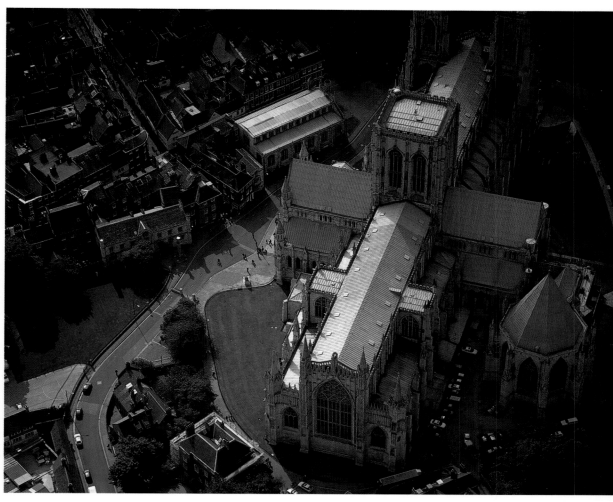

FOUNTAINS ABBEY

Left There are two versions of the story that led to the founding of Fountains Abbey by a group of 13 Benedictine monks. They certainly came from St Mary's Abbey in York, but it is unclear whether they were kicked out after a riot or if they chose to leave, finding life at St Mary's too liberal. Whatever the truth, they had disagreed with the abbot at St Mary's about something but found the support of the Archbishop of York, who took them to what was then nothing more than an area of waste ground in the River Skell valley. This was to be the site for Fountains Abbey, so-called because of the springs of water that existed in the area.

YORK MINSTER

Above York Minster, was originally founded as a missionary church. Historically, it has been the place of Christian worship since 627 when King Edwin was baptised here, although at the time it was little more than a wooden structure. Since then it has been damaged at least five times by fire, some started by accident – most recently by lightning in 1985 – but also occasionally on purpose, such as in the case of religious lunatic Jonathan Martin in 1829. Consequently, it has been almost continually rebuilt, improved and restored and, while still boasting beautiful wooden carvings and stained glass dating back to the twelfth century, today stands as the largest medieval cathedral in northern Europe.

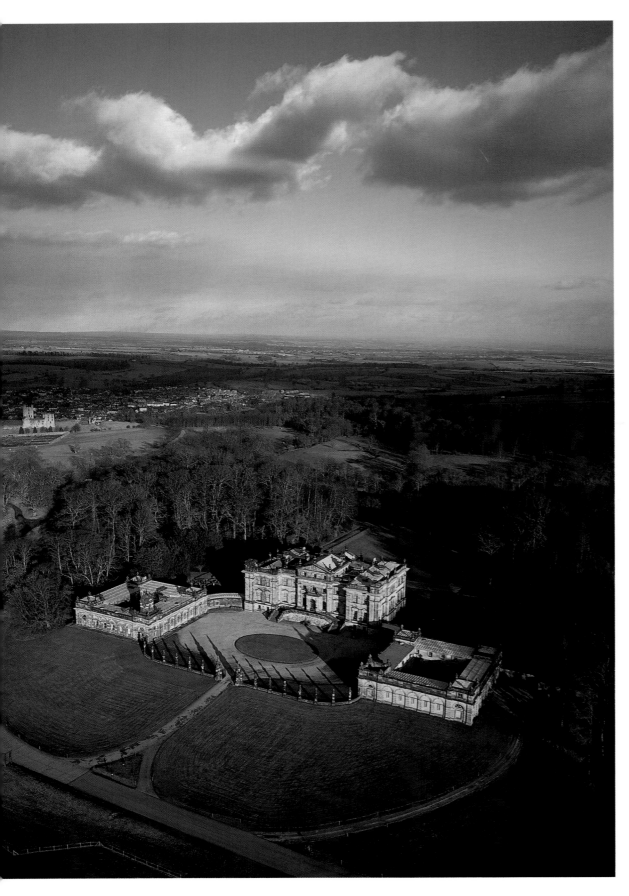

DUNCOMBE PARK

Left Using a style of gardening that incorporates the natural landscape and described as 'the supreme masterpiece of the art of the landscape gardener' for its pains, these early eighteenth-century green gardens, complete with vast terraces, temples and woodlands, cover 35 acres. However, that diminishes in size when compared to the 450 acres of parkland they are situated in. Since 1986, both the house and the gardens have been restored by Lady and Lord Feversham, descendants of the original occupier. The extensive parkland became a nature reserve in 1994 and is a treasure-trove of trees, plants and birdlife.

CASTLE HOWARD

Right Certainly ranking among the greatest architectural wonders of Yorkshire, the palatial Castle Howard was built for Charles Howard, the 3rd Earl of Carlisle to replace Henderskelfe Castle, built on the same site but destroyed by fire in 1693. His choice of architect came as something of a surprise, as Sir John Vanbrugh was better known as a playwright at the time and was only an amateur architect. However, unhindered by formal training and with a theatricality that shines though the building, Vanbrugh brought many innovative designs to the castle. The grounds include Vanbrugh's Temple of the Four Winds (see page 63) as well as two lakes in its spacious 1000 acres. Originally begun in 1699, the castle remains in the hands of the Howard family.

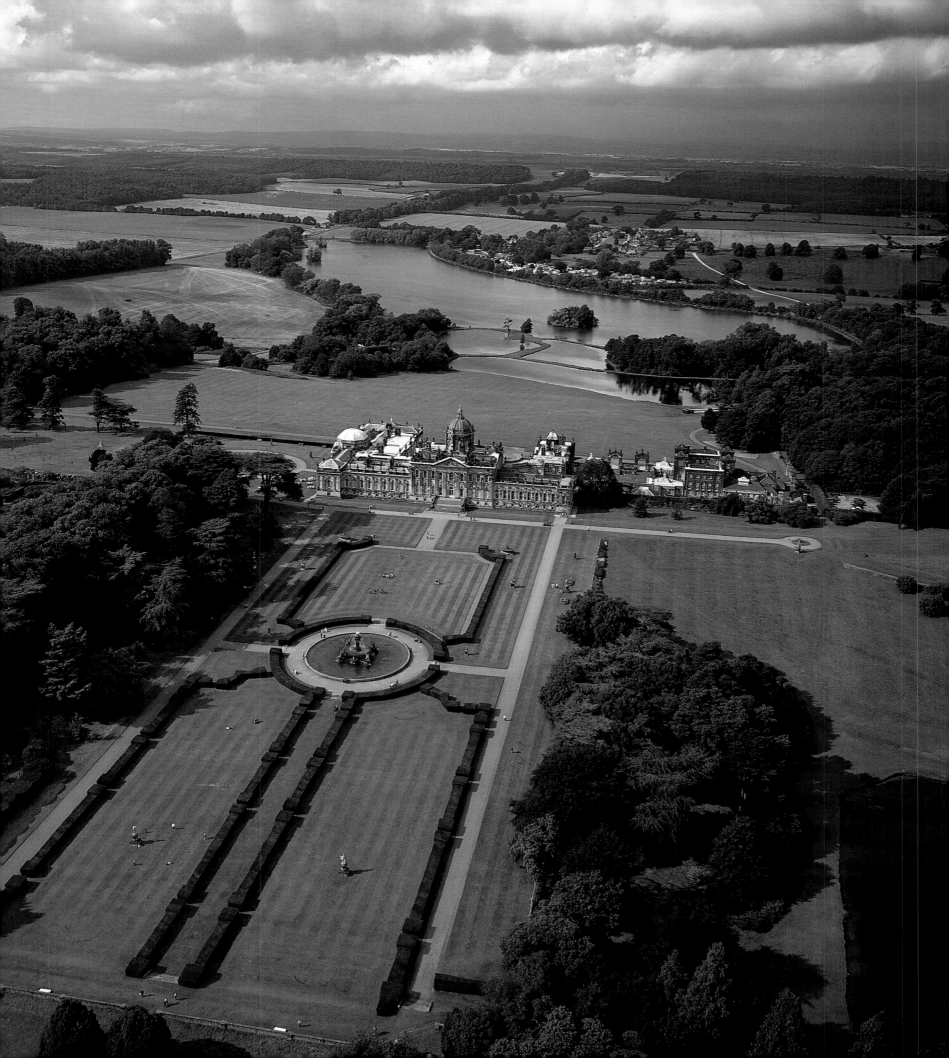

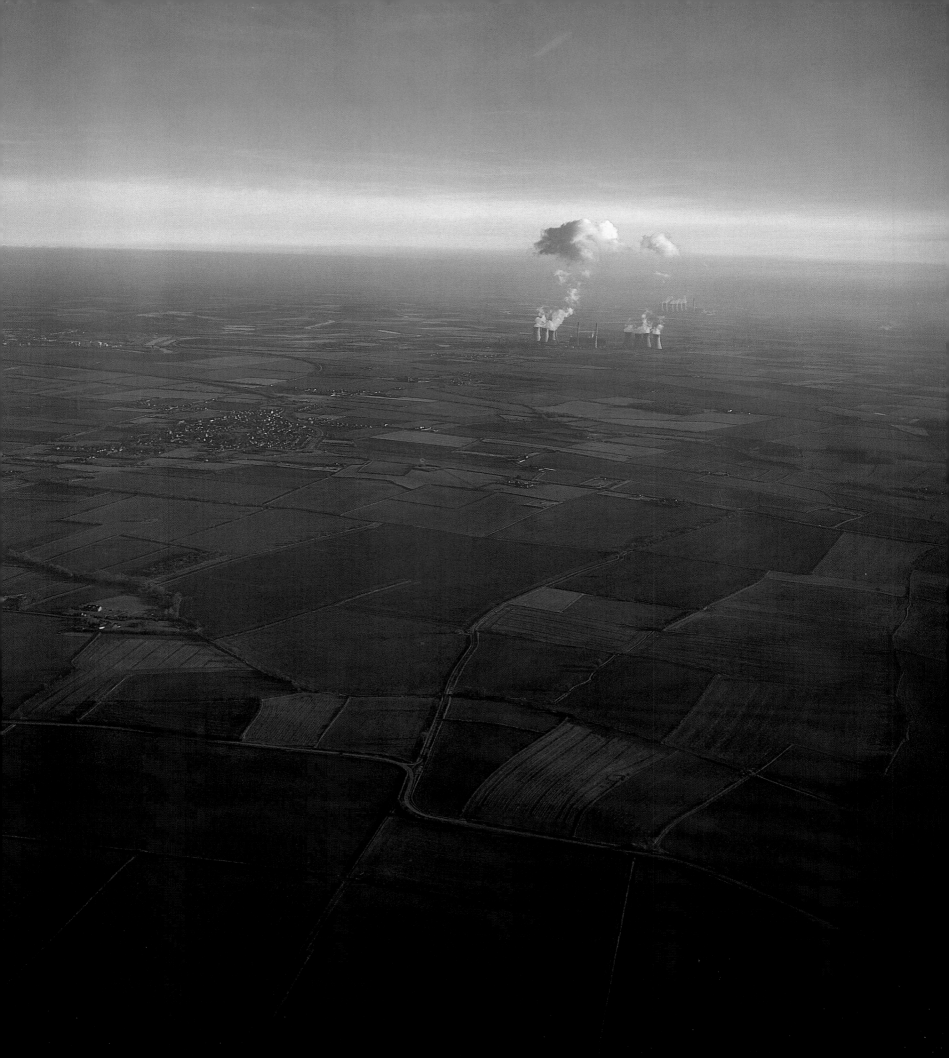

NATURAL PATTERNS AND MAN-MADE SHAPES

Visitors to Yorkshire are often surprised by the vast amount of open space that has survived even when the cities were all but choked with factory fumes. What is even more surprising for the unsuspecting is that this expanse of open space is anything but a perfectly uniform patchwork of flat fields that stretch for as far as the eye can see. The landscape of Yorkshire is varied, imperfect and scarred. It is a colourful riot of dales, fields, moors, hills, crevices, wild flowers, rough grassland, damp grassland, blanket bog, swathes of heather, becks and rivers.

Since the beginning of time, man has looked to his surroundings for his most basic of necessities, such as food and shelter. Some features of the landscape have taken thousands of years to evolve. Take, for example, the natural limestone pavements, formed over the last 12,000 years, which are common sights. Glaciers have scraped the land until they reached limestone, and over time, rainwater has carved out natural blocks

and crevices. In other ways the view is very different today than just a hundred or so years ago. Agricultural techniques have moved on, thanks to the Industrial Revolution, and each change has a knock-on effect that was never predicted. Farms and old hay meadows are rarer than ever and man has raped the moors in search of lead and coal.

Protection of the environment is now a serious business, and the designation of two National Parks in Yorkshire shows that the matter is attracting close attention. Power stations still exist, pumping pollution into the atmosphere, but people are exploring renewable sources of energy.

In this section, natural shapes such as a harvested field or a flooded field are juxtaposed with bizarre man-made patterns. Power stations, wind farms and the pods of an American monitoring station demand a closer look. But that's the thing about aerial photography; the mundane becomes extraordinary and patterns, invisible from the ground, become amazing from the air.

POWER STATION

Left Yorkshire would have had many more working factories in the late eighteenth century than exist today, but that was before anyone knew the negative effect pollution can have on the atmosphere. The fat chimneys pumping out smoke here look incongruous when juxtaposed with such richly rural surroundings.

ROAD NEAR MALHAM TARN

Above This road may look isolated as it snakes through the surrounding fields, but situated near the famous Malham Tarn its lonely appearance belies the amount of traffic it gets.

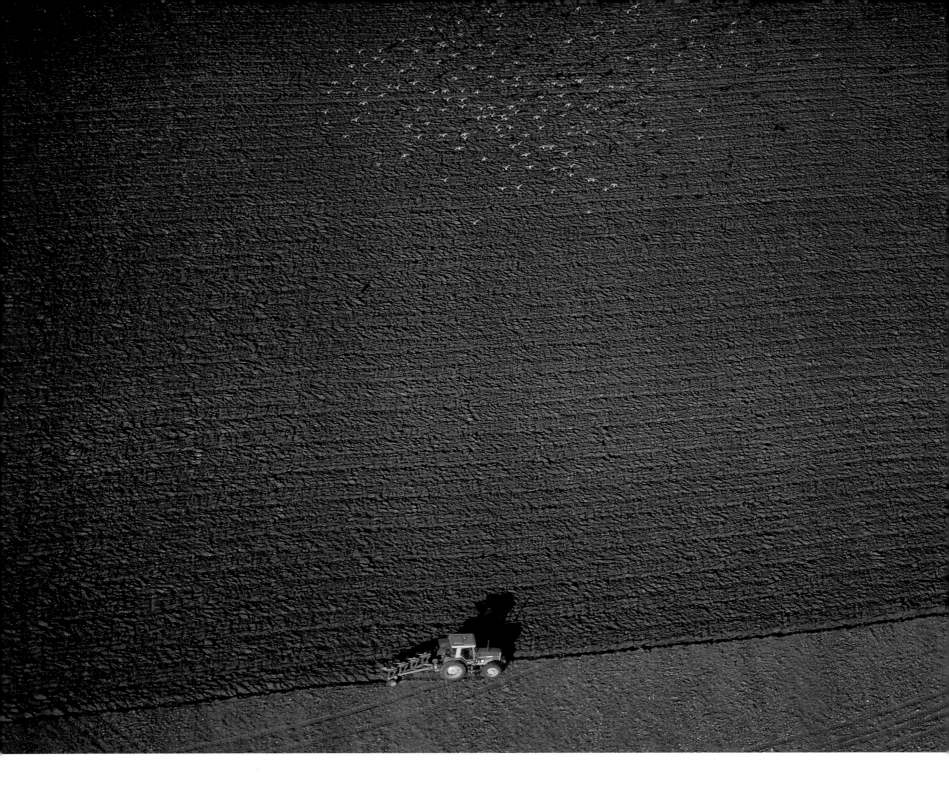

Ploughing and Harvesting

The word harvest brings with it connotations of reaping in plentiful abundance. In Yorkshire, geese were fattened in the field after harvest, ready to be made into the famous Yorkshire pies. These were encased in thick pastry it time for Michaelmas (29 September) but also to last for weeks. The pastry would have soon gone stale but it was not meant to be eaten; it merely served as a lid that to lift off when the pie was served and afterwards replaced to protect and preserve the meat. Farming techniques may have improved over the years, but the theory of harvest is the same. What really stands out in the first photograph is just how precisely the farmer ploughs his fields. As for the second photograph – (*right*) what caused the farmer to lose his concentration and create a wiggly line?

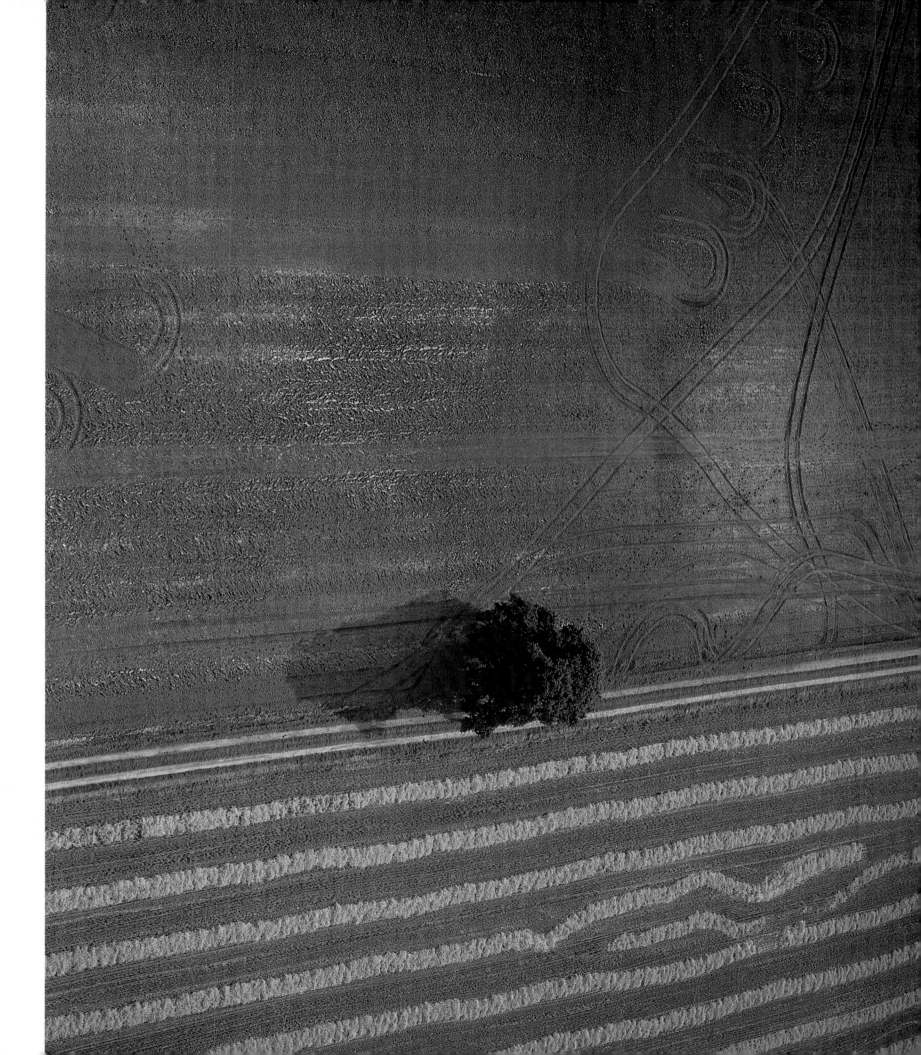

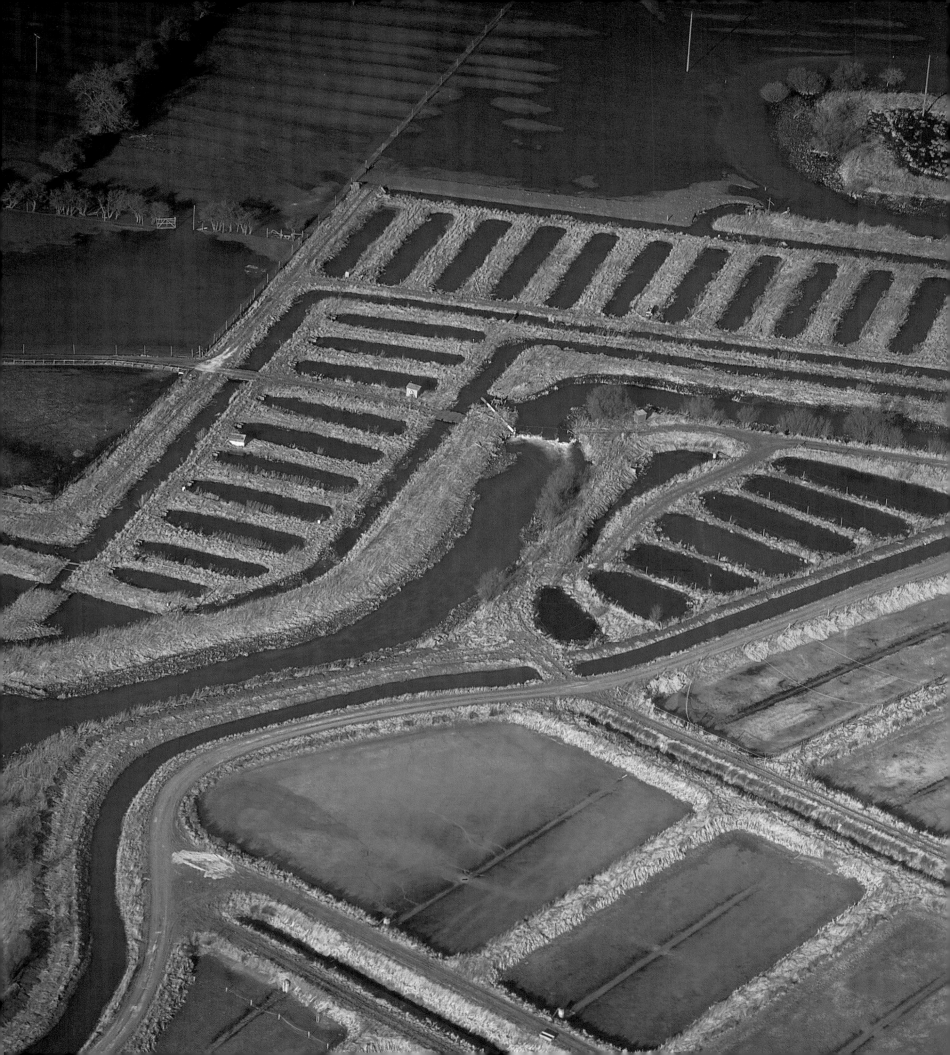

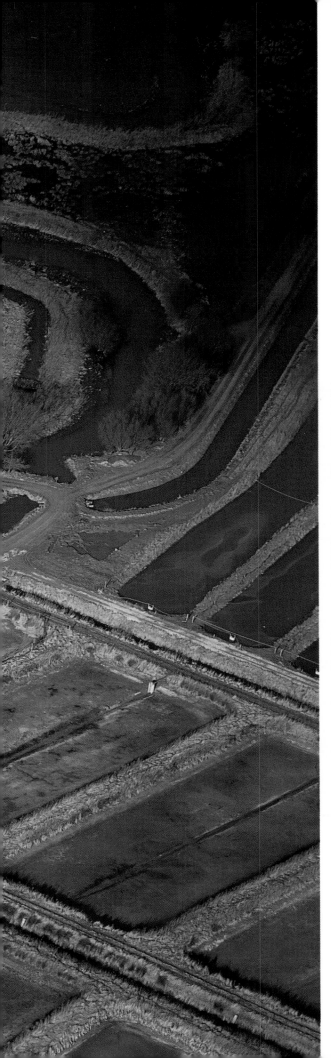

FISH FARM NEAR SKERNE

Left Fish farms are now thriving in Yorkshire despite the fact that the 150 years of pollution caused by the Industrial Revolution killed so many fish in the rivers. The aims of these fish farms are to achieve 'profitable production, efficiency of natural resources, best aquatic environmental practice and a way forward to keep pace with world aquaculture consumption without compromising the overall ecological integrity of ecosystems.'

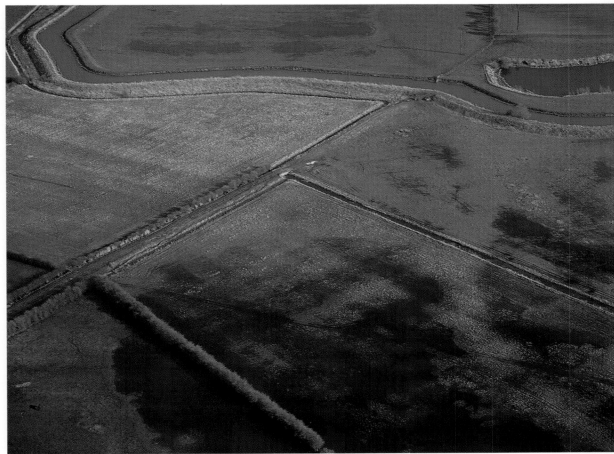

FLOODED FIELDS NEAR BRIGHAM

Above Flooding has long been an all too common occurrence in Yorkshire and can have extremely damaging effects on people, animals and the environment. With such a high saturation of water, these fields become a squelchy swamp that wreaks havoc with crops and wildlife. The plains around Brigham ensure a susceptibility to flooding but luckily for the villagers, Brigham sits on a rise and misses out on the worst effects of the water.

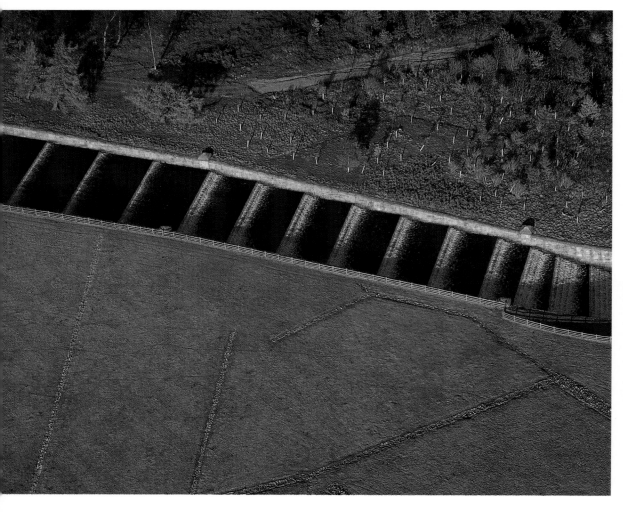

LEIGHTON RESERVOIR

Above In Yorkshire you can truly believe that so much of the world is covered with water, as the elements mix in a way quite unlike other parts of the United Kingdom. There are no serene lochs, like in Scotland, and no gentle lapping of the waves, as in parts of southern England. Instead the water is more unpredictable, flooding whole regions or biting violently into the ever-eroding coastline. Sometimes it is easy to tame the water, such as at Leighton Reservoir where the water playfully trickles down the staircase in a series of mini-waterfalls. On other occasions it disappears from view entirely and reveals unexpected sights.

THE RIVER HUMBER

Right The tide is out on the Humber Estuary, the silt beneath is wrinkled and soft and the pipes running along its length look like a railway track.

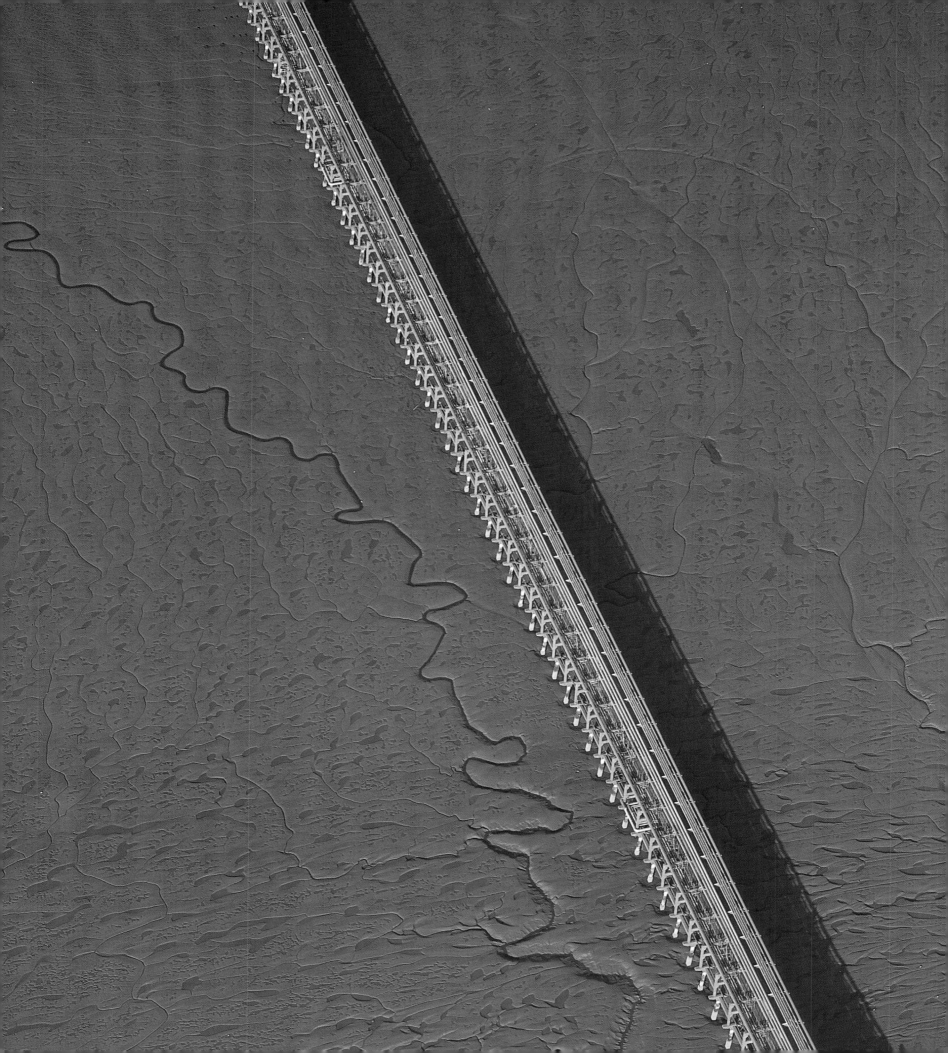

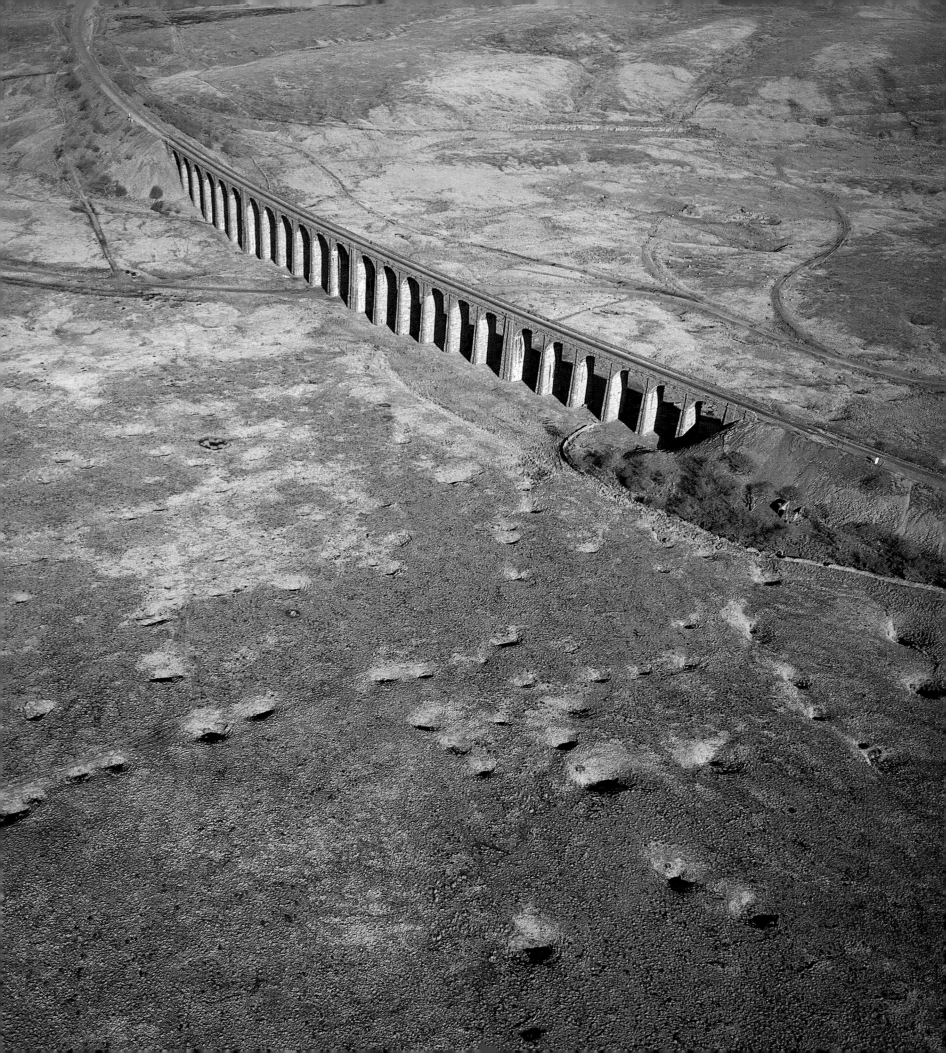

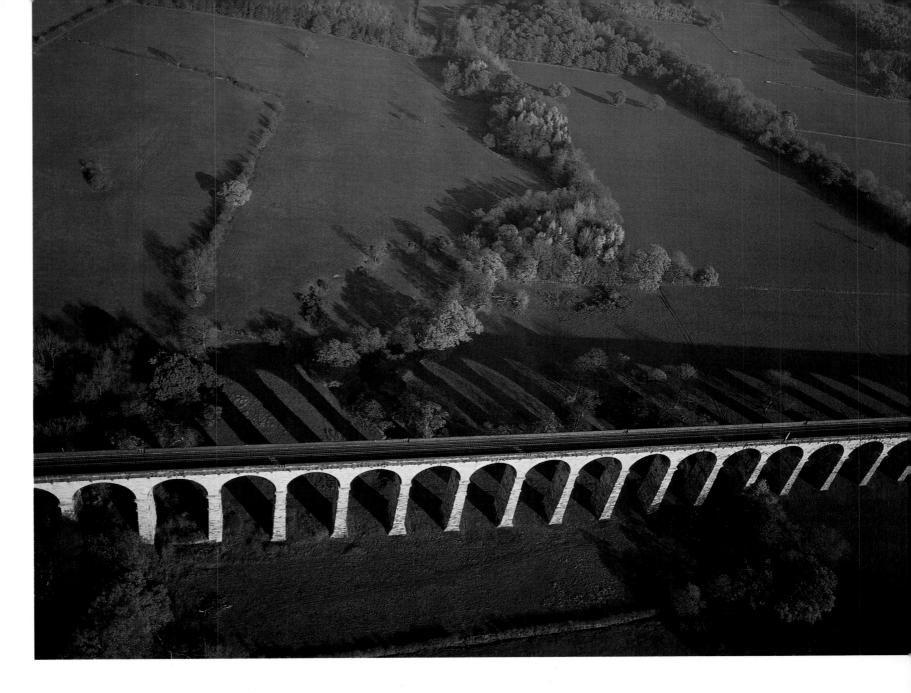

RIBBLEHEAD VIADUCT

Ribblehead Viaduct is often honoured with the acknowledgement that it is one of the most beautiful sights on the Settle to Carlisle line. Surrounded by the Three Peaks of the Yorkshire Dales – Pen-y-Ghent, Ingleborough and Whernside (see page 33) – the viaduct has 24 arches, crosses Batty Moss 31m (104ft) below, is 402m (440yd) long and took five years to build. During the construction, 2000 people (mostly navvies) lived in filthy conditions at Batty Green. Gambling, fighting and drinking were the main recreations and one navvy reportedly sold his wife for a barrel of beer. As it is one of the remotest and wildest areas in Yorkshire and one prone to severe weather conditions, it was the most difficult section of the line to be built. In 1938, Ribblehead became a meteorological report point and the stationmaster and staff received special training to compile and send hourly reports on weather conditions. Nonetheless, it was not unheard of for signalmen to get blown off the embankment and during the war, a train carrying vehicles was pushed over by the force of the wind.

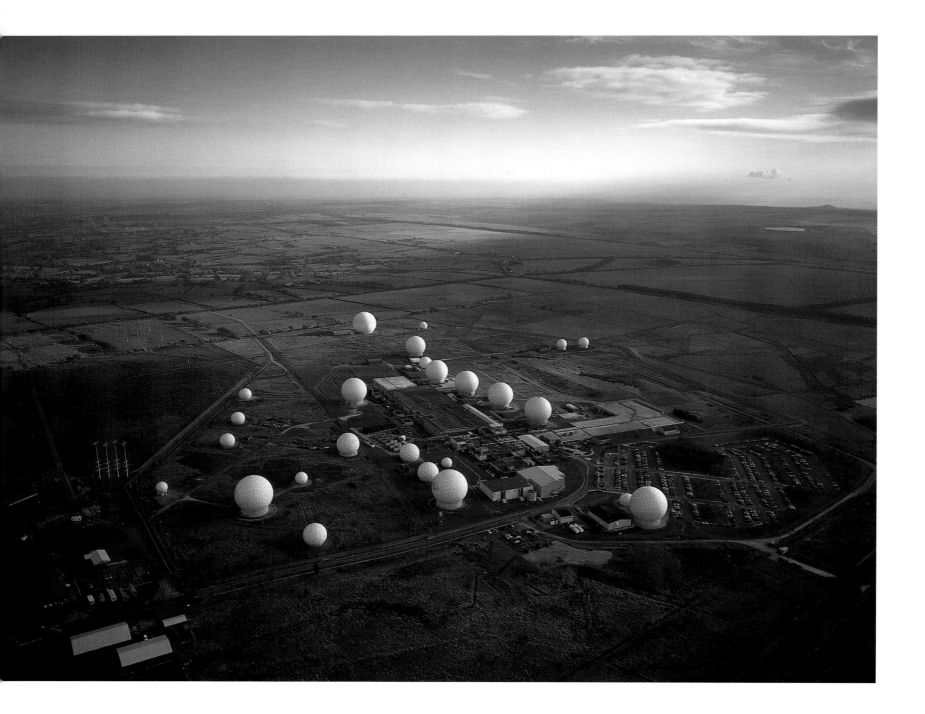

MENWITH HILL

These bizarre pods rising from the ground are part of the 560 acres that belong to the American listening station known as Menwith Hill. The land is owned by the British Ministry of Defence who have allowed the United States government to use it since 1951, although the site only became operational in 1959. This base was first established to intercept radio signals and it primarily focuses on Europe, northern Africa and western Asia. The reason for this is that satellites, responsible for communications in these areas, are not visible from the United States, but are from Menwith Hill. There is a shroud of secrecy over the activities at the base, and many people protest against its existence, citing violation of civil liberties and lack of accountability as reasons for shutting it down.

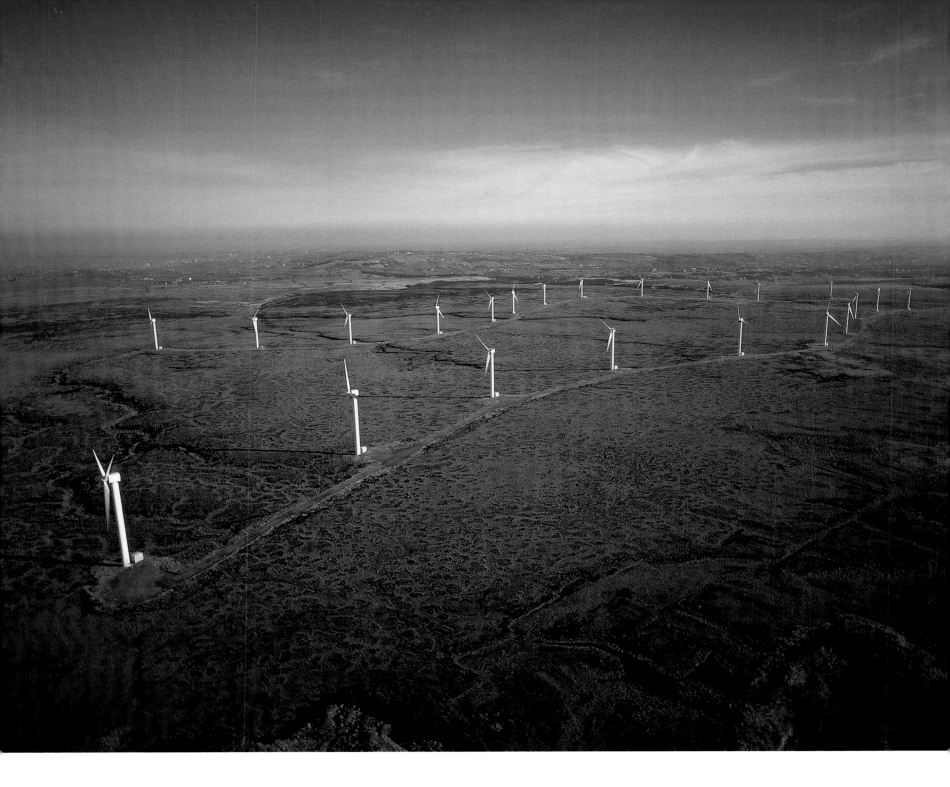

WIND FARM, NORTH OF WROOT

With key words of the twenty-first century including environment, protection and renewable, wind farms are one way to make efficient use of an energy source that is all of the above. Aesthetically speaking, they have caused some controversy and have been damned as a hideous intrusion into the landscape. However, given that global warming and its effects are now an everyday reality, the need to cut down on emissions from coal, oil and gas-fired power stations is paramount. Far from it all being doom and gloom, not only are all British political parties committed to working towards providing ten per cent of the United Kingdom's electricity supplies from renewable sources by 2010, but also the United Kingdom currently has the best wind resource in Europe.

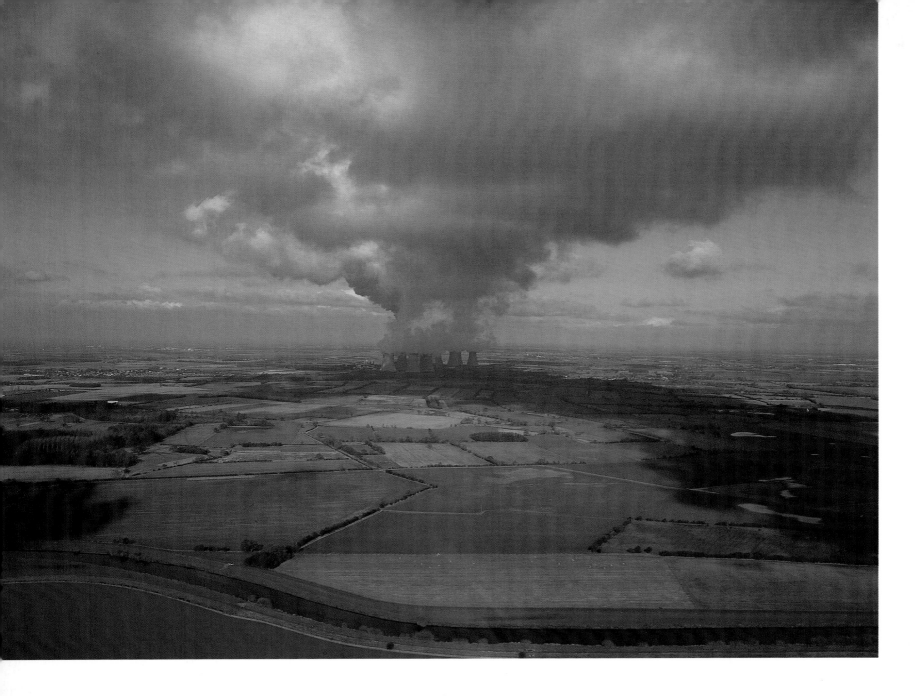

Drax Power Station

This amazing photograph demonstrates clearly just how all-encompassing the emissions from power stations can be. After a *Lancet* report discovered that children born near toxic landfill sites were more likely to have birth defects, Friends of the Earth started to campaign for a reduction in pollution from many factories. The Environment Agency has also seen a need to reduce emissions, and has cut allowable emissions of sulphur dioxide at a number of factories, including this one, in an attempt to reduce the rate of global warming. On a different level, these two photographs show just how much the landscape can change with the weather. In the first photograph, the power station overlooks acres of green fields; in the second, these fields have been transformed into a vast lake as a result of flooding in November 2000.

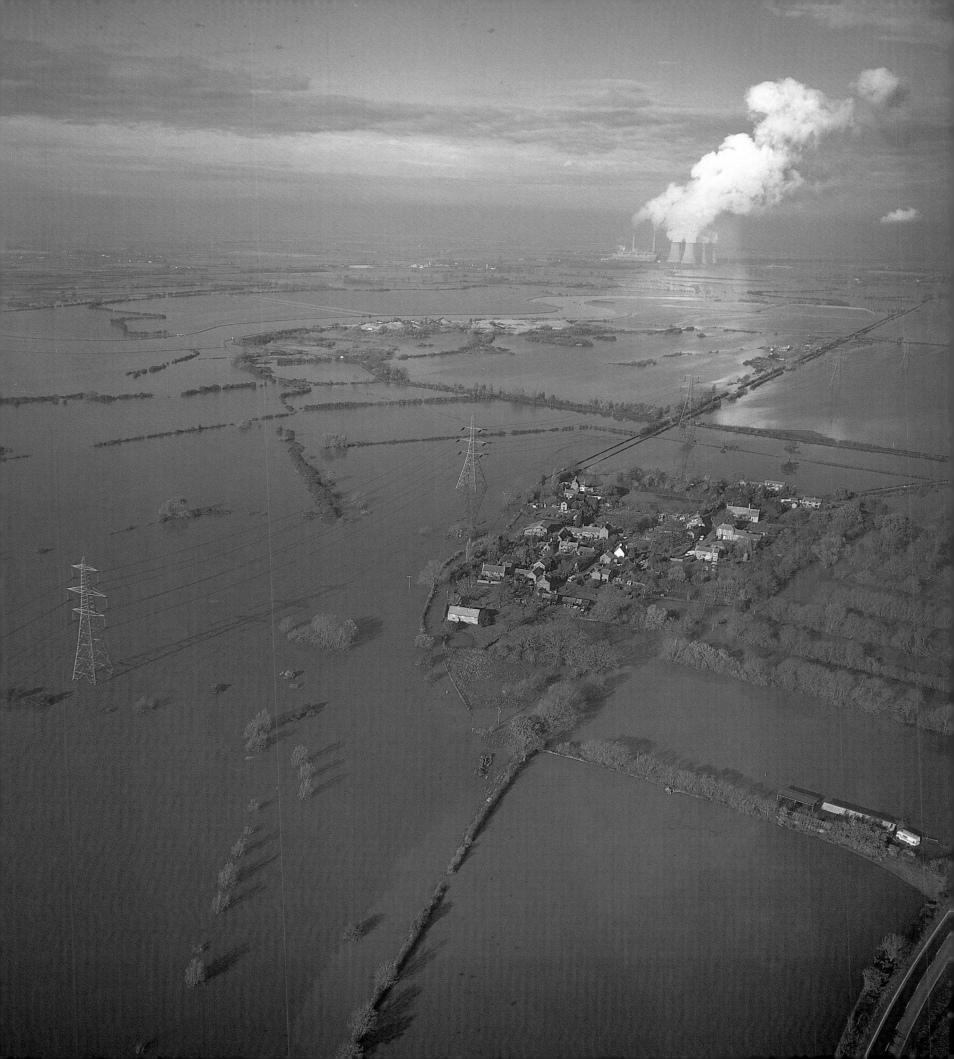

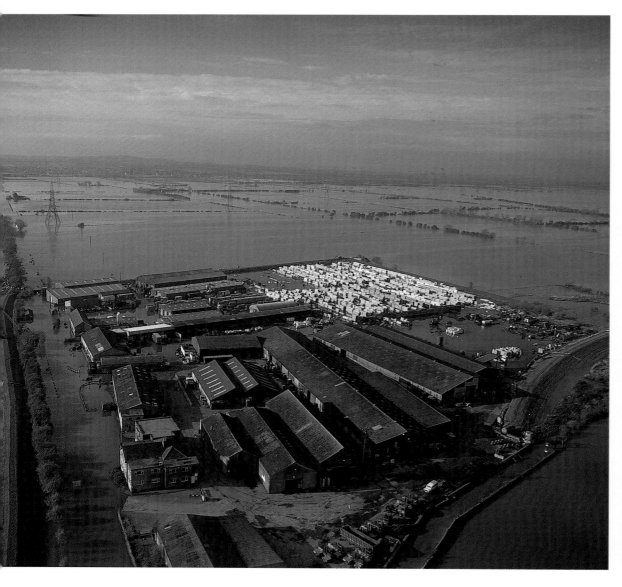

FLOODING NEAR RIVER OUSE

Yorkshire is particularly susceptible to flooding, which can be caused by rainfall, melting snow, even tidal surges or a combination of all three. Some places suffer more than others; for example, the 30-mile flat plain of the Vale of Pickering is poorly drained and so it is especially liable to flooding. The effects of flooding are widespread and can be devastating. More than just an inconvenience, floods can cause people to lose their possessions, property and in the most severe conditions, even their lives. Furthermore, flooding can have harmful effects on the environment, ranging from river bank erosion, the pollution of water courses and spread of disease to the loss of crops and livestock. The exceptional autumn rainfall, which brought about these floods in November 2000, was widely attributed to global warming.

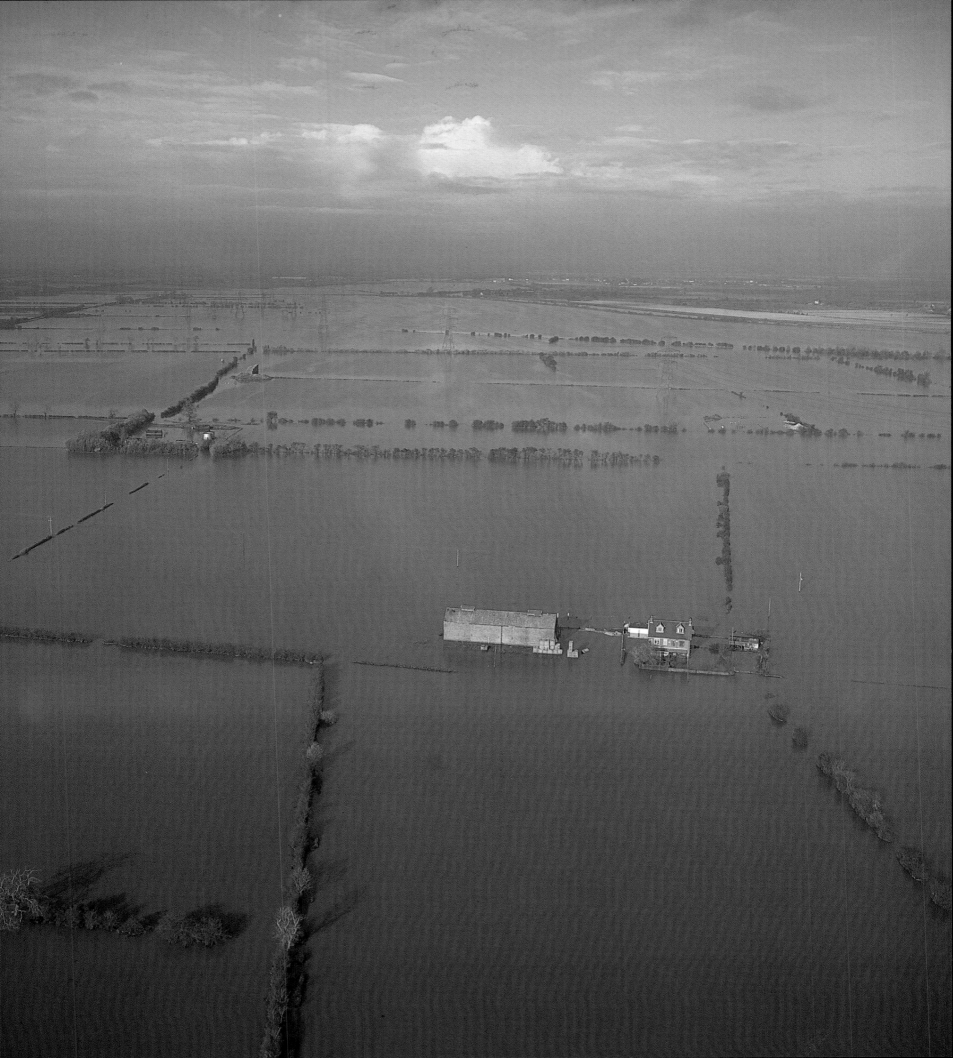

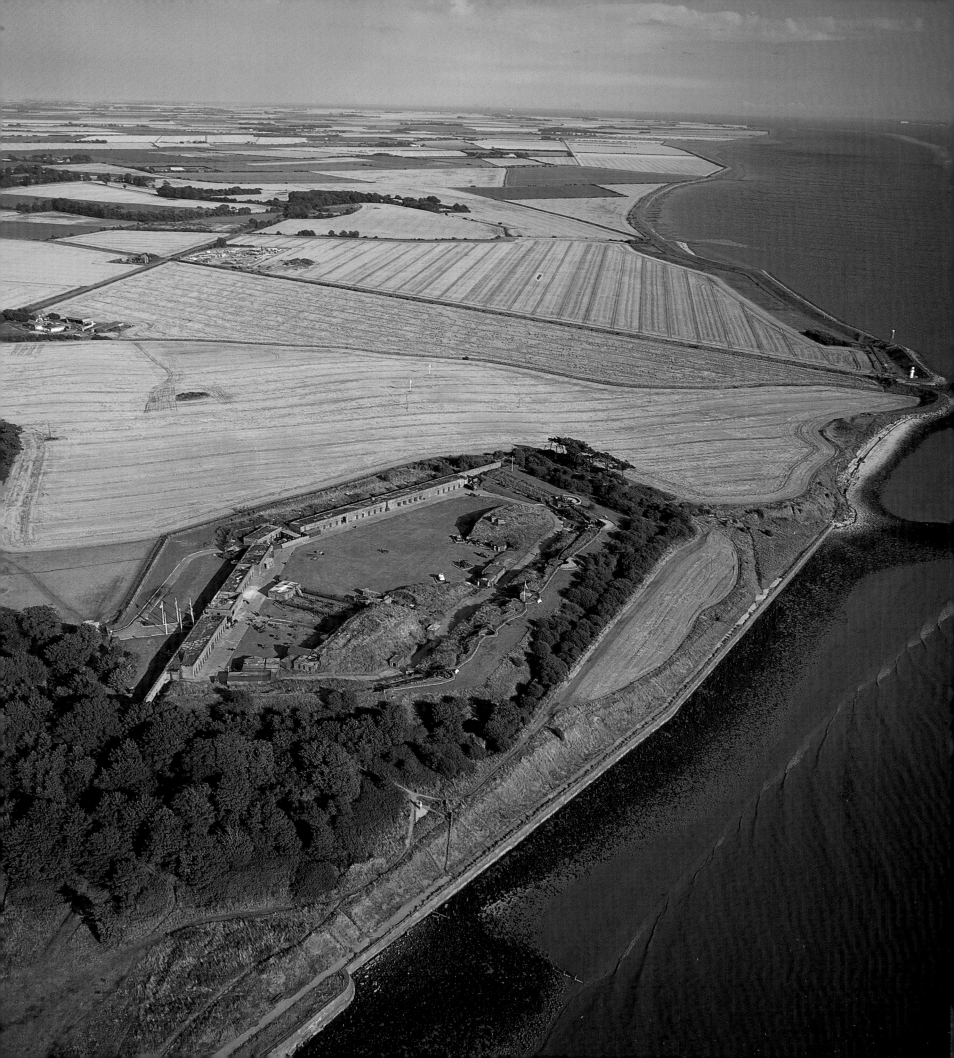

COASTLINE

ANY YORKSHIRE VILLAGES that were documented in medieval times are already known to have disappeared completely. The reason, for once, is not the fault of man. Rather it is the continuous attack of the sea that pounds violently against the coast and takes chunky bites out of the shoreline. The coastline of Holderness is particularly vulnerable to this effect and is in a state of almost constant flux, as the crashing waves of the North Sea destroy the cliffs at a rate of around 1m (1yd) each year.

The tranquillity of the sand and pebble beach at Spurn Head, and the fact that it has been designated as a Nature Reserve by the Yorkshire Wildlife Trust, belies the fact that it has a treacherous past with ships. Perhaps the only clue is that Spurn Head has the only lifeboat station that is permanently manned by a crew. Of course, there was also a lighthouse here, but today the only light is a flashing green starboard one on the end of the point and fixed green lights at the end of the pilot's jetty.

Of the remaining coastal villages, many have less than respectable pasts. Here, as in other parts of the coast, smuggling was profitable business, especially in the eighteenth century. Fishing villages, such as Robin Hood's Bay (see page 114), provided ideal landing spots for illegal cargo and the premium trade was in tea, spirits, silk and lace.

But Yorkshire does also have a more reputable relationship with the sea. Its great maritime history is neatly encapsulated in the story of one of the region's most famous sons, the explorer Captain James Cook. He is most closely associated with Whitby, as it was from here that he first set sail in 1747. Later, as a Royal Navy Officer, his famous ships, *Endeavour*, *Resolution*, *Discovery* and *Adventure*, were also built in Whitby.

The uses of the sea extend further than this, however. For hundreds of years, the Yorkshire coast has played a major part in millions of people's lives. From fishing for food, to ship building to tourism and watersports, the water here is much more than just a feature of Yorkshire topography.

FORT PAULL OVERLOOKING RIVER HUMBER

Left From at least 670, the site of the present Fort Paull was the prominent point of the major north/south frontier of the *Humbrenses* or 'people of the Humber' – an obvious choice for Henry VIII as a defensive fortress.

FISHING TRAWLER

Above Fishing trawlers are not an unusual sight in this part of the world that has long been famed for its extensive seafaring activities.

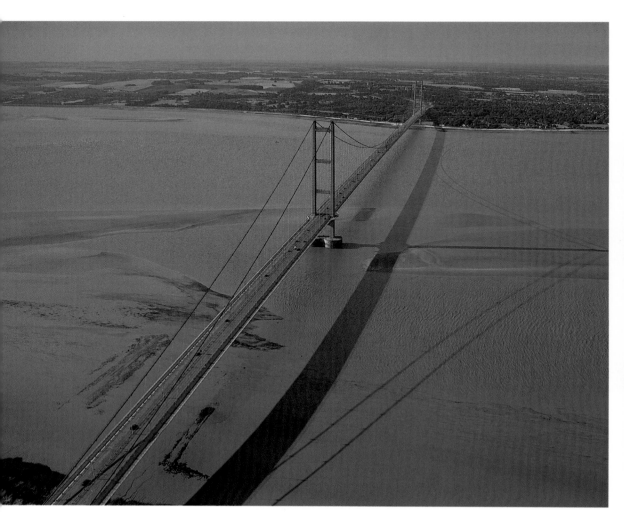

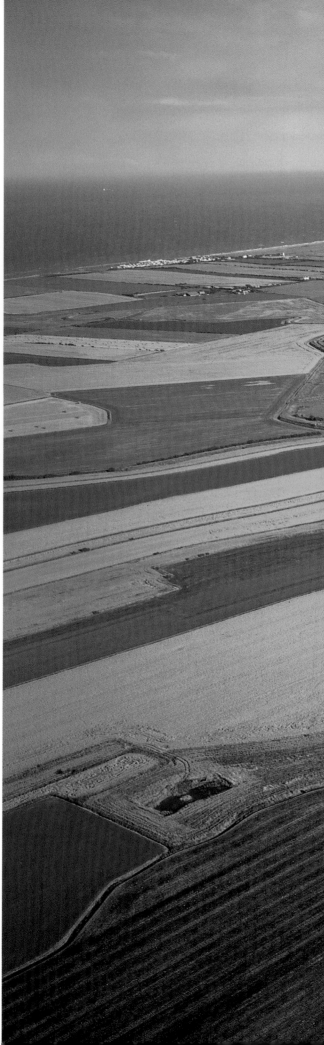

HUMBER BRIDGE

Above Developed out of the design initially used for the Severn Bridge near Bristol, the Humber Bridge was deemed necessary to cross the last major unbridged estuary in Britain. Construction of the suspension bridge began in 1972, funded by loans from the government. Although estimated to cost £28 million, adverse weather conditions, inflation and loan costs saw the total shoot up to a staggering £151 million by the time the bridge was opened to the public in 1981. Toll income generated around £18 million last year, and the debts are set to be repaid by 2032. Unfortunately, the bridge is only designed to have a 120-year lifespan, leaving 60 years before it will all start again.

LOOKING OUT TO SPURN HEAD, EAST OF HULL

Right The east Yorkshire coast curves in a gentle arc between the cliffs of Flamborough Head in the north and then bends inland to the unique shape of Spurn Head. A finger-thin isthmus measuring 3½ miles long and only 50m (105ft) wide in places, Spurn Head has evolved over many centuries as a result of the erosion of the Holderness coast and the mercilessness of the North Sea. As the coastline has receded, towns and villages have literally disintegrated and others, like Kilnsea, have had to move.

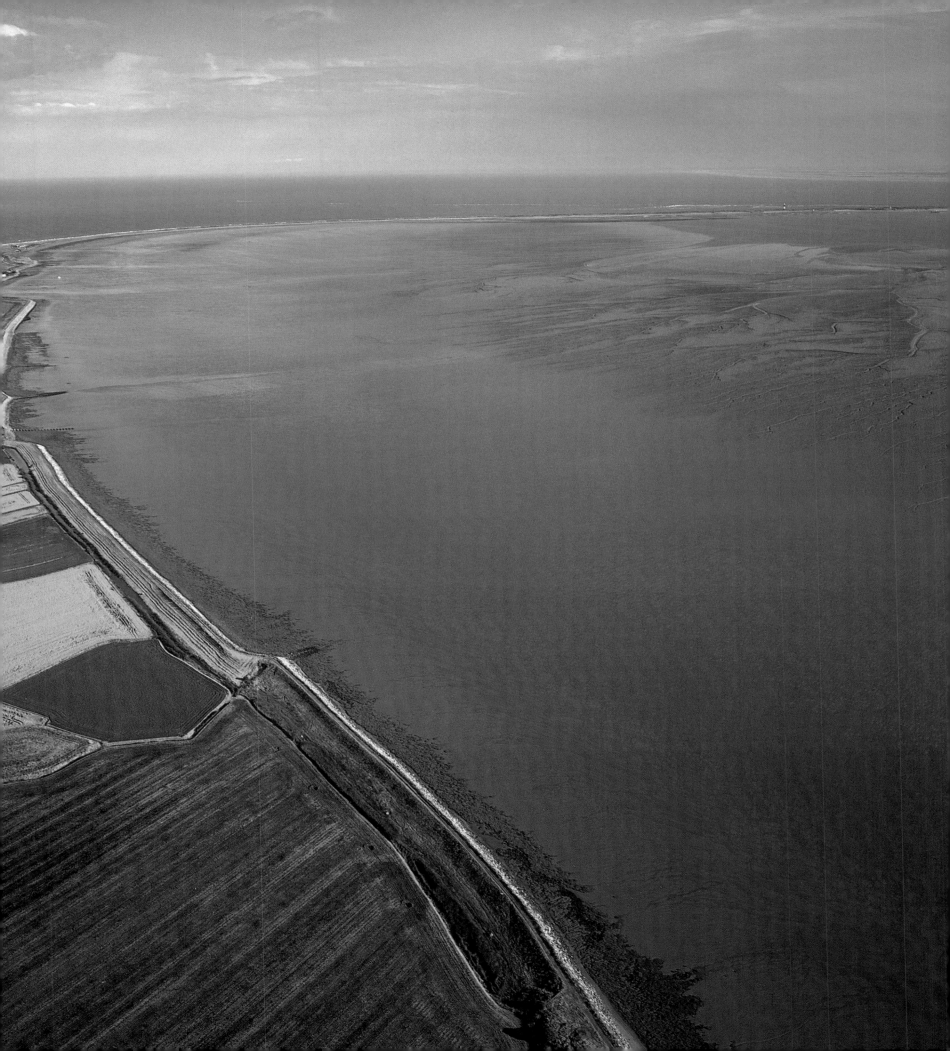

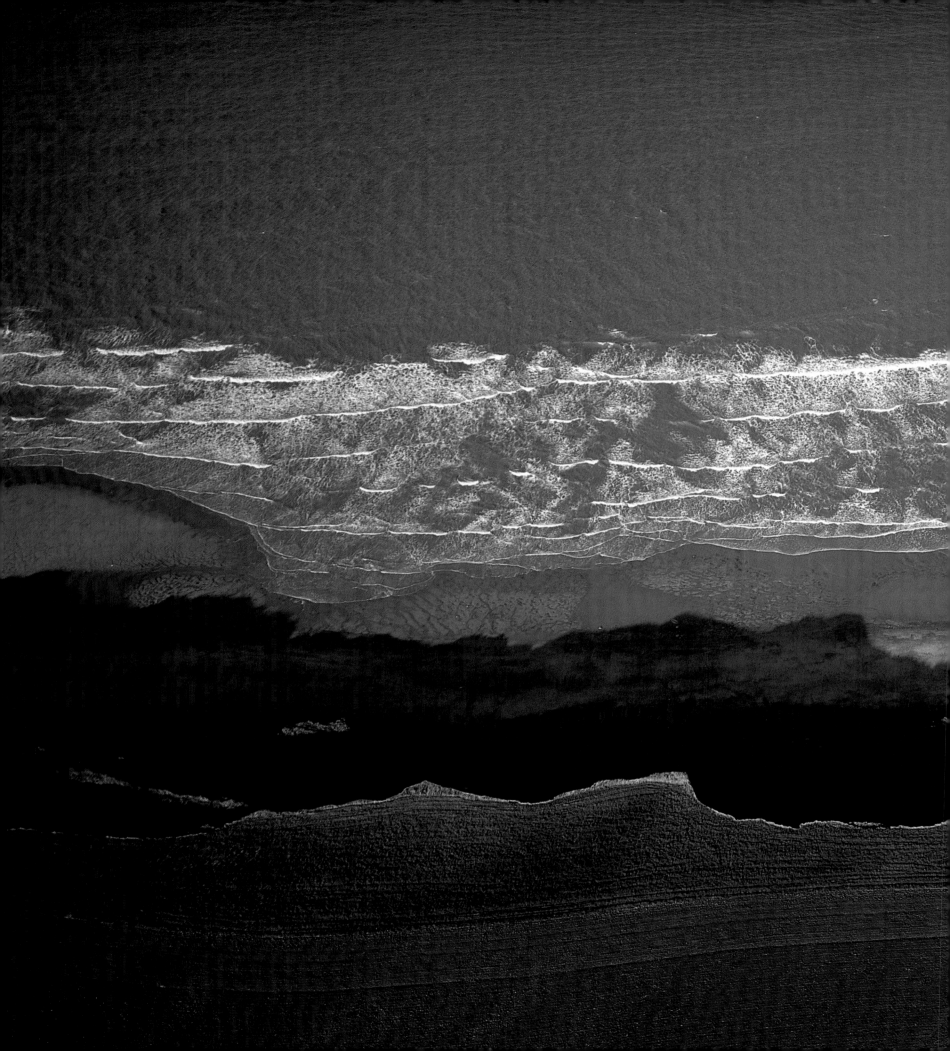

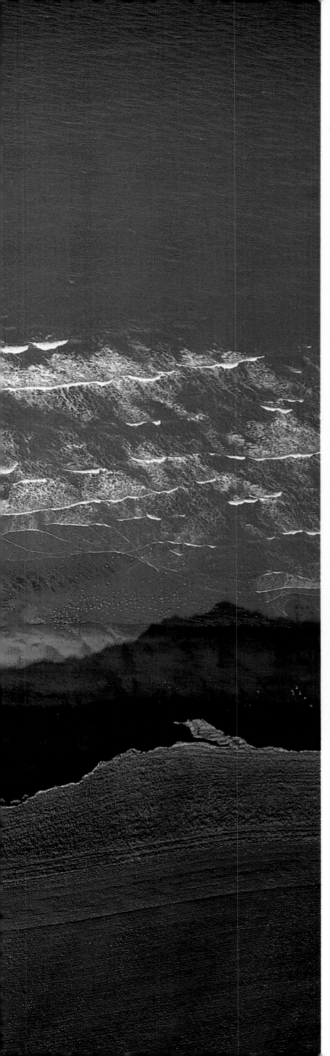

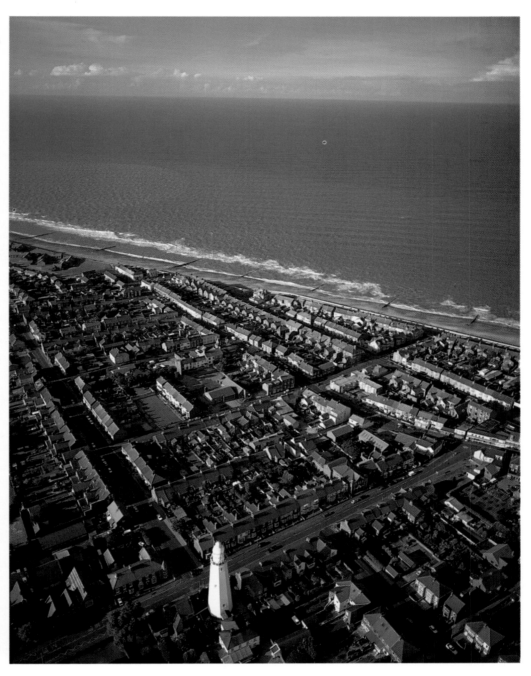

WITHERNSEA

Spurn Head may be the stretch of coastline most effected by erosion, but it is not the only part. The incessant motion of the North Sea is eating away at various parts of the coast and its effects are seen here just north of Withernsea (*above*). Withernsea itself is a pleasant seaside resort that benefited enormously from the opening of the railway line in nearby Hull. Two of its most prominent features are the stump of a castle on the sea front and a lighthouse (foot of the photograph) dedicated to Withernsea's most famous daughter, the actress Kay Kendall.

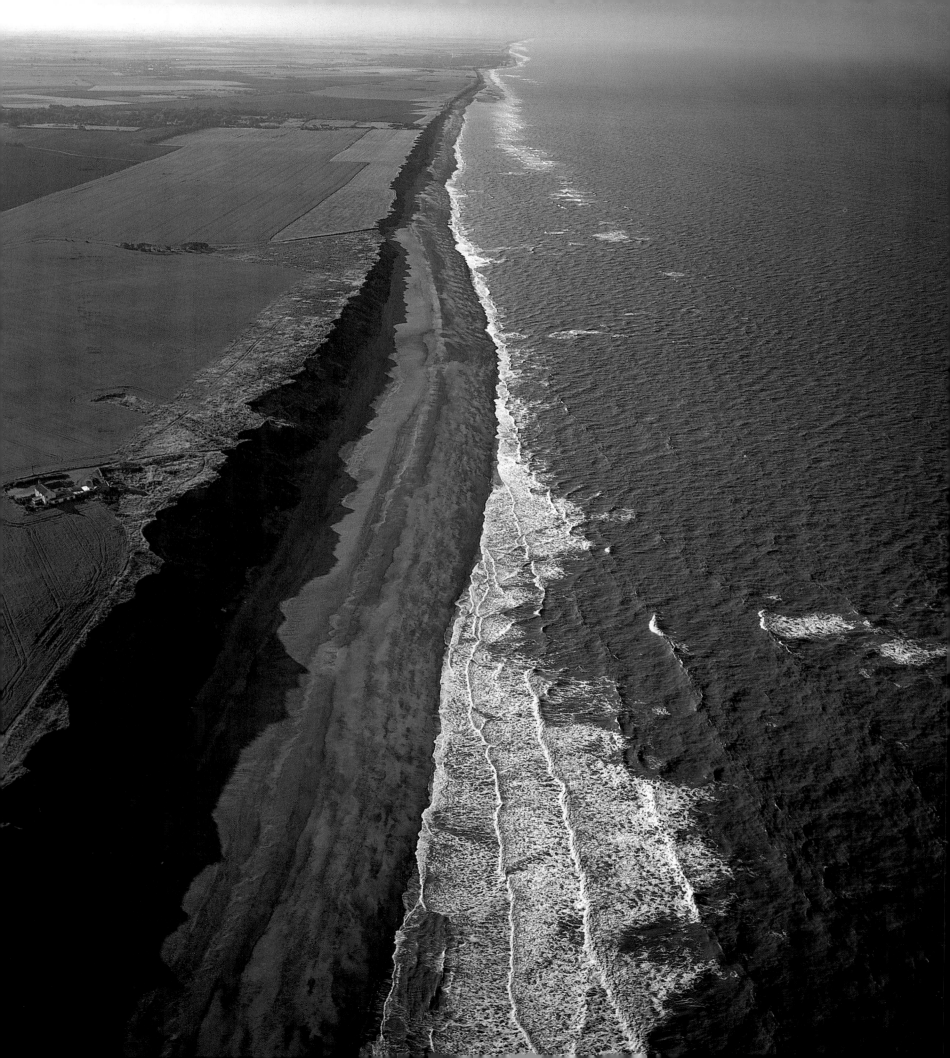

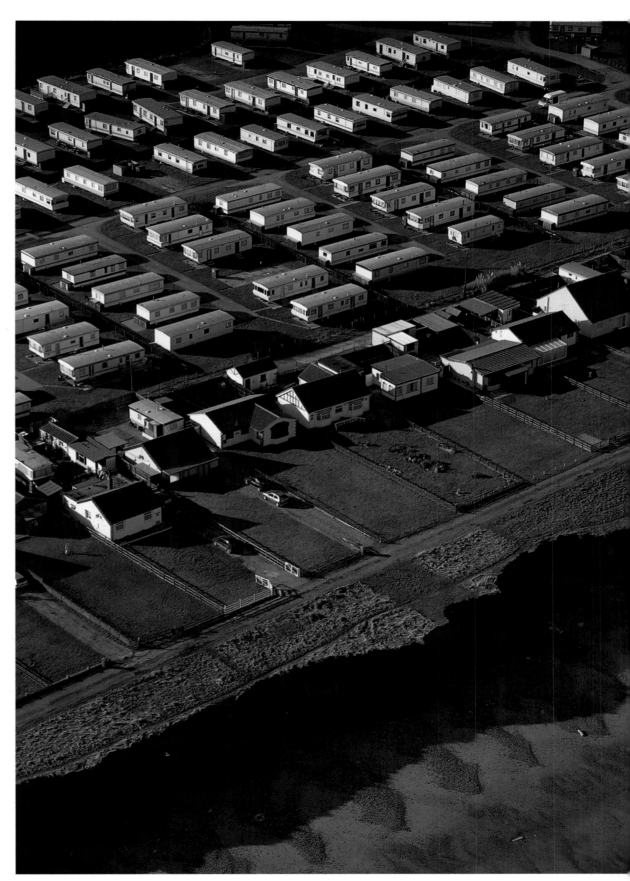

LOOKING NORTH TOWARDS HORNSEA

Left A few miles further on to the north, just out of sight in this photograph, is the lively seaside resort of Hornsea. Packed with tourists each summer, who might take part in the water sports, mini-golf or great bird watching that the area has to offer, no one would guess that just a couple of miles south there could be a stretch of coastline that looks so totally deserted. The single house in the midst of so much open countryside might look lost and lonely, or it might represent a welcome escape from the noisy crowds, depending on your point of view.

CARAVAN PARK NEAR ULROME ON THE EAST COAST

Right Ulrome is often described as having a rural feel to it, and many of the houses in the village bear testament to that. Nonetheless, Ulrome's proximity to the seaside – it is less than a mile to the beach – has meant that it has become an ideal location to cater to the holidaymakers who invariably come each summer. To cope with this onslaught, many camping and caravan sites have sprung up over recent years. By the look of things in this photograph, however, the inhabitants of these sea-front houses and caravans will soon have to look elsewhere, as the water is slowly but surely creeping up on them.

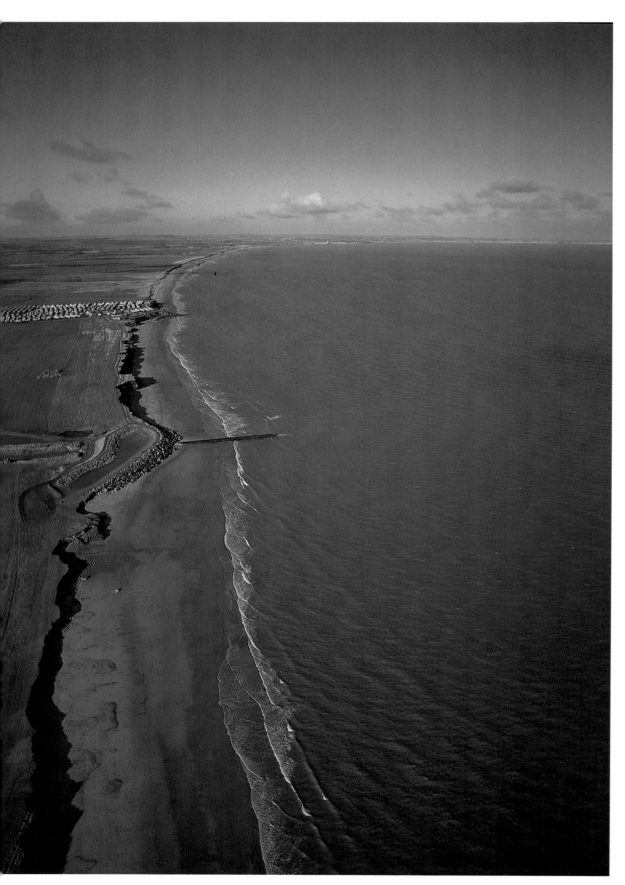

FROM BARMSTON TO BRIDLINGTON

Left Even from the ground, the views both ways from Barmston are stunning and on a clear day you can see for miles up and down the coast. From the air, you can see considerably more than that and this particular photograph looks at a section of coast stretching north towards Bridlington Bay. At Barmston's headland, it is thought that coastal erosion has led to around 2½ miles being shaved off.

BRIDLINGTON BAY LOOKING WEST

Right From this angle, Bridlington Bay does not appear to be too badly whipped by the sea and the shoreline looks relatively straight. What really stands out, apart from the contrast in colours, is the acre upon acre of open landscape beyond the seashore. The sense of emptiness is striking, and there is no major settlement between here and York.

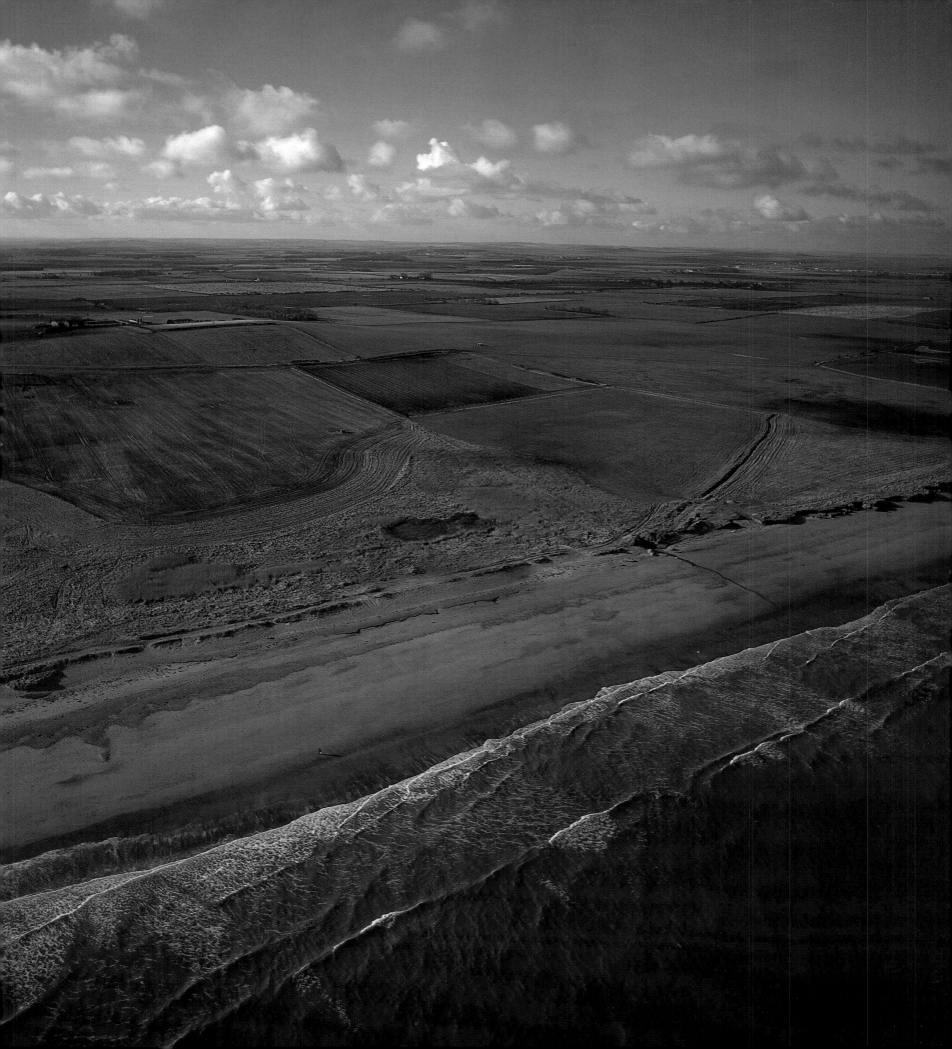

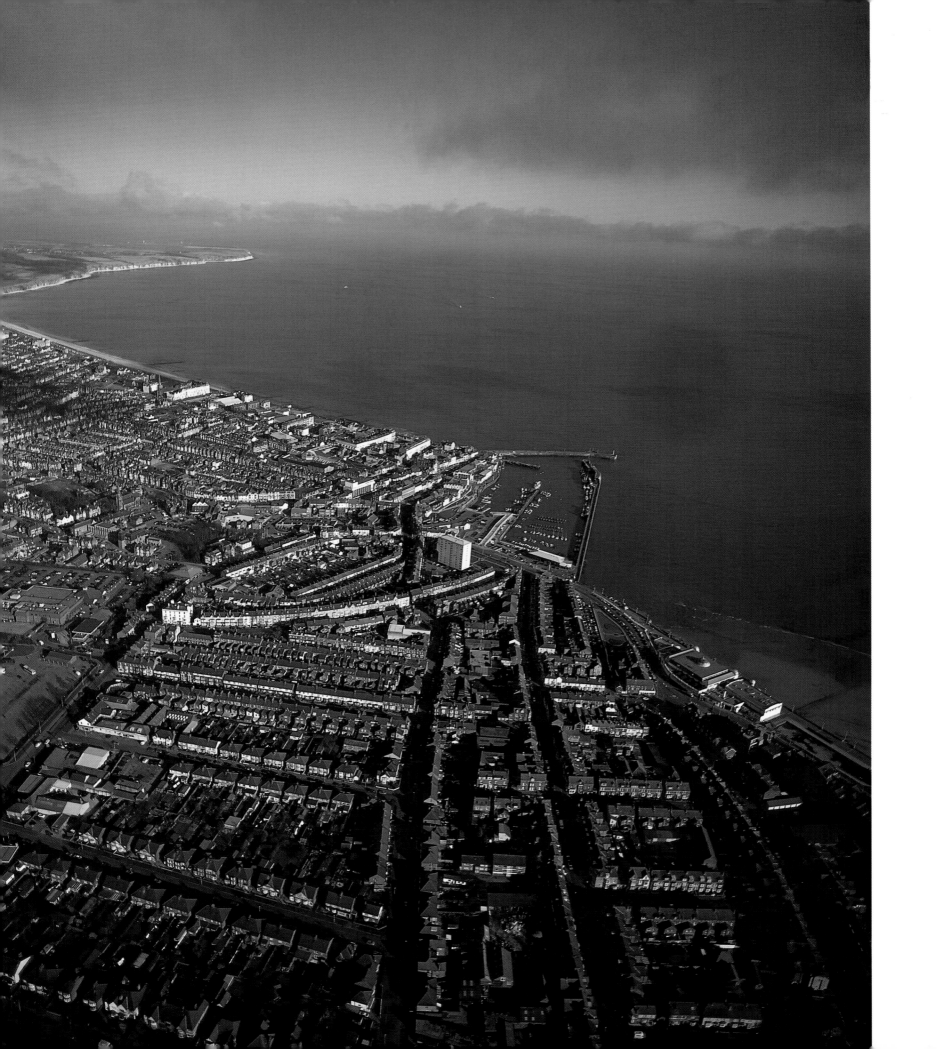

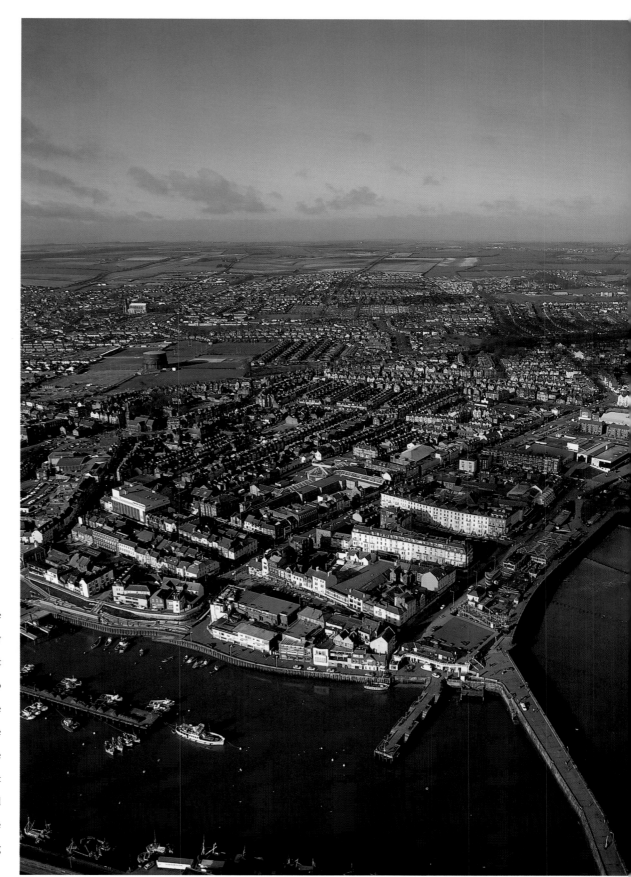

BRIDLINGTON

Bridlington is a popular seaside resort that, to the unbridled delight of many visitors, still boasts a busy working harbour. As well as the brisk fish trade that has always been the town's mainstay, Bridlington also used to export Irish gold to the Continent. The harbour originates from Roman times and was once sheltered by two forts, one to the north and one to the south. The northern pier still houses an ancient cannon and an old ship's anchor. Historically, the old town with its maze of narrow streets is about a mile inland with the community around the harbour being newer and more modern.

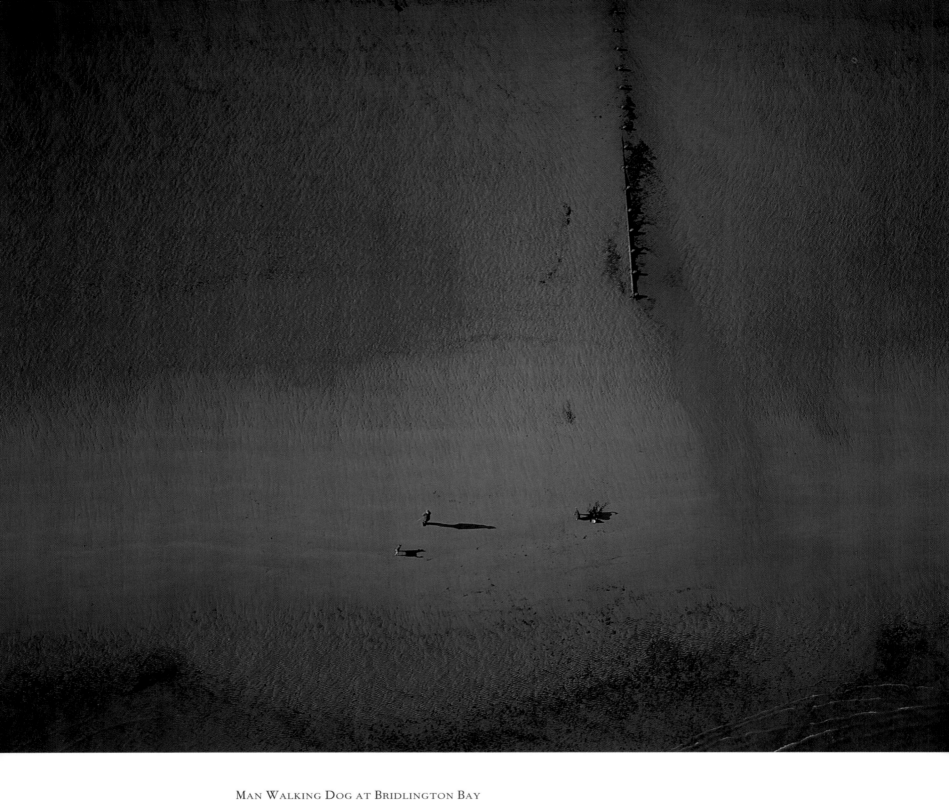

MAN WALKING DOG AT BRIDLINGTON BAY

Walking must be the favourite pastime of those who
live in or visit Yorkshire, and certainly a solitary stroll
along the beach makes a change from the plethora of
different routes you can take across the moors. This is
also one of the only photographs that features a person
and clichéd though it may be to say so, from this bird's-
eye view, he really is as small as an ant.

Gulls on Bridlington Bay

Anyone who has ever visited an English holiday resort will be able to recall the evocative squawk of a gull's cry that invariably accompanies such an event. More than one gull 'singing' at a time and the noise is something akin to a group of wailing banshees, so you can imagine the noise these birds would make. Around this particular part of the coastline, gulls are not the only types of bird you are likely to see or hear. Just up the coast is the RSPB reserve at Bempton Cliffs. A huge number of seabirds colonize the chalk cliffs including puffins, kittiwakes, guillemots and England's largest colony of gannets.

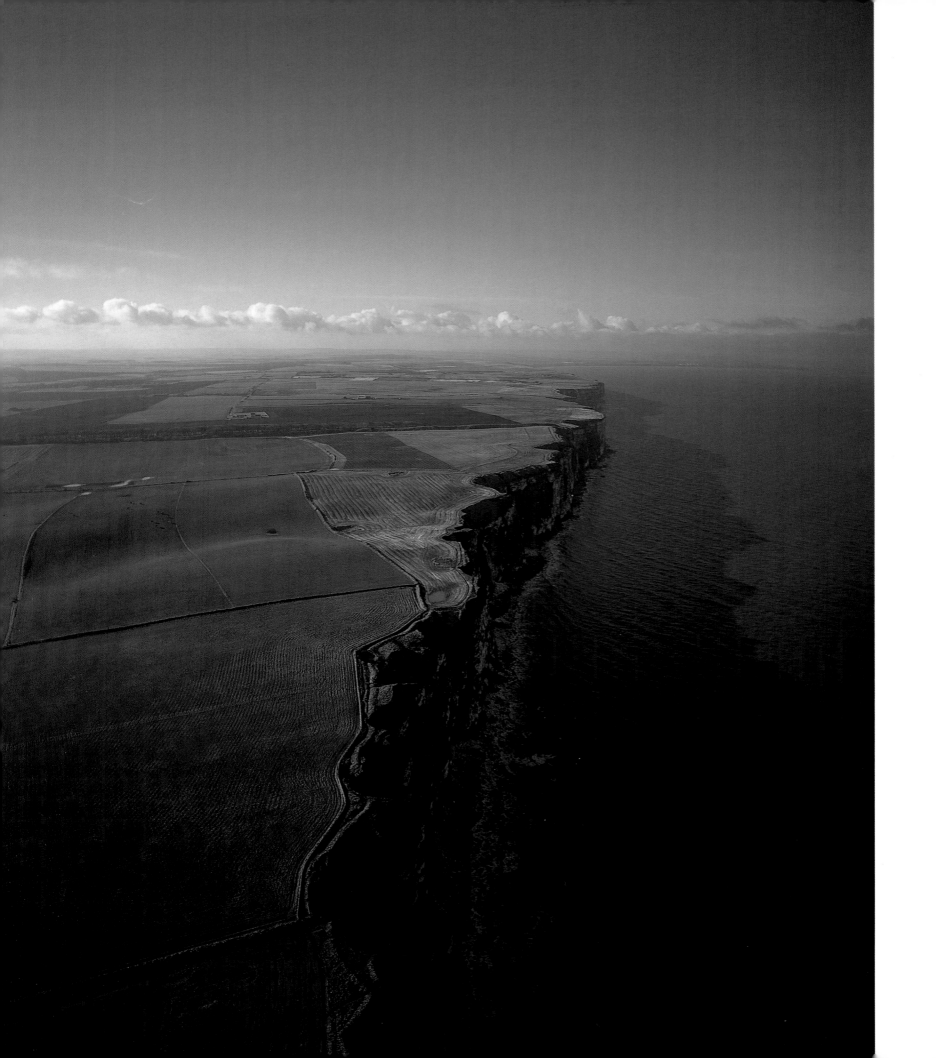

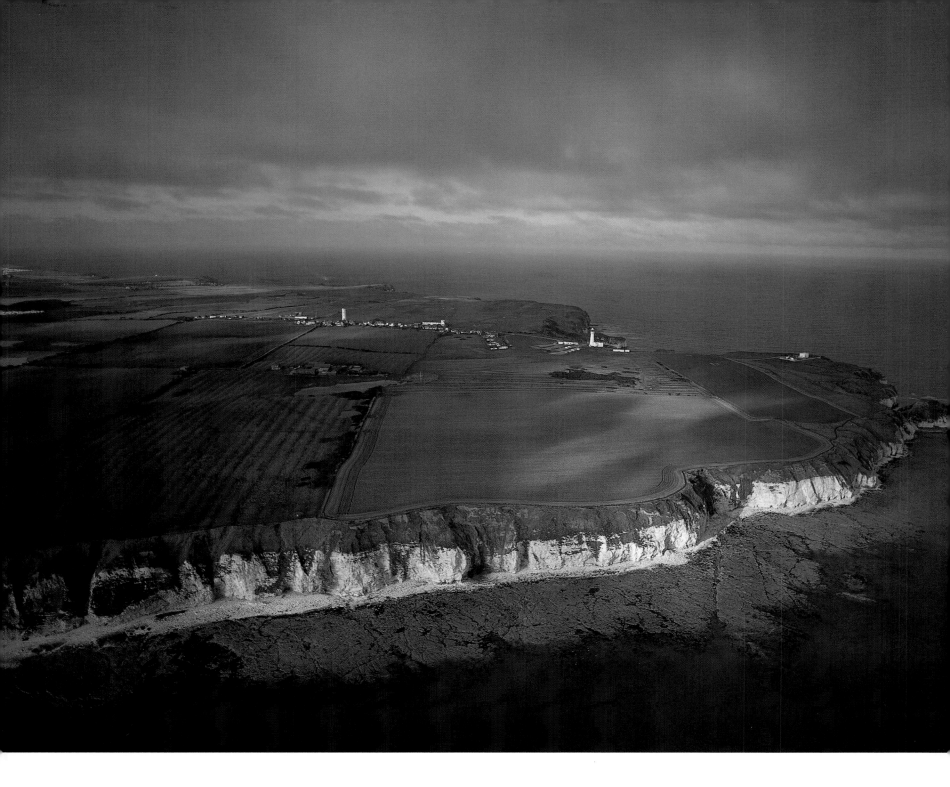

North Cliff

Left North of Flamborough, these cliffs have been subjected to the same constant thudding of the sea. Just east of here is Thornwick Bay, a beautiful rocky inlet, which shelters the Smugglers' Cave. The water never leaves the cave, even at the lowest tides, and consequently the cavern can only be entered in a boat.

Flamborough Head

Above Flamborough Head is probably the best-known area around Bridlington. On the ground you cannot fail to notice the noise of hundreds of kittiwakes nesting in the cliffs, but from the air the two lighthouses of 1806 and 1674 are particularly prominent. Flamborough Head is almost cut off from the mainland by Danes Dyke, a large ditch and bank that runs straight across it. Situated right on the 'nose' of Yorkshire, Flamborough Head has suffered from the pounding of the sea against the cliffs, which has resulted in a plethora of rocky bays and caves.

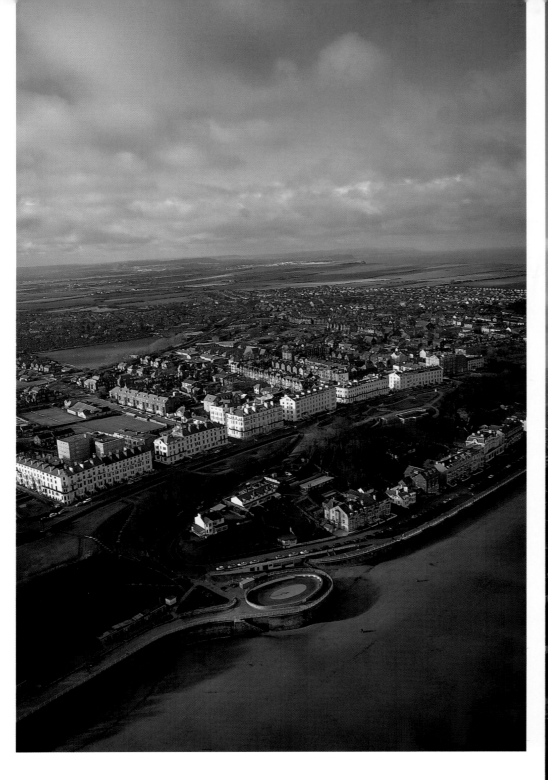

FILEY

Above Filey is often overshadowed by its larger neighbours, such as Scarborough and even Bridlington, but nonetheless it is a popular holiday resort in its own right. The resort is framed by a great sweep of cliff, which ends beneath the headland, at a ridge of rocks called Filey Brigg.

SCARBOROUGH

Right The twelfth-century castle, on the site of a Roman signal station, stands on a headland between the two bays of Yorkshire's premier seaside resort. In the seventeenth century, Scarborough became a spa resort.

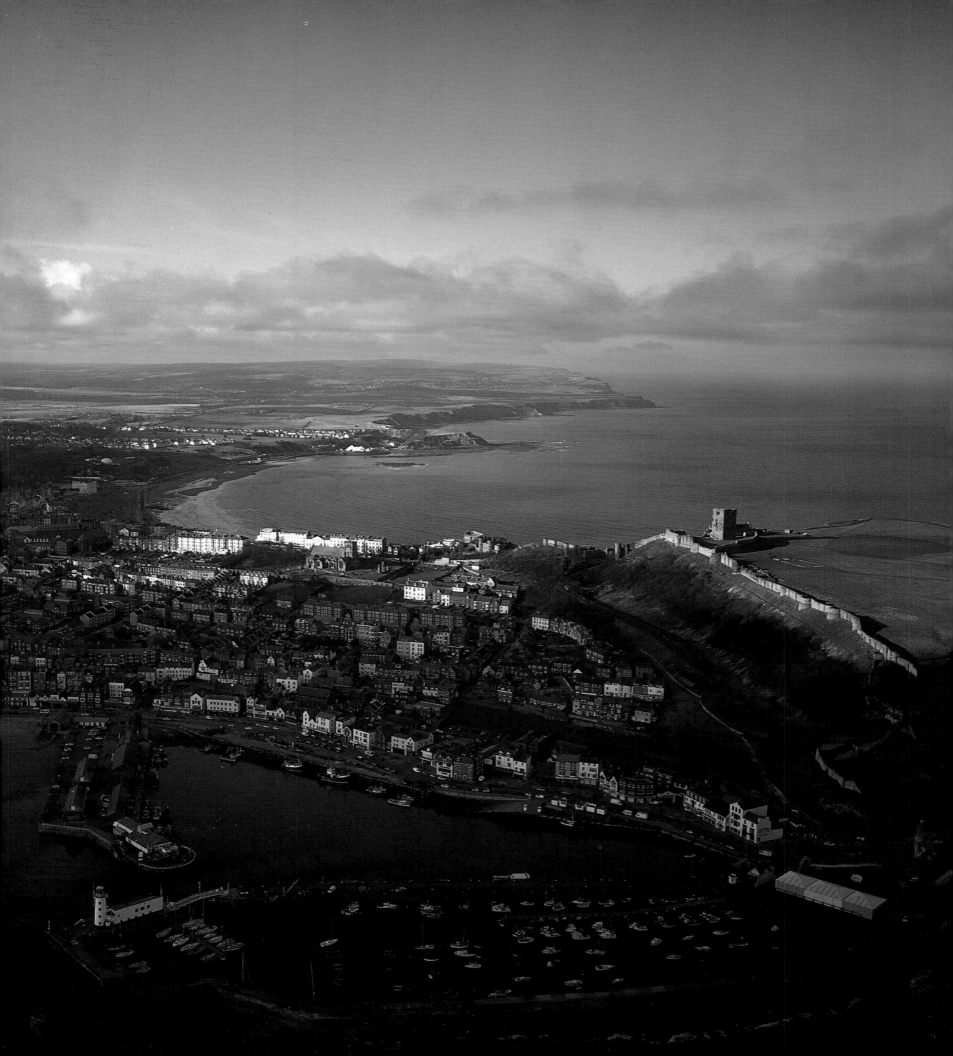

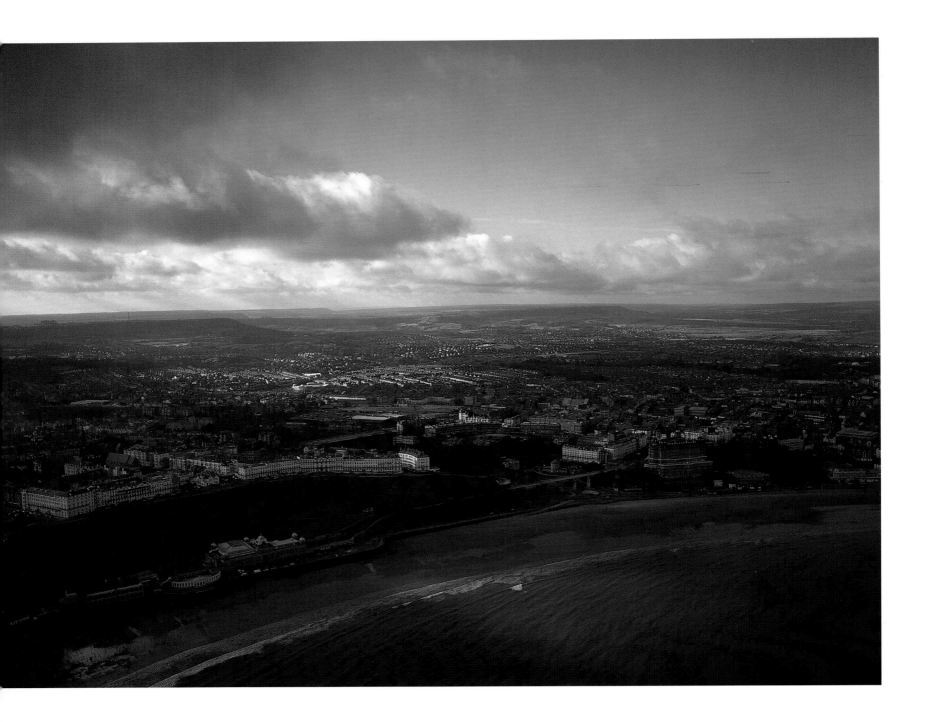

SCARBOROUGH

Scarborough put itself on the map in 1626, when a certain Mrs Farrow discovered a type of acid water originating from the south of the town. Over the next 100 years, doctors proclaimed the water could cure at least 30 different ailments including 'melancholy and windiness', and royalty and other visitors flocked to the area. By the end of the century, a new spa sanctuary had been built, and a radical new treatment was offered – bathing in the sea. As well as this miracle water, Scarborough also had a prosperous harbour. It quickly became a major part of the North Sea trade with Germany and Scandinavia. In 1845, the railway arrived , bringing holidaymakers en masse, but surrounding industry played a bigger part in the economy in the twentieth century as sea trade declined.

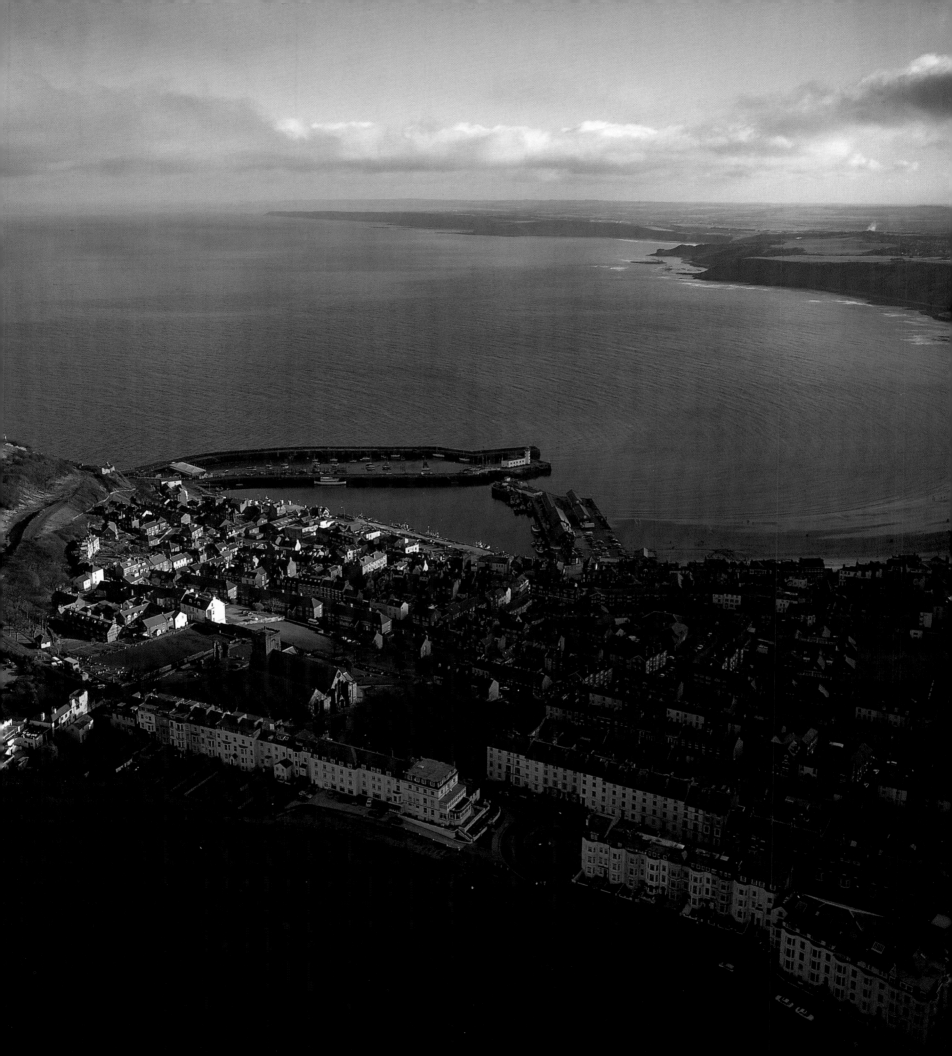

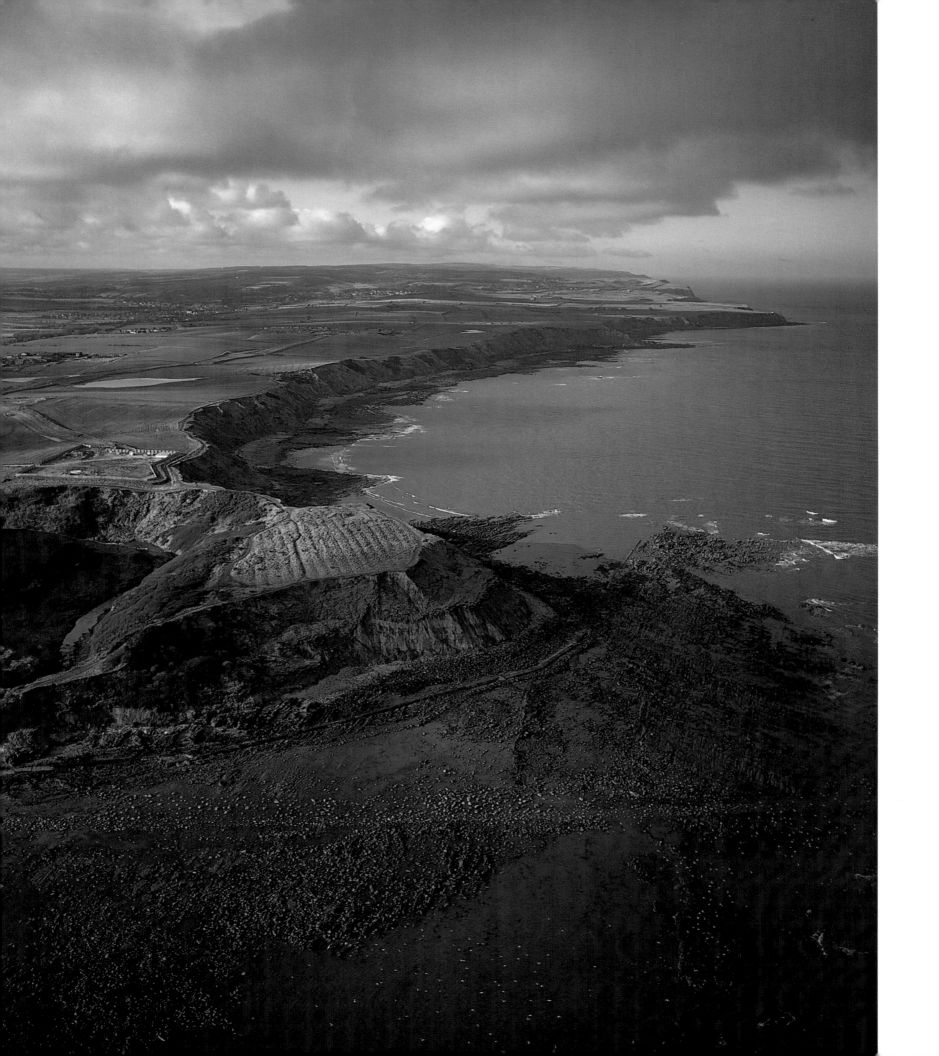

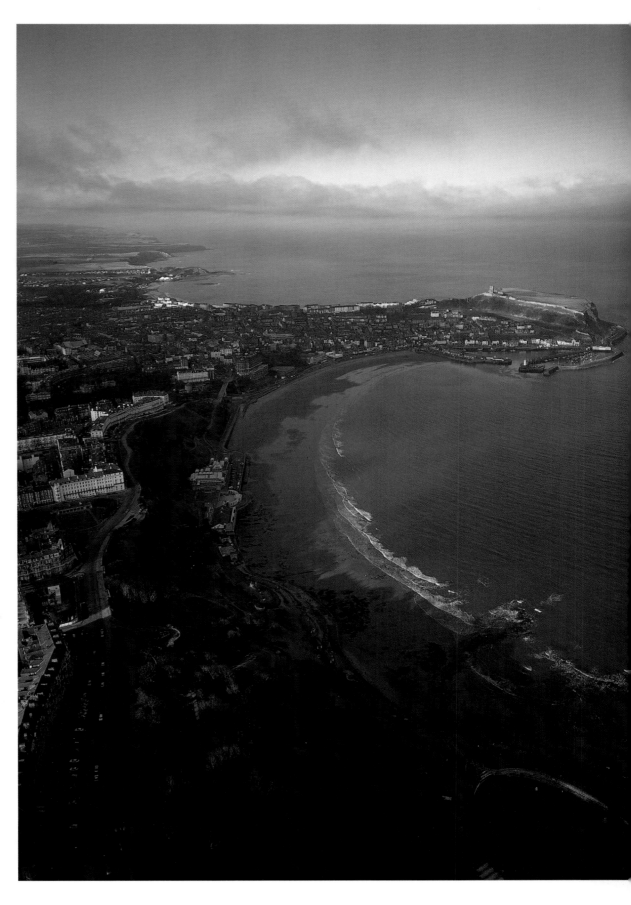

CLEVELAND WAY LOOKING TO CROMER POINT

Left On either side of Scarborough, the trail known as the Cleveland Way is a well-trodden walk and one that is no doubt blister-inducing at around 110 miles. However, it is one often undertaken for the beautiful panoramic views it offers and the astonishing amount of historical sites the walker comes across along the way. Bronze and Iron Age circles of obscure purpose can be seen on the moor, and the coast has five Roman signal stations, which used to send signs in the form of either smoke or light to warn of enemies approaching from the sea.

SCARBOROUGH

Right Scarborough is the oldest resort in the county and in the eighteenth century attracted the more daring of society who came for the adventure of a bracing dip in the North Sea. Scarborough's novelties now include one of the world's longest railway station benches, seating 228 people, and a museum dedicated to the eccentric family of artists, the Sitwells.

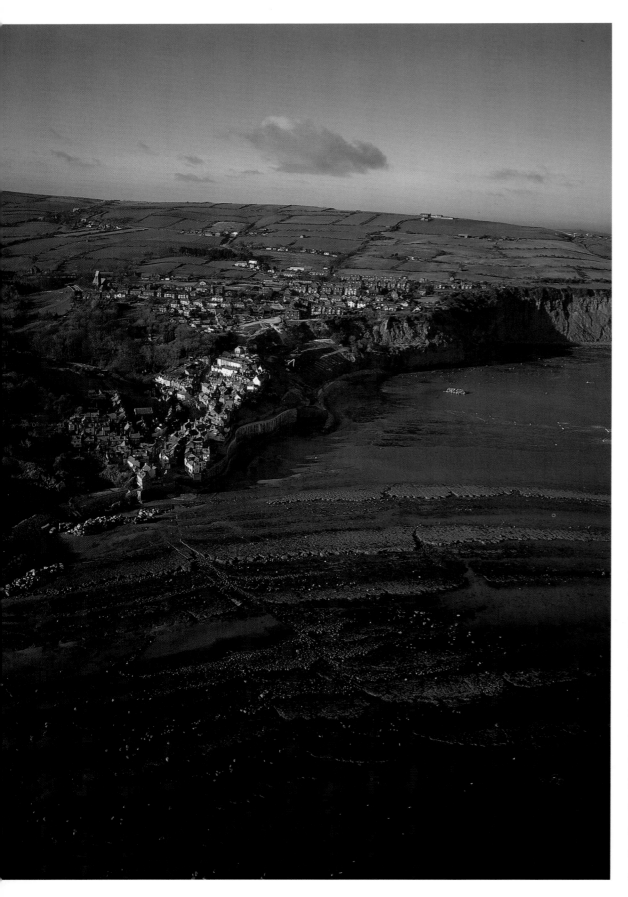

ROBIN HOOD'S BAY

Stretching from North Cheek, also known as Ness Point, to Ravenscar, Robin Hood's Bay is one of the most visited spots along this sweep of coastline. It was called Robbyn Huddes Bay as early as 1538, although the connection to the famous outlaw of Sherwood Forest has been lost over the years. Local stories include suggestions that this was either the place he took his summer holidays, that he came here to help the monks of Whitby against the Danes, or that he was chased here by enemies and escaped by dressing up as a fisherman. Locals often refer to their postcard-perfect village simply as Bay or Bay Town. The narrow alleys, streets and tiny courtyards are tightly packed with cottages. In fact, these abodes are so crammed together that stories tell of how smugglers would pass their illegal booty between cottages all the way up the hill, and the pursuing King's men would remain completely clueless. For centuries, the village survived by profits brought by the smuggling of brandy, gin, tea and silks from Holland, combined with fishing. As well as a source of food and income, the sea here has become a mecca for geologists, with the main cliffs eroded to a point that reveals sections dating back 160 million years to the Jurassic Period.

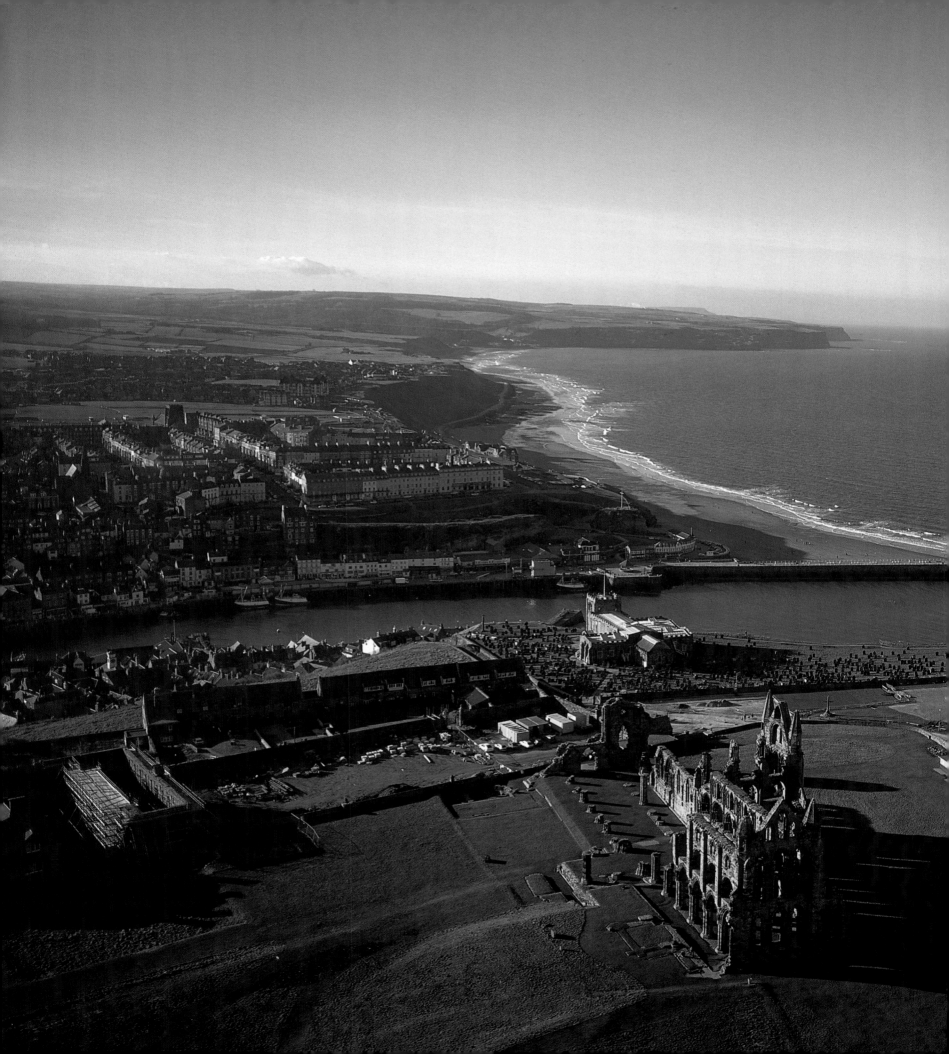

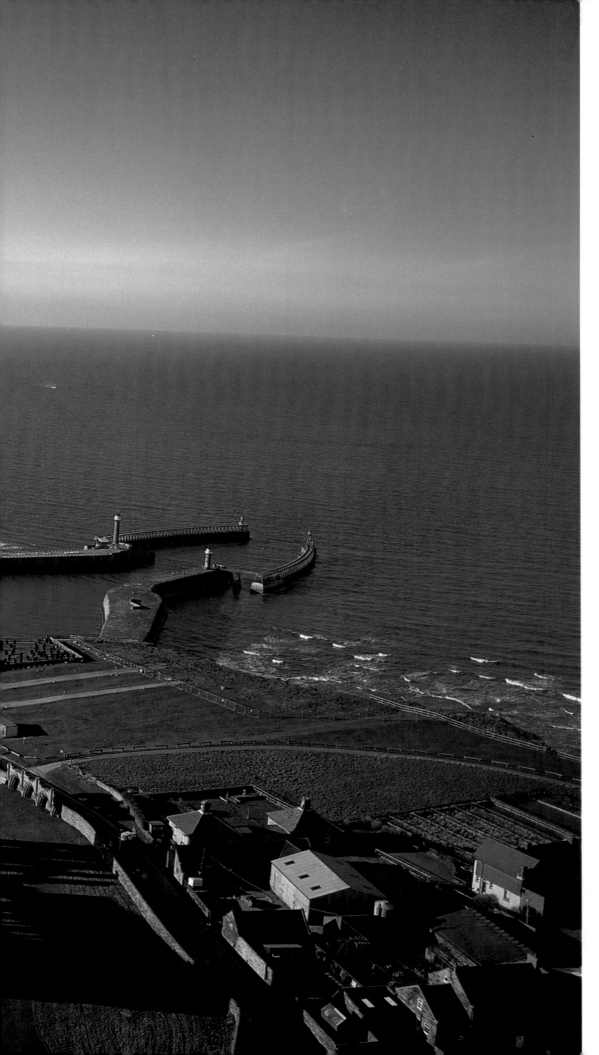

WHITBY

The ancient fishing town of Whitby is part of the Heritage Coast of northeast England and the town has a thriving holiday resort trade. The relatively recent arrival of the replica of Captain Cook's ship *HM Bark Endeavour* has also helped to keep Whitby in the news. The town is nothing if not charming, and although the harbour has had a distinguished past, adding the title of main whaling port in northern England to its many accomplishments, it was a book that really put Whitby on the map. From the old town it is an exhausting 199-step climb up to the parish church, and it was when watching a coffin being carried up these steps that Bram Stoker decided to set part of *Dracula* here. Close by are the ruins of Whitby Abbey, successor to one founded here by St Hilda.

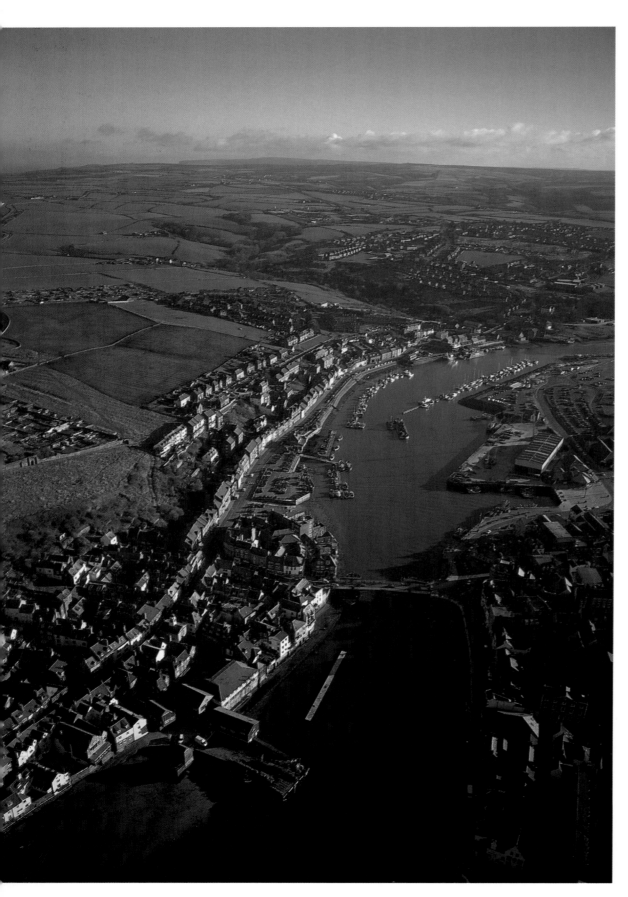

WHITBY HARBOUR

Situated at the mouth of the River Esk, Whitby is divided into an East Bank and West Bank, connected by a swing bridge. The current bridge was constructed in 1909, but the original bridge was known to exist as far back as 1351. Pictured here looking both out towards the sea and looking in from the sea, the harbour covers around 80 acres in total. The harbour was originally developed to ship out alum mined at Guisborough in the sixteenth century, although it soon expanded into building its own ships. By 1706, Whitby was the sixth largest port in Britain, turning over around 130 ships a year, and the shipbuilding industry continued for the next 200 years. Today, smaller boats such as Yorkshire cobles are still built at two small yards in the harbour using traditional methods.

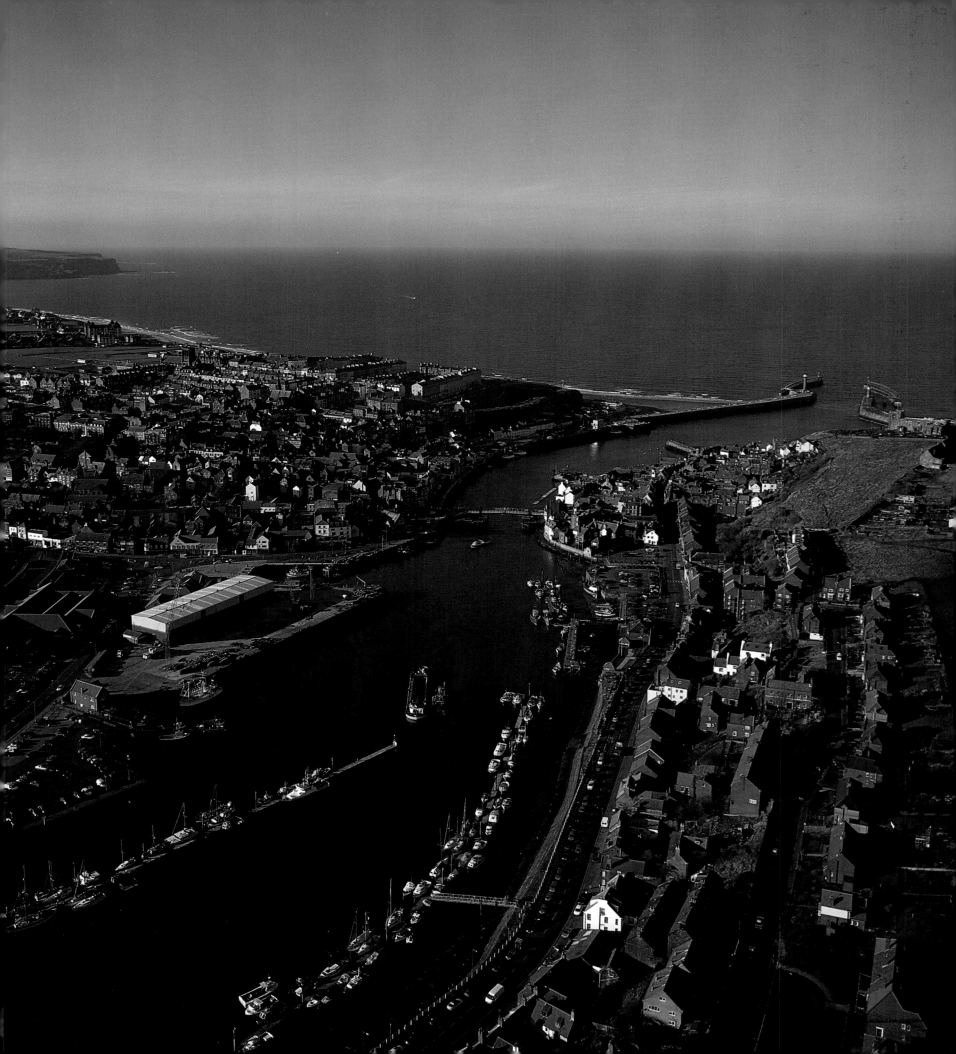

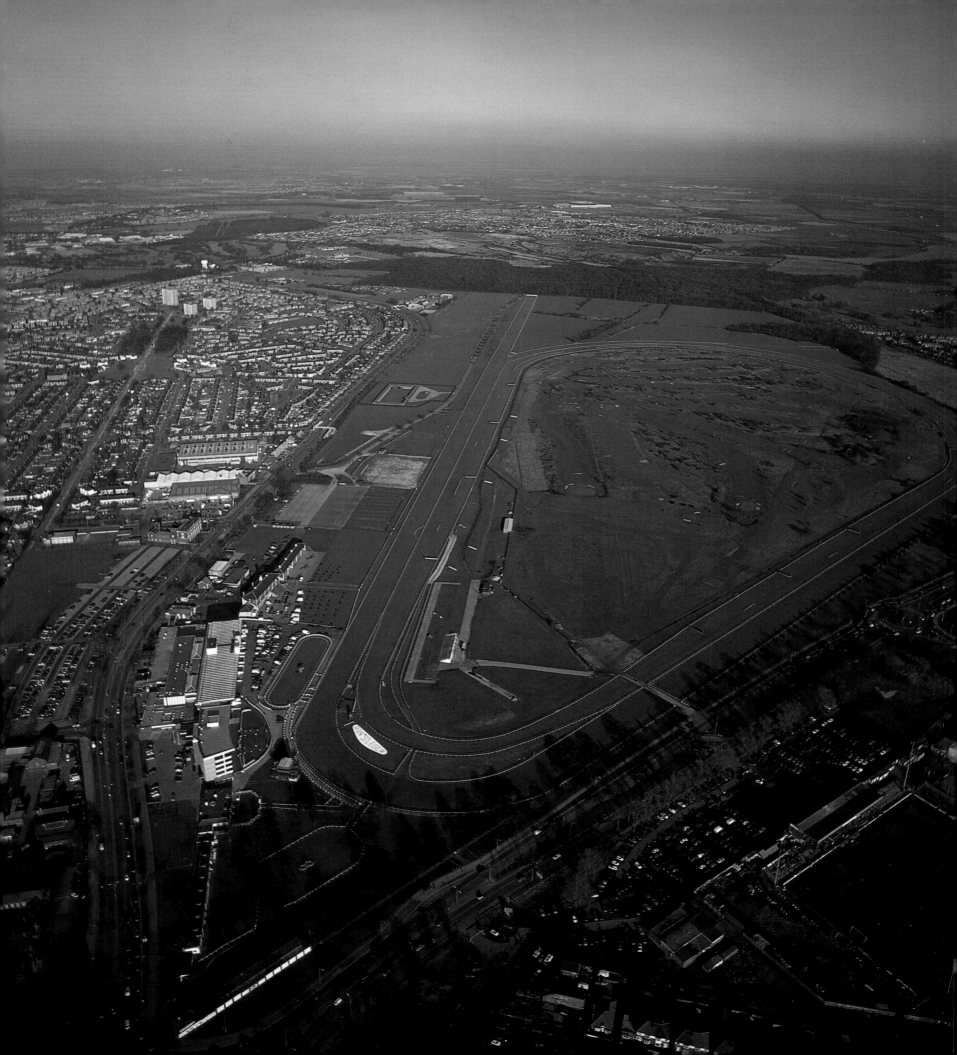

SPORTING LIFE

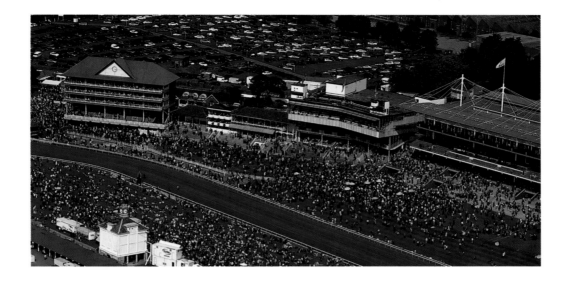

IT IS A WELL KNOWN and often mentioned saying that Yorkshire air makes you hungry. Nothing to do then with the enormous choice of activities on offer for visitors and locals alike. Clubs throughout the county offer cricket, hockey, orienteering, tennis, archery, football, swimming, golf, rugby and yachting, to mention just a few. The North of England has made a big commitment to ensure that its sporting facilities can rival those of other countries, and this has culminated in the building of the magnificent Alfred McAlpine Stadium in Huddersfield. This huge centre combines sport, health and fitness with leisure and commerce and is a stadium fit for the twenty-first century (see page 126).

Another reason people visit Yorkshire time and time again is to simply go walking, take in big gulps of the fresh country air and perhaps even pursue another interest at the same time such as botany, geology or ornithology. There is a plethora of guide books dedicated to suggestions for walks all over Yorkshire, and if that isn't thrilling enough for you, you could always try climbing one of the Three Peaks or even potholing.

Fishing is another favourite and peaceful pastime. Sea anglers are well catered for all around Whitby, although for the very best fishing you really need to go further afield and hire a boat. The River Esk is Yorkshire's only genuine salmon river, and even that has been better known for its sea trout catches over the last few years.

However, from the air, it is the racecourses that really grab the attention. While perhaps not reaching the fame of Ascot, Doncaster, Ripon and York racecourses are home to some very prestigious races and horse racing is always a great day out. What is most striking from this perspective is what a difference it makes if they are empty or thronging with people. The empty racecourses beg to be filled and you can almost feel the exciting atmosphere of the ones that are primed for action.

DONCASTER RACECOURSE

Left To those in the know, Doncaster racecourse has a reputation as one of the finest in Europe, producing racing

of the highest order. The photograph captures the racecourse looking quite deserted but there are flat and jump

courses here meaning all-year-round racing. It also hosts the famous St Leger Handicap every September.

YORK RACECOURSE

Above Packed with people, some dressed up to the nines, a day at the races can be an exciting day out for all

members of the family.

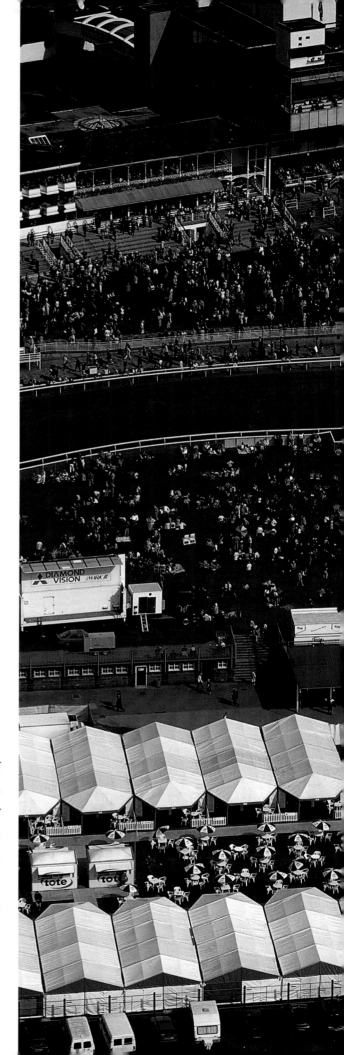

York Racecourse

The brochure for York racecourse begins with a quote from Simon Scrope of Danby-on-Yore in 1731: 'Tomorrow we set out for York to see the new horse course, lately made on Knavesmire, and to join the great goings of the week, life of which no town or city can compare with for gaiety, sport and company all of one mind.' Two and a half centuries later, the racecourse is still increasing in popularity and was voted the United Kingdom's '2000 Northern Racecourse of the Year'. Top-class racing, including a Derby trial and the Magnet Cup, one of the best handicaps in the country, excellent facilities and good viewing from all the enclosures makes York one of Britain's top tracks.

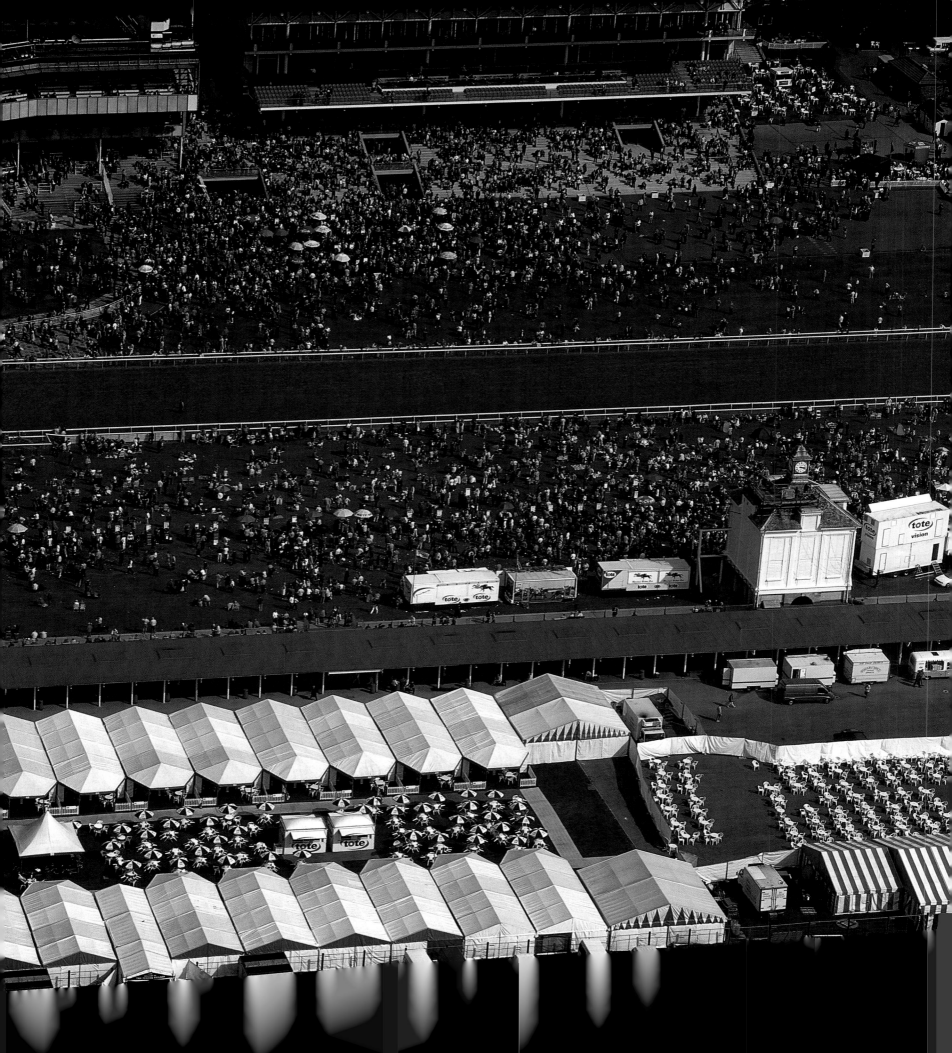

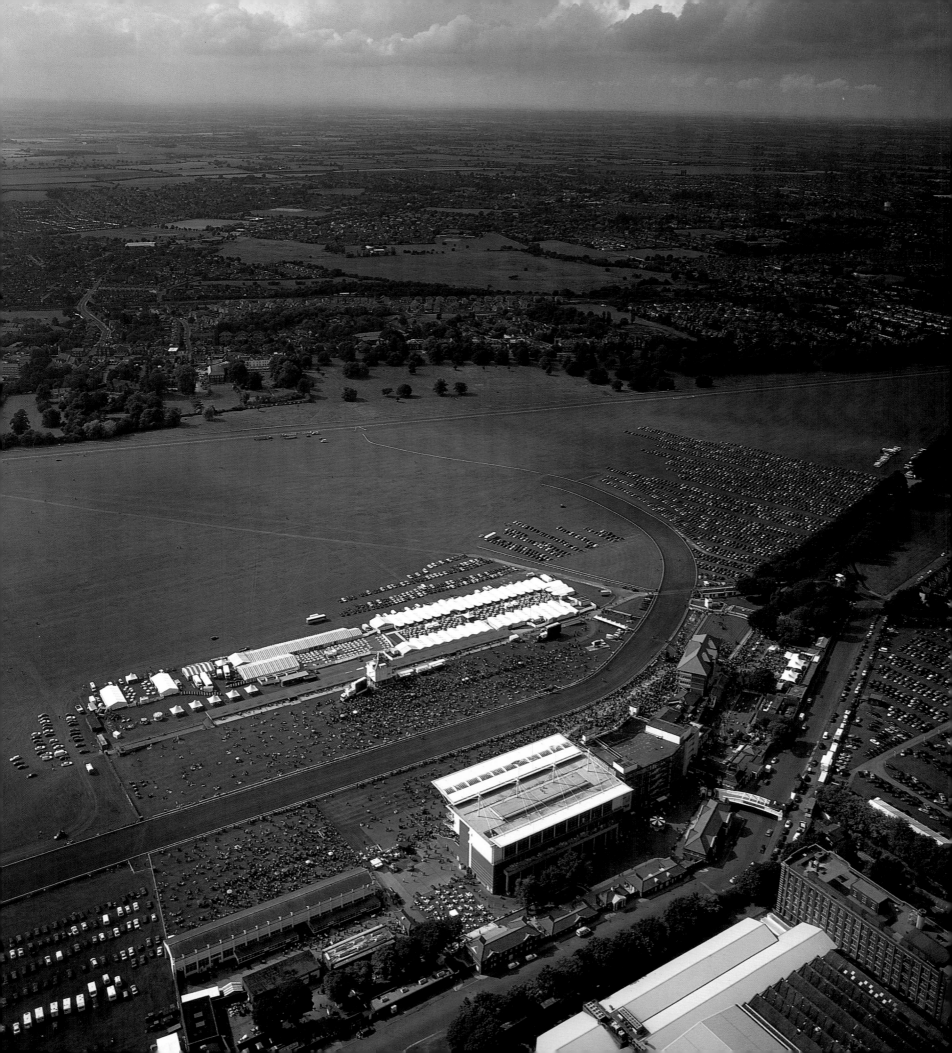

YORK RACECOURSE

Left There are a total of nine racecourses in Yorkshire and there are two different types of horse racing on offer, flat and jump. Wetherby stages jump racing only, which takes place in the winter; Catterick and Doncaster stage both flat and jump, and all the rest — including Ripon and York — stage flat racing only, which takes place in the spring and continues through to the summer.

RIPON RACECOURSE

Right Ripon racecourse has long been renowned as 'Yorkshire's Garden Racecourse' on account of its extremely attractive surroundings, which include the floral Spa Gardens. The oval circuit has a circumference of more than a mile and a half, which is considered large. However, the slightly cramped bends mean that it is regarded as a sharp track.

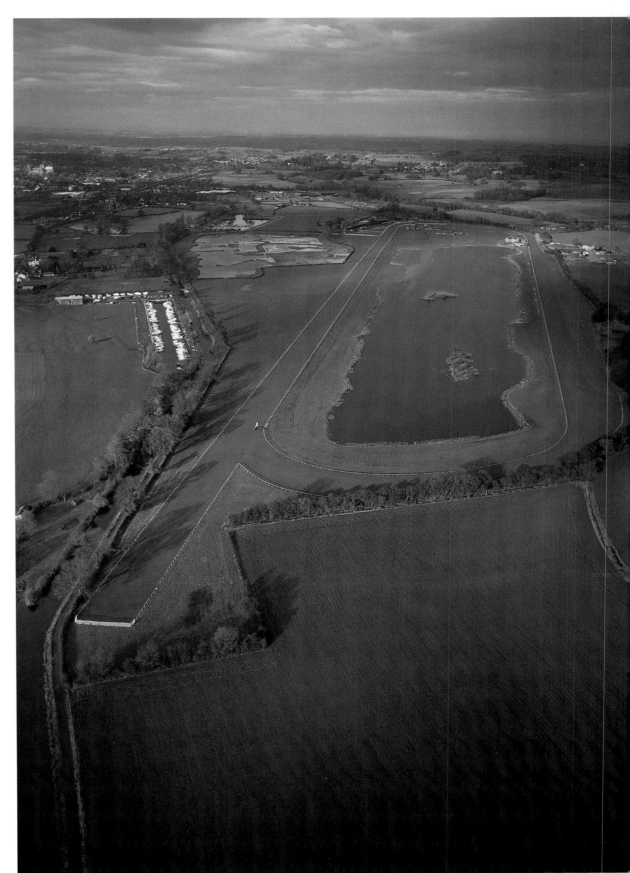

THE ALFRED MCALPINE STADIUM

Above This amazing and ultra-modern sports, leisure and commercial complex cost £40 million to implement. It was the result of a wish to create a versatile sports facility and a partnership between Kirklees Metropolis Council, Huddersfield Town FC and Huddersfield Rugby League Club, who put their heads together in November 1991. Including almost everything imaginable from a nine-screen cinema with over 2000 seats to a 50-bay golf driving range with a 460m (1500ft) golf superstore, the centre piece of the 51-acre site has to be the stadium, built to seat 24,500 fans. It also was the winner of the RIBA Stadium of the Year award.

ELLAND ROAD

Right Elland Road is Leeds Football Club's ground and the original stadium was opened in 1878. This more recent building has a capacity of 40,000 and several of the Euro 1996 matches were held here.

INDEX